Charles Sheeler in Doylestown

Charles Sheeler in Doylestown

AMERICAN MODERNISM AND THE PENNSYLVANIA TRADITION

Karen Lucic

Allentown Art Museum

The exhibition "Charles Sheeler in Doylestown: American Modernism and the Pennsylvania Tradition" was organized by the Allentown Art Museum, Allentown, Pennsylvania, and is supported by grants from the Harry C. Trexler Trust, Allentown; an anonymous donor; and the National Endowment for the Arts, a federal agency.

Distributed by the University of Washington Press

Library of Congress Catalog Number: LC 97-70845
ISBN 0-295-97643-8

Edited by Paula Brisco
Designed by Phillip Unetic
with Lori Cohen and Maria DiLeo
Tritone negatives by Robert Hennessey
Printed by Meridian Printing
Printed in the United States of America

Cover: *Staircase, Doylestown*, 1925 (detail; full image cat. 23), oil on canvas, 25 ⅛ x 21 ⅛ in., Hirshhorn Museum and Sculpture Garden, Smithsonian Institution, Washington, D.C., Gift of Joseph H. Hirshhorn Foundation, 1972 (72.265). Photo: Lee Stalsworth.

EXHIBITION ITINERARY

Allentown Art Museum, Allentown, Pennsylvania
April 6–June 22, 1997

Amon Carter Museum, Fort Worth, Texas
August 23–November 2, 1997

Cincinnati Art Museum, Cincinnati, Ohio
December 19, 1997–March 1, 1998

Contents

Charles Sheeler in Doylestown
American Modernism and the Pennsylvania Tradition

Karen Lucic, *Guest Curator*

Sarah Anne McNear, *Consulting Curator*

Foreword

In 1987, the Allentown Art Museum was in the conceptual stages of an exhibition dealing with Charles Sheeler's work made in or inspired by his residence in nearby Bucks County, Pennsylvania, when we learned of the splendid Sheeler exhibition about to open at the Museum of Fine Arts, Boston. Even as we postponed our plans, Carol Troyen at the Museum of Fine Arts encouraged us to investigate Sheeler's aesthetic and historic roots centered in a small eighteenth-century stone house that is a forty-minute drive from Allentown. "Charles Sheeler in Doylestown" is the exhibition conceived ten years ago. Such is the enduring nature of Sheeler's work that it can stand close scrutiny at frequent intervals and still remain fresh and revealing.

The trustees of the Allentown Art Museum have encouraged and supported exhibitions of works of art made by artists who have a special kinship with this region. Among the first projects for the brand-new Allentown Art Museum was the early retrospective of Charles Sheeler's work organized by Richard T. Hirsch in 1961. By that time, Bucks County had gained a chic ethos, as successive waves of high-profile literary and theatrical people from New York found peaceful country retreats in rural Pennsylvania. When Sheeler and his friend Morton Livingston Schamberg arrived in Bucks County about 1910, the area provided an unexploited, picturesque landscape and an indigenous Pennsylvania Dutch culture still largely unexplored. In Doylestown, Henry Chapman Mercer was gathering his collection of American tools that are now installed in the Mercer Museum not far from the house Sheeler rented. However, Henry Mercer the antiquarian stands in stark contrast to Sheeler, who used the same material culture as a springboard for an original expression in a modernist idiom.

We are very fortunate to have enlisted Karen Lucic, Associate Professor, Vassar College, as guest curator for this exhibition. Her essay exceeds all expectation in achieving insights into an artist both mysterious and apparently straightforward. Sarah Anne McNear, Curator of Exhibitions and Collections at the Allentown Art Museum from 1988 to 1996, was the impetus for reviving this project in 1991. She has shepherded the exhibition and catalogue from inception through installation. This includes contacts with the lenders to the exhibition, who have selflessly deprived themselves in the interest of the success of this project. Although named elsewhere in this catalogue, I want to thank Mrs. William H. Lane for her extraordinary generosity. This catalogue has been handsomely designed by Phil Unetic, who never fails to express a profound understanding of an artist's intent, and Paula Brisco edited the manuscript with her usual style and grace. Robert Hennessey, with whom we had never before worked, applied his craftsmanship to the reproductions of Sheeler's vintage photographs. Karen Bausman, F.A.A.R., Principal, Karen Bausman & Associates, contributed to the design of the installation of this exhibition in Allentown. Thanks are also due to the Museum's Associate Registrar, Carl Schafer; his assistant, Sofia Bakis; and Philip Roeder, Building Operations Manager, whose combined efficiency has contributed greatly to the completion of the exhibition. Ambitious projects like this one need partners. Barbara Gibbs, Director of the Cincinnati Art Museum, and Rick Stewart, Director of the Amon Carter Museum in Fort Worth, were both keenly interested from the earliest stages of organization.

"Charles Sheeler in Doylestown" received ready and generous support, in both its research and planning phase as well as its execution, from the National Endowment for the Arts. This beleaguered federal agency deserves more credit than it usually gets for making locally generated projects like this one a reality. I owe a debt of thanks to the trustees of the Harry C. Trexler Trust for a generous grant in support of the exhibition in Allentown. I also want to extend my gratitude to Priscilla Payne Hurd, trustee emerita of the Allentown Art Museum, for her enthusiasm for the Bucks County landscape and its artists.

Peter F. Blume
Director
Allentown Art Museum

Preface

"Charles Sheeler in Doylestown: American Modernism and the Pennsylvania Tradition" investigates one artist's lifelong engagement with the rich, distinctive traditions of rural Bucks County. It charts Sheeler's discovery of the region's architecture and artifacts beginning about 1910, when he and fellow artist Morton Livingston Schamberg rented an eighteenth-century farmhouse in Doylestown. It assesses what impact this seminal event had on Sheeler's early career, and how his cyclical return to Bucks County themes in later life reveals poignant attachments and emotional depths not usually ascribed to this twentieth-century painter and photographer—known primarily as an iconographer of the machine. By analyzing Sheeler's core attachment to the preindustrial vernacular, this exhibition and its catalogue reconstruct his attempt to reconcile past and present in a series of powerful, complex pictures that resulted from his enduring fascination with the Pennsylvania tradition.

My own investment in this topic has deep and long-established roots. A native (but early transplanted) Pennsylvanian myself, I first arrived at Sheeler's highly charged thresholds during graduate study more than a decade and a half ago. This work ultimately resulted in a dissertation, numerous articles, and a book, *Charles Sheeler and the Cult of the Machine*, in which I examined the complicated and ambivalent nature of the artist's urban, technological, and industrial imagery. These publications brought me to the attention of the Allentown Art Museum. Its director, Peter Blume, and curator, Sarah Anne McNear, had long cherished the idea of a Sheeler exhibition focusing on the artist's time in Pennsylvania, a fitting sequel to the major retrospective of his work mounted by the institution in 1961. My deepest thanks go to them for giving me the opportunity to complete my portrait of Charles Sheeler by highlighting his perspective on the preindustrial American past. I am also indebted to other associates of the museum—Paula Brisco, Sofia Bakis, and Phillip Unetic—for assistance with the catalogue.

Numerous individuals generously aided this project in a variety of ways, especially my dissertation advisor in the Department of the History of Art at Yale University, Jules David Prown, and my dissertation committee—Ann Gibson, Alan Trachtenberg, and Wanda Corn. Professor Corn also graciously agreed to be an advisor on this project, as did Carol Troyen and Theodore E. Stebbins, Jr. My thanks go to them as well as to other friends and colleagues for invaluable assistance, enthusiastic support, and insightful comments: Avis Berman, Naomi Sawelson-Gorse, Susan Fillin-Yeh, Kim Sichel, Christine Poggi, Ellen Chirelstein, Marian Cohn, Francesca Consagra, Nicholas Adams, Rebecca Zurier, Patricia Kane, Thomas Hill, and Robert Goldberg. My student assistants at Vassar College, Jennifer Gauthier and Jennifer Chwalek, helped with research and footnote checking.

Various museum professionals shared their time and expertise with me, including current and former staff members at the Museum of Fine Arts, Boston—Karen Quinn, Erica E. Hirshler, and Norman Keyes, Jr.; the Bucks County Historical Society—Betsy Smith, Jean Dawson, James Blackaby, Kenneth Hinde, Linda Dyke, and Terry McNealy; and the Philadelphia Museum of Art—Ann Temkin, Ann Percy, Gina Kaiser, Tom Loughman, Marge Cohen, and Rolando Corpus. I also sincerely thank other museum and library professionals: Rick Stewart, Barbara McCandless, Patricia Willis, Judy Throm, Nancy Yeide, Linda Simmons, Anne-Louise Marquis, Cheryl Brutvan, John Wilson, Peter Galassi, Lowery Stokes Sims, Ida Balboul, Kay Bearman, Lawrence Libin, Judy Hayman, Mary Jane Jacob, Wilfred Scott, Charles Millard, E. Jane Connell, Richard Guy Wilson, David Utters, and Ronald Pisano. Various gallery owners and personnel were equally helpful: Eric W. Baumgartner, Meredith Ward, Roland Augustine, Richard York, James Maroney, Peter MacGill, Howard Read, and Terry Dintenfass. Mr. and Mrs. Carroll L. Cartwright and Joanna T. Steichen granted permission for the reproduction of works in this catalogue. Mrs. Richard Kyle invited me into her house to interview her husband, Charles Sheeler's nephew, at a difficult time. I am beholden to her, as I am to the former owners of the Jonathan Worthington house, Helen Regelman, who patiently allowed me to measure and photograph the building, and to Susan and David Mulholland, who were extraordinarily cooperative in allowing me access to the house and who gave me valuable information and assistance.

Of course, grateful acknowledgment is due to all the lenders to this exhibition. Without their willingness to part with beloved objects, this project could never have been realized. I would like to mention in particular those with whom I have had the pleasure to meet or with whom I have spoken personally: Mr. and Mrs. Romano Vanderbes, Mr. Bruce V. Zeman (acting on behalf of Mr. Arthur E. Imperatore), Mr. Carl Rieser, Mr. and Mrs. Bernard Schwartz, and other gracious anonymous lenders. Sandra B. Lane deserves a special acknowledgment for her extraordinary kindness, assistance, and cooperation. She and her late husband, William H. Lane, have long been loving caretakers of the photographs from the Sheeler estate, conscientiously preserving this material for the future. Their efforts to honor the artist's legacy have made it possible to truly represent his Bucks County period in this exhibition.

Finally, I lovingly dedicate this publication to my husband, Douglas Winblad, whose contributions to my life and work have been inestimable.

Karen Lucic
Guest Curator

Charles Sheeler, Modernism, and National Identity

I don't like these things because they are old, but in spite of it. I'd like them still better if they were made yesterday because then they would afford proof that the same kind of creative power is continuing.

Charles Sheeler, 1938

During a long and impressive career as one of America's leading modernists, Charles Sheeler produced compelling icons of the Machine Age. Trained in a spontaneous, impressionistic approach to landscape subjects, he experimented with pictorial compositions inspired by Cézanne and Picasso before developing a seemingly impersonal, machine-inspired style—now often labeled precisionism. In this mode, he depicted New York skyscrapers, locomotive engines, power plants, and factory complexes near Detroit (fig. 1). These pictures from the 1920s and 1930s established his reputation as "the Raphael of the Fords,"[1] and this characterization persists into our time. Recently, the critic Michael Kimmelman dubbed Sheeler "an iconographer for the religion of technology," and art historian Matthew Baigell called him "the true artist of corporate capitalism."[2] Indeed, Sheeler once compared the great medieval cathedral at Chartres to the American factory system, adding that "maybe industry is our great image that lights up the sky." But he concluded his thought with an unexpected remark, "The thing I deplore is the absence of spiritual content."[3] Sheeler's astonishing turn of mind indicates a surprisingly divided and unresolved attitude toward the subject matter for which he is best known.

If America's innovative technological achievements did not provide secure access to "spiritual content" for

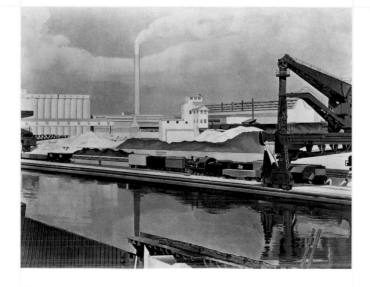

Sheeler, where else did he search for integrated wholeness? What other subjects contributed to his sense of personal, artistic, and national identity? The answer to these questions lies in a far less familiar aspect of his work. America's preindustrial handcraft traditions, such as regional barns, folk painting, and Shaker furniture, provided a fundamentally important but often overlooked—wellspring of the artist's creativity.[4] He first discovered such generative models in Bucks County, Pennsylvania, where a hand-hewn spiral staircase, splintered sideboarding and crumbling plaster walls, and venerable fieldstone buildings inspired startlingly modernist images.

The Machine Age left some of Sheeler's needs unsatisfied, and throughout his career, he consistently turned to old, handcrafted artifacts in his quest to discover or invent an aesthetic foundation for an indigenous American modernism. The fact that early twentieth-century artists like Sheeler so ardently sought out preindustrial objects as models for their modernist work is one of the era's most intriguing paradoxes. Evaluating these artists' simultaneous attraction to the old and the new provides a key to understanding the complexity of American culture during the early twentieth century.

But what did it mean to be a modern artist in America during this era? What defined the art that American modernists tried to create? Difficult to answer today,

these questions must have been even more perplexing in Sheeler's time. Certainly, then—as now—the task of modernist self-definition involved developing an original, experimental style that displayed a sophisticated knowledge of international vanguard trends. But this merely pushes the question back. What in fact constituted international modernism? Paintings by formidable innovators such as Cézanne, Matisse, and Picasso challenged the conventions of pictorial representation established in the West during the Renaissance. These artists favored abstract forms, nonnaturalistic color, and numerous expressive departures from conventional illusionism. Subsequent artists, such as Malevich and Mondrian, wanted to create new, universally valid forms of visual expression in totally nonobjective idioms.

As a young artist, Sheeler first encountered such radical innovations during a trip to Paris in 1908–09. This experience convinced him to renounce the late impressionist technique he had learned in art school and to join the modernist camp. "Returning to my studio meant discontent and an unwillingness to resume where I had left off before that voyage of such great portent. An indelible line had been drawn between the past and the future …," he later wrote.[5] In 1913, the Armory Show in New York provided further exposure to revolutions in modernist painting, and it must have been simultaneously exhilarating and daunting to witness the bewildering proliferation of new stylistic options coming from Europe. Sheeler nevertheless quickly grasped one explicit feature of modernist aesthetic practice: "a picture could be as arbitrarily conceived as the artist wished."[6] (See cat. 4.)

Modernists forged a welter of distinct stylistic innovations in the first two decades of the twentieth century. But beneath their disparate expressions, all of them fundamentally challenged the long-established role of art to represent the world. In doing this, they confounded everyday expectations of what constitutes legitimate picturemaking and were understood by their contemporaries to elevate form over associative or descriptive content. Although overtly rejecting the past, modernists actually continually reconfigured tradition by looking for visual stimulation beyond established academic norms—to non-Western, folk, and vernacular

sources. Not merely a prescribed set of stylistic features, modernism encompassed a new way of thinking about traditional models and means of representation.

In America, the task of defining oneself as a modernist became even more complex after World War I. It now meant not only studying developments from abroad but establishing a distance from them as well. Severely disillusioned with the war-ravaged nations on the Continent, American critics warned artists in this country against slavish emulation of the European avant-garde. They urged native painters to distinguish their work significantly from foreign contemporaries. Suddenly, the need arose to establish roots in native ground.

This nationalistic project posed serious challenges, however. In the first place, European modernism possessed enormous authority and served as a profoundly stimulating (and simultaneously intimidating) model. The poet William Carlos Williams, who wanted to be a painter in his early career, testified to the American vanguard's ambivalence toward French artists: "We looked upon the French with a certain amount of awe because we thought they had secrets about art and literature which we might gain. We were anxious to learn, and yet we were repelled too."[7] Furthermore, the predilection for abstraction in modernist art tended to limit assertions of specific national or local identity. Nevertheless, American artists like Sheeler heeded the calls for cultural self-sufficiency, and one of their most effective responses involved developing an iconography that embraced the dominant features of America's rapidly modernizing environment— urbanization, industrialization, mass marketing, and other technological innovations. These widely admired aspects of American society were unparalleled in the world during the early twentieth century and therefore effectively served artists looking for powerful national symbols. No wonder Sheeler made such concrete features of urban/industrial modernity central to his artistry. His novel adaptation of the machine aesthetic dramatically evoked both the power and sensorial qualities of the technological environment (fig. 1). This allowed Sheeler to retain his modernist credentials, even while incorporating a rigorously realistic and uncannily "objective" approach to painting in the late 1920s and 1930s.[8]

In the first three decades of the twentieth century, "uniquely American" art depicted the country's characteristic modernity in styles that were considered experimental and inventive. Sheeler excelled at this kind of artistic self-presentation, and through it, established himself as a premier iconographer of the Machine Age. Given his modernist program, we might imagine that the past had no relevance to Sheeler. Why seek out Bucks County barns when New York City and Detroit provided abundant stimuli for the fashioning of American identity? But Sheeler *did* portray barns as well as factories, always maintaining an active dialogue between preindustrial traditions and technologically sophisticated modernity. William Carlos Williams perceived this in Sheeler's art when he wrote that the artist "is the watcher and surveyor of that world where the past is always occurring contemporaneously and the present always dead needing a miracle of resuscitation to revive it."[9] In other words, according to Williams, Sheeler approached the past in a way that ameliorated the stultifying forces of the present.

Indeed, to modernists of Sheeler's generation, the past—in the form of folk and vernacular traditions (see cat. 40)—gave another viable answer to the question of what constituted a uniquely American art. Not the past as defined by the academy, but as newly discovered, reconstituted, as if seen for the first time through a modernist lens.[10] In 1917, the New York artist and gallery owner Robert Coady voiced prevalent sentiments of the time. "We need our art. But ... [it] can't come from the Academy or the money old ladies leave.... Our art is, as yet, outside of our art world."[11] Coady catalogued diverse materials that he felt attested to the vitality of aesthetic production in this country:

The Panama Canal, the Sky-scraper and Colonial Architecture ... Indian Beadwork, Sculptures, Decorations, Music and Dances ... The Crazy Quilt and the Rag-mat ... The Cigar-Store Indians ... The Factories and Mills ... Grain Elevators, Trench Excavators, Blast Furnaces—This is American Art.[12]

Coady listed items stemming from popular, vernacular, folk, and industrial culture. He also interestingly commingled past

and present ("the Sky-scraper and Colonial Architecture") in his evaluation of appropriately indigenous subject matter that could inspire a legitimate American art.

Such conceptual marriages of old and new, of the local and the cosmopolitan, characterized the "usable past" quest in America during the years following World War I. Initially formulated by the literary scholar Van Wyck Brooks, this intellectual project involved a critique of American society and values as either ineffectually genteel or ruthlessly materialistic. Brooks believed that from the time of Puritan colonization, both these polarities had impeded the establishment of vital aesthetic traditions. He wrote in 1918:

The present is a void, and the American writer floats in that void because the past that survives in the common mind of the present is a past without living value. But is this the only possible past? If we need another past so badly, is it inconceivable that we might discover one, that we might even invent one?[13]

Brooks called for a fundamental reevaluation of America's literary past and the overturning of the established canon in order to discover or even to invent another, more vital history.

Brooks's challenge echoed those of figures in the art world, like Coady, who wanted America to express a confident cultural self-sufficiency. These critics condemned the elite painting styles of the immediate past as derivative and irrelevant. They hoped that discovering a heretofore unrecognized indigenous lineage might inspire contemporary artists to create a separate but equal status for their work in relation to foreign achievements.

Aesthetic reimaginings of the past did not come automatically, however; they demanded considerable ingenuity from artists. In Sheeler's case, he had to distinguish his regard for Bucks County traditions from the turn-of-the-century nostalgia for colonial Americana. Since the mid-nineteenth century, antiquarians had been decrying the deleterious effects of industrialization and urban development on traditional culture in the United States.[14] The 1876 centennial celebrations around the country fueled preservationist concerns; along with it came a fervent nationalism that peaked during Sheeler's youth. Love of nation resembled a secular religion; George Washington, a Christlike saint. Buildings the first president visited became "shrines" and "meccas."[15] Similar reverence grew for less illustrious forebears, and this adoration also applied to the artifacts associated with them. Some commentators grew rhapsodic:

How precious are the old memories in our own homes and households! The ring worn by a beloved mother now in her grave, how we cherish the holy thing!... As with home, so with country. Patriotism is not merely a sentiment; it is a principle born in our nature and part of our humanity.... Home and country! alike in the heart's best affections.[16]

Love of ancestors, country, and the artifacts associated with them stimulated such sentimental outpourings.[17]

Had Sheeler been searching for conventional patriotic subjects, he could have easily found them in Bucks County. Numerous buildings associated with the Revolutionary War remain there. In fact, George Washington crossed the Delaware River to fight the Battle of Trenton not far from Doylestown. Near this spot stands the well-preserved eighteenth-century Thompson-Neeley House where Washington made crucial military decisions just prior to crossing the river. And Sheeler actually knew and admired this handsome fieldstone building.[18] Yet probably because of its antiquarian and patriotic associations, he avoided it as an artistic subject. He once explained to an interviewer that he "sought neither the quaint nor the historical," adding, "I wouldn't paint Washington's Headquarters."[19] His questioner therefore concluded that "Sheeler is highly resistant to associative meanings...."[20] Sheeler himself stated, "My paintings have nothing to do with history or the record—it's purely my response to intrinsic realities of forms and environment."[21]

In numerous statements, Sheeler disassociated his regard for the past from nostalgic yearnings, while simultaneously voicing his profound aesthetic appreciation for handcrafted objects of preindustrial America. "I don't like these things because they are old, but in spite of it," he declared. "I'd like them still better if they were made yesterday...."[22] As his biographer Constance Rourke noted:

At Doylestown he had begun to acquire early furniture and pottery of that region, not with a collector's interest—he has never been anything of an antiquarian—but for the pleasure they could give and because they were useful.[23]

Such denials of antiquarianism protected Sheeler's reputation as a modernist primarily interested in aesthetic issues, despite his depictions of preindustrial, locally specific subject matter. His view of the American craft tradition is therefore intriguingly complex and seemingly paradoxical. It represents a formalist, ahistorical reevaluation of vernacular material—a position congruent with the concerns of the European avant-garde—that also satisfied nativist critics, like Coady, Brooks, and Rourke, who demanded an art based on a uniquely *American* heritage.[24]

 The pages that follow describe Sheeler's ingenious attempt to reconcile the conflicting demands of his cultural context while simultaneously creating hauntingly beautiful works on Bucks County themes. This story is told in three sections. "The Doylestown House" focuses on Sheeler's seminal photographic portrait of his eighteenth-century stone farmhouse and related works depicting the same subject. Also included are comparative images by some of the artist's contemporaries, such as Morton Livingston Schamberg (cat. 5), Aaron Siskind (cat. 6), and Paul Strand (cat. 19), as well as collateral material—letters, publications, and other documents—that reveal the cultural, historical, and personal significance of this building. "Bucks County Barns" examines the artist's series of photographs and drawings depicting vernacular architectural traditions of the region. In addition, examples of barn imagery from folk, commercial, and popular culture further illuminate Sheeler's work. Finally, "Doylestown Revisited" explores the series of drawings and paintings begun in the early 1930s that were inspired by the earlier photographs of the Doylestown house. It also encompasses other late works that revive the theme of the Bucks County barn.

 Earlier scholars such as Rourke have recognized the importance of Sheeler's Doylestown period. But this comprehensive investigation of the artist's engagement with rural Pennsylvania demonstrates in unprecedented depth how the architecture and decorative arts of Doylestown

helped Sheeler forge his carefully constructed identity as an American modernist—an identity that was at once self-consciously public and intimately personal. This material—viewed in its cultural context—helps us understand how the artist established an important place for the preindustrial past in his work, despite living in a predominantly ahistorical Machine Age. Sheeler often effectively veiled his loves and fears, but by closely examining his Bucks County imagery, a complex picture emerges that overturns the common view of the artist as a single-minded advocate of industry and technology. By bringing the past near, yet keeping it at arm's length, Sheeler created imagery that possesses an almost ineffable richness and poignancy—qualities that are never far from the surface in Sheeler's art.

NOTES

1. Charles Corwin, *New York Daily Worker*, 4 February 1949, p. 12, quoted in Martin Friedman, "The Art of Charles Sheeler: Americana in a Vacuum," in *Charles Sheeler* (Washington, D.C.: National Collection of Fine Arts, Smithsonian Institution Press, 1968), 57.

2. Michael Kimmelman, "An Iconographer for the Religion of Technology," *New York Times*, 24 January 1988, sec. H, pp. 29–30; Matthew Baigell, "American Art and National Identity: The 1920s," *Arts Magazine* 61 (February 1987): 51.

3. Quoted in Frederick S. Wight, "Charles Sheeler," in *Charles Sheeler: A Retrospective Exhibition* (Los Angeles: Art Galleries, University of California, 1954), 28.

4. Sheeler's attraction to the Shakers has received some scholarly attention. See, for example, Faith and Edward D. Andrews, "Sheeler and the Shakers," *Art in America* 1 (1965): 590–95.

5. Autobiographical notes, Charles Sheeler Papers, Archives of American Art, Smithsonian Institution (hereafter AAA), Roll Noh 1, frame 65.

6. Ibid., frame 74.

7. Quoted in Constance Rourke, *Charles Sheeler: Artist in the American Tradition* (New York: Harcourt, Brace and Co., 1938), 49. Rourke's biography is largely based on autobiographical notes written by Sheeler in 1937. (See note 5 above.) For a recent source on the American response to the European vanguard, see Steven Watson, *Strange Bedfellows: The First American Avant-garde* (New York: Abbeville, 1991).

8. See Karen Lucic, *Charles Sheeler and the Cult of the Machine* (Cambridge: Harvard University Press, 1991), 43–73, and Rick Stewart, "Charles Sheeler, William Carlos Williams, and Precisionism: A Redefinition," *Arts Magazine* 58 (November 1983): 100–14.

9. William Carlos Williams, "Introduction," *Charles Sheeler: Paintings, Drawings, Photographs* (New York: Museum of Modern Art, 1939), 6–7.

10. See Susan Fillin-Yeh, *Charles Sheeler: American Interiors* (New Haven: Yale University Press, 1987).

11. Robert J. Coady, "American Art," *The Soil* 1 (1917): 55. See also Judith K. Zilczer, "Robert J. Coady: Forgotten Spokesman for Avant-Garde Culture in America," *American Art Review* 2 (November/December 1975): 77–89.

12. Coady, "American Art," *The Soil* 1 (1917): 3–4.

13. Van Wyck Brooks, "On Creating a Usable Past," *The Dial* 64 (11 April 1918): 339.

14. Hugh Prince, "Revival, Restoration, Preservation: Changing Views about Antique Landscape Features," in *Our Past Before Us: Why Do We Save It?*, ed. David Lowenthal and Marcus Binney (London: Temple Smith, 1981), 45–46.

15. Charles B. Hosmer, Jr., *The Presence of the Past: A History of the Preservation Movement in the United States Before Williamsburg* (New York: G.P. Putnam's Sons, 1965), 41, 62, 81, 84, 88.

16. Statement by James Pollock, former governor of Pennsylvania, made in 1879. Quoted in Hosmer, *Presence of the Past*, 83.

17. Such sentiments also frequently expressed the will of the Anglo-Saxon elite to affirm its cultural dominance over newly arrived immigrants with radically different ethnic backgrounds. This retrospective mood was not unique to America, of course. Similar longings for a preindustrial past surfaced in all the industrialized nations during this time. Kenneth Ames, introduction to *The Colonial Revival in America*, ed. Alan Axelrod (New York: W.W. Norton, 1985), 11–14.

18. In 1920, Sheeler wrote that he had discovered a building in Bucks County "almost as fine as the Neeley house which seems to be our standard for comparisons." Sheeler to Mr. Swain, 18 June 1920, Henry Mercer Correspondence, Spruance Library, Bucks County Historical Society (hereafter BCHS).

19. Quoted in Wight, "Charles Sheeler," 27. Sheeler was not always consistent in living by these strictures, however. During the 1930s, he accepted a commission to paint several buildings at Colonial Williamsburg, and in 1943, he painted the Capitol Building in Washington, D.C. See Carol Troyen and Erica E. Hirshler, *Charles Sheeler: Paintings and Drawings* (Boston: Museum of Fine Arts, 1987), 28, fig. 22.

20. Wight, "Charles Sheeler," 21.

21. Quoted in ibid., 35.

22. Quoted in Rourke, *Charles Sheeler*, 136. In this passage, the artist specifically refers to Shaker objects, which he began to collect in the 1920s. Sheeler's relation to the Shaker tradition is also a formative aspect of his art, but it is a topic beyond the scope of this catalogue. A recent discussion of Sheeler and Shaker design appears in Karen Lucic, "Charles Sheeler and Henry Ford: A Craft Heritage for the Machine Age," *Bulletin of the Detroit Institute of Arts* 65 (1989): 37–47.

23. Rourke, *Charles Sheeler*, 99.

24. See Joan Shelley Rubin, *Constance Rourke and American Culture* (Chapel Hill: University of North Carolina Press), 1980, and Rubin, "A Convergence of Vision: Constance Rourke, Charles Sheeler and American Art," *American Quarterly* 42 (June 1990): 191–222.

The Doylestown House

Born in Philadelphia in 1883, Charles Sheeler (cat. 1) received formal artistic training in his native city.[1] From 1900 to 1906, he studied at the School of Industrial Art and at the Pennsylvania Academy of the Fine Arts, where he met Morton Livingston Schamberg (cat. 2). A brilliant and inventive young artist, Schamberg—like Sheeler—tended to be a loner.[2] As Rourke described their friendship, "They felt themselves to be two against the world."[3] Schamberg accompanied Sheeler on his seminal trip to Paris, where they discovered the work of Cézanne, Matisse, Picasso, and Braque. The experience inspired them to emulate these European innovators. As Sheeler explained, "I had an entirely new concept of what a picture is…."[4]

In 1908, Sheeler and Schamberg jointly rented a studio at 1822 Chestnut Street and began their lives as professional artists in Philadelphia. Initially unable to support themselves through the sale of paintings, both began to supplement their incomes with commercial photography in about 1912.[5] Schamberg specialized in portraits, while Sheeler concentrated on photographs of buildings. Simultaneously, they continued their experiments with modernist painting.

William Merritt Chase had schooled Sheeler and Schamberg in a fluid, impressionistic style at the Pennsylvania

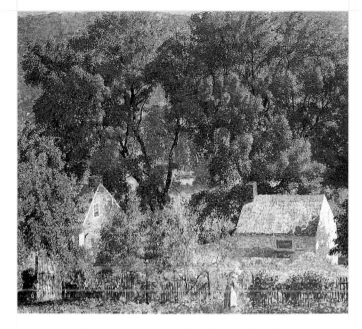

Fig. 2
Daniel Garber
The Sun in Summer
1919
Oil on canvas
The Museum of American Art
of the Pennsylvania Academy of
the Fine Arts, Philadelphia
(1945.14.2)

Academy. This technique initially dazzled Sheeler, but he soon became a critic of his education after graduation. In retrospect, it meant little to have studied at the school so closely associated with the renowned artist Thomas Eakins.[6] Sheeler and Schamberg also chafed at their confinement in Philadelphia during their early careers and longed for what they felt would be a more cosmopolitan artistic environment.

But curiously, these urbane modernists discovered an inspiring alternative in rural southeastern Pennsylvania. There the two friends received an informal aesthetic education in the rich vernacular traditions of that region; Sheeler would treasure this formative experience for the rest of his life.

From their days at the Pennsylvania Academy, Sheeler and Schamberg had often sketched the Bucks County countryside north of Philadelphia.[7] According to his own (much later) recollection, Sheeler stumbled onto an uninhabited, eighteenth-century farmhouse in Doylestown during one of these sketching excursions in about 1910. The little fieldstone dwelling was built in 1768 by Jonathan Worthington, a Quaker of English ancestry. Charming but decrepit, the empty house captivated Sheeler, and his inquiries about it led him to Henry Chapman Mercer, the town's self-appointed guardian of historical artifacts.[8] As a student, the young

artist had carefully studied the Barber Collection of Pennsylvania German ceramics at the Pennsylvania Museum (now the Philadelphia Museum of Art), and in their conversations, the older man learned of Sheeler's already well-developed interest in regional artifacts.[9] Favorably impressed, Mercer introduced Sheeler to the family who owned the house and quickly secured the lease for the artist.[10] Thereafter, Sheeler and Schamberg regularly used the house as a weekend and summer retreat (cat. 3). Even after Sheeler moved his professional base to New York City in 1919, he retained the house until 1926, using it during occasional visits to Doylestown.

Sheeler and Schamberg's decision to establish a studio in Doylestown had propitious ramifications. City dwellers from birth, both artists—like many others of their time—desired a rustic outpost in which to work. Beginning in the nineteenth century, American artists commonly rented or owned studios in the countryside.[11] Bucks County became an especially attractive haven for urban artists seeking a tranquil, picturesque environment. On the shores of the Delaware River about fifteen miles from Doylestown, the town of New Hope became the area's most prominent artists' colony. Edward Redfield, William Lathrop, Daniel Garber, and several other impressionist painters settled in the region at the turn of the century. Transforming abandoned farm buildings and old mills into studios and dwellings, they established a well-known "school" of regional landscape painting.[12]

In a typical work of 1919 titled *The Sun in Summer* (fig. 2), Garber presents two rural buildings nestled within the trees. The foliage dominates the composition and, in fact, largely obscures the dwellings. Garber's vision of human habitation nestled benignly within a protective natural environment embodies the New Hope artists' pervasive pastorialism. Even when depicting stone quarries or coal barges, they commingled industry and nature comfortably; only rarely does the industrialized landscape appear ugly or damaged.

Under Chase's tutelage, Sheeler painted similar subjects employing a spontaneous, *plein air* approach.[13] Yet he did not join the well-established New Hope colony after graduation. Even as a student at the Pennsylvania Academy, Sheeler disliked Redfield's work.[14] Following his trip to Paris, he continued to depict rural buildings in the Bucks

County farmland, such as *Landscape, Abstraction,* c. 1915 (cat. 4), but now he presented these motifs in a fundamentally different style from the New Hope school. The same was true of the contemporaneous work by Schamberg, such as *Landscape, Bridge,* 1915 (cat. 5). Formally experimental, these two paintings indicate the artists' exposure to modernism in Europe, at the Armory Show, and at "291" gallery in New York operated by the photographer Alfred Stieglitz. Sheeler and Schamberg's choice of relative isolation in Doylestown over the gregarious and well-established New Hope colony gives evidence of a desire to separate themselves, both socially and stylistically, from a community of popular local artists and from their own earlier training at the Pennsylvania Academy.

HENRY CHAPMAN MERCER

An understanding of the artist's relationship with Henry Mercer illuminates the history of Sheeler's engagement with the vernacular traditions of the Doylestown region.[15] A wealthy native of Bucks County (the first member of his family arrived in 1684) who was active in the local Arts and Crafts movement, Mercer was born in Doylestown—the county seat of the region—in 1856. He studied law at the University of Pennsylvania, but archeology became his consuming passion in the 1880s. His interests shifted again in the 1890s from prehistoric artifacts to American material culture of the colonial period and the early Republic. At the turn of the century, he founded a small-scale ceramic factory, called the Moravian Pottery and Tile Works, inspired by the all-but-extinct Pennsylvania German pottery traditions of the region.[16]

Mercer revived the preindustrial handicrafts of the region because he wanted to highlight and preserve objects showing the creativity of the ordinary, anonymous early settlers of Bucks County. He began collecting their artifacts because he felt the lives of such people embodied the real significance of the American past. Since these early craftspeople rarely left written records of their activities, Mercer viewed their tools, houses, and other artifacts as the best evidence of their part in creating the American nation. For Mercer, these anonymous individuals were as important as the military and political figures glorified in history books.[17] To fulfill his goal of reconstructing everyday life in preindustrial America,

Mercer eventually amassed more than 30,000 vernacular artifacts, which he gave to the Bucks County Historical Society in 1916. He wanted his collection permanently on view in order to present the contemporary public with an expanded history of America.[18]

The construction of old houses especially interested Mercer, and he grew increasingly alarmed at the rapid disappearance of Doylestown's historic architecture due to the impact of modernization.[19] As early as 1907, Mercer began placing concrete markers in front of significant houses in the vicinity. These tablets recorded the original builder and the date of construction. He hoped that these markers would alert the public to the history of the structures and thereby help ensure their preservation. In fact, in 1908 Mercer placed a tablet next to the northwest portal of the house that later captured Sheeler's attention (cat. 6).[20] This would have immediately alerted the artist to the building's historic status.

The small farmhouse most likely interested Mercer because it stood (and still stands) not far from the Moravian Pottery, on the boundaries of his Fonthill estate.[21] In addition, it represents a type of dwelling once ubiquitous in pre-Revolutionary Bucks County.[22] The southeast and northwest facades mirror one another with a central door and an asymmetrically placed window on each side. Both the first and second floors (approximately eighteen by twenty-one feet) allowed division into two small rooms by a central partition.[23]

Most antiquarians of the period would have been more interested in the builder of the house, Jonathan Worthington, than in the structure itself. But Mercer cared less for its genealogical associations than its architectural features.[24] He valued the house because it was one of the oldest in the region, and it had survived with much of its original features intact, including hardware, interior staircases, and triangular doorway hoods.[25] But in 1908 the house's roof needed repair, an adjacent log dwelling stood in ruins, and the building belonged to a local family uninterested in its history. In fact, the owner was planning to tear it down until Mercer interceded by paying to repair the roof; from that time until his death in 1930, Mercer remained vitally concerned with the house's welfare.[26]

Sheeler and Mercer remained friendly throughout

the artist's years in Doylestown, and the older man's collection of vernacular artifacts must have fascinated Sheeler. During this period Sheeler began collecting examples of early Pennsylvanian objects himself (see cat. 43). But of all the interests the two men had in common, "the little house," as they affectionately referred to it, remained their most intimate mutual concern. The house changed owners numerous times during Sheeler's tenancy,[27] which made Mercer extremely nervous about its future. He always feared that a new owner would alter the structure in some way inappropriate to its historic status. But while Sheeler lived there, the house remained quite rustic, apparently without electricity or central heating. Sheeler and Schamberg did whitewash parts of the interior and strip away many recently added appurtenances when they first moved in. One of their associates, Fanette Meyers, indicated that their goal was to create a purified aesthetic space that resembled the modernist exhibition galleries of Stieglitz's "291" in New York.[28] But they apparently did nothing to endanger the house's preservation, and because they left the original hardware and other features intact, Mercer valued their tenancy.

In 1922, Mercer displayed his trust for Sheeler's care of the house by urging the artist to buy it in order to protect it from "some vandal or moneygrubber."[29] Sheeler wrote back to Mercer, assuring him that he "adored" the place and even planned to restore the log kitchen, but he did not feel sufficiently established to buy it at that time.[30] Other letters confirm that Sheeler continued to maintain a vigilant watch over the house. In 1924, Mercer—justifiably concerned about "latch thieves"—proposed removing an unusual piece of hardware from the exterior door (cat. 7). He promised Sheeler that he would replace it with an exact replica made by a local craftsman,[31] but the artist politely refused the request because he was unwilling to accept a modern substitute for an authentic piece of Americana. Surprisingly—given how vigorously he tried to distance himself from antiquarian concerns— Sheeler was in this instance more conscientious than Mercer about preserving a historic object in its original context.

Despite their mutual love for the little house, Sheeler and Mercer were from different generations and backgrounds, and in certain respects—as revealed in the lock incident—their attitudes toward historic American artifacts also differed. Sheeler maintained the house as a personal sanctuary and a repository of vernacular forms to inspire his modernist project. Mercer subscribed to an Arts and Crafts ideal of preserving the past for the entire community—as a way of teaching others how to establish a proper relationship with artifactual traditions. Yet both men wanted to preserve the house to counteract modernizing forces in the present.[32]

THE MEANING OF THE DOYLESTOWN HOUSE

Although the artist exhibited a highly proprietary attitude toward the Worthington house, he was eager to share it with those he loved. From the beginning, he jointly inhabited it with Schamberg, and in his correspondence with other artists and collectors, he often urged them to visit. These letters underscore its importance as a refuge for the artist from a hectic urban existence. Although the artists and writers of Sheeler's generation seemed to celebrate modernization in depictions of skyscrapers and factories, they often felt alienated from their nation's cityscapes and were in fact troubled by industrial transformation and social disruption. The unfettered commercialism of urban America, especially in New York City, provoked many bitter complaints from this group.[33]

Sheeler retreated to the Doylestown house whenever he could get away from his professional activities in Philadelphia, and after 1919, from similar pressures in New York City. He encouraged his friends and patrons Walter and Louise Arensberg to join him and partake of the house's salutary effects: "Have you and Lou anything better to do this weekend than to visit the hermit of Doylestown?"[34] Sheeler was especially anxious to share his rural retreat with Stieglitz during the demise of the "291" gallery in 1917—an extremely disheartening time for the older photographer. Sheeler felt that Stieglitz's depressed spirits would greatly benefit from the restorative power of the Worthington house. In his letter of invitation, he personifies the structure for Stieglitz: "… the little house will be so happy to receive you … whenever you can get away—and I can add from experience the advantage it has proven to call a halt in the midst of the rush—go out there, put one's windows up and let the fresh air clear out the atmosphere."[35] More than just a refuge, the

house was a place that encouraged elevated contemplation: "You may lie on the grass and gaze at the stars—or marvel at the universe in a handful of dirt—the requisites for either are there, so come along."[36] Sheeler's lines evoke both the poetry of Blake ("to see a world in a grain of sand") and Whitman ("I lean and loaf at my ease … observing a spear of summer grass"). These ebullient phrases come as a surprise to those familiar with the habitual reticence of Sheeler's discourse. The house inspired a different kind of language, one that spoke of spiritual renewal as well as artistic inspiration.

THE PHOTOGRAPHS

Sheeler's first commercial assignments involved photographing recently completed buildings designed by Philadelphia architects.[37] In New York, he also photographed works of art owned by galleries and private collectors. In about 1917, he began his first extended effort at uncommissioned, "fine art" photography in Doylestown.

A mood of elevated appreciation for the Worthington house—so evident in his letters—inspired Sheeler to produce a series of photographs depicting the dwelling. Four exterior views and twelve interior shots comprise the group, which Sheeler labeled collectively "Doylestown House."[38] The images, especially those of the interior (cats. 9–18), represent a milestone in the artist's career—both as a photographer and as a painter. Using dramatic lighting, spatial distortions, and unconventional framing, Sheeler focused on seemingly mundane features of the house, such as doors, windows, staircases, a cast-iron stove, and an empty mirror. By varying his presentation of these motifs, he invested them with uncommon aesthetic and thematic power. In creating such images, he established firm mastery of a modernist idiom.

Since the series marks a watershed in Sheeler's artistic development, its precise dating is important, and scholars have often assumed that it began in 1914 or 1915.[39] But recently, two experts on Sheeler's photographs, Theodore Stebbins and Norman Keyes, have argued for a later date. Sheeler first exhibited his photographs of the house at the Modern Gallery in New York, owned by Marius de Zayas, in a one-person show held from 3 to 15 December in 1917. An earlier exhibition at the Modern Gallery in March 1917 also included Sheeler's

photographs but no images of the Doylestown house. This has led Stebbins and Keyes to conclude that the series was probably executed between the two exhibitions, in the spring, summer, or early fall of 1917.[40] A letter from Sheeler to Stieglitz dated 22 November of that year discusses the series' significance,[41] which supports the idea that it was only recently completed. Therefore, we may reasonably assume that all the photographs were taken in 1917.

Sheeler's letter to Stieglitz is significant for reasons other than dating, because it is one of the artist's few surviving discussions of the series. The letter outlines Sheeler's plan to market the photographs:

About the photographs of my house, which I am glad to hear you liked—de Zayas was quite keen about them and proposes to make a show of the set (12)—following according to schedule, the present (Derain) show.

I decided that because of something personal which I was trying to work out in them that they were probably more akin to drawings than to my photographs of paintings and sculptures and that it would be better to put them on a different basis—to make only three sets—one to be offered as a complete set (12) at $150—and the remaining two sets,—singly at $15.00. I'll talk to you further about it when I see you.[42]

Sheeler mentions only in passing the "something personal" he was trying to work out in the photographs. But the letter makes clear that they had the status of "fine art" for Sheeler. More like drawings—unique, one-of-a-kind artifacts—than mechanically reproduced images, they were worth more to Sheeler than the commercial photographs he had previously produced.[43]

Here Sheeler describes the number of images in the original series as twelve, yet sixteen negatives and fifteen prints of the subject were found in the artist's estate. Contemporary reviews of the 1917 Modern Gallery exhibition do not specify which twelve out of the sixteen images Sheeler considered the definitive "set," although they do make clear that both exterior and interior views were included.[44]

Titles for the individual photographs in the series also pose difficulties because many of them have been exhibited

and published with various names over the years. Some of the mats supporting vintage prints are inscribed in Sheeler's hand, "Pennsylvania House/photograph by/ Charles Sheeler."[45] But one exhibited at the Thirteenth Annual John Wanamaker Photography Exhibition in 1918 (see cat. 18) carried the title "Bucks County House, Interior Detail."[46] Although these early titles vary somewhat, they do confirm the artist's original plan to treat the photographs as a cohesive unit, with each individual image contributing to a larger category—"Doylestown House," "Pennsylvania House," or "Bucks County House." And significantly, all these variant titles highlight the specific local identity of the subject, unlike Sheeler's landscape paintings of 1913–16, to which he assigned generic titles.

Sheeler employed various approaches to modernist photographic composition as the series progressed. This clearly emerges in the contrast between the interior and exterior views of the house. Taken in natural light, the exterior shots exhibit a subtly graduated tonal range, unlike the interior views, which display bold contrasts created by artificial light. The exterior shots are more inclusive and traditional; the interior, more fragmentary and innovative.

The most comprehensive image is *Doylestown House: Exterior View* (cat. 8). This photograph situates us at a distance, looking up at the southeast facade of the little fieldstone building standing on the crest of a hill. Judging from the abundant foliage and maturing corn stalks to the right of the house, Sheeler took the picture in late summer or early autumn. Morning light comes from the east, emphasizing the house's outline against the bright sky. The branches of a large, dark tree anchor the composition to the right and cast a long shadow on the variegated stones of the building's facade. Signs of aging abound: the repaired shingled roof still sags in the middle, and on the southwest facade, the ancient ruined hearth slopes down irregularly from the wall to the ground.

This is no casual snapshot. A novel sensibility informs Sheeler's composition, in the balancing of tree and house and in the dappled shadow pattern falling across the facade. (Compare cat. 3.) But these formal elements do not interfere with the comprehensive visual survey of the house's structure. The photograph also reveals the dwelling's

relationship to the natural environment: the hill on which it stands, the growing plants around it, the transient natural light. This exterior view is pleasing and accomplished but does not take us by surprise. When Sheeler transports us into the interior, however, he fundamentally challenges our aesthetic preconceptions.

Surveying the interior views, we sense the profundity of Sheeler's project. Here thematic implications resonate in both the subject's associations and in formal elements, such as lighting, composition, and framing. In these images, Sheeler makes an ancient building relevant to his modernist aesthetic concerns. Furthermore, he reexamines basic assumptions about a photograph's status as a representation of the physical world. This challenge is paradoxical and ambiguous, yet deeply intriguing visually.

Sheeler selectively surveyed his subject for potential images, favoring certain portions of the house and excluding others. *Doylestown House: Stairs from Below* (cat. 10), *Doylestown House: Open Door* (cat. 11), *Doylestown House: Stairway, Open Door* (cat. 12), *Doylestown House: Stairway with Chair* (cat. 13), *Doylestown House: Door with Scythe* (cat. 14), and *Doylestown House: Downstairs Window* (cat. 17) all depict the southeast portion of the first floor. Two images, *Doylestown House: Interior with Stove* (cat. 15) and *Doylestown House: Stove* (cat. 16), portray—as their titles indicate—the stove in an adjacent area. The remaining images represent areas on the second floor. *Doylestown House: Stairwell* (cat. 9) again focuses on the southeast corner, while *Doylestown House: Open Window* (cat. 18) depicts the northwest wall.

Unlike the exterior views taken in daylight, Sheeler took these photographs at night when he could exercise complete control over lighting. Through dramatic illumination and unconventional framing, Sheeler created an evocative relationship of contrasts that suggests basic experiential oppositions. The photographs encompass light and dark, high and low, heat and cold, open and shut. They define the extreme limits of sensorial experience that the viewer might encounter in moving through the shadowy regions of this old house. Doors, windows, staircases, stoves, fireplaces, and ambiguous light sources are the focal points for the transfor-

mation of one phenomenon into its opposite. Sometimes these polarized oppositions even suggest mutually exclusive possibilities.

Because the series exhibits a dualistic structure, each photograph tends to have one or more related mates. For example, *Stairwell* (cat. 9) and *Stairs from Below* (cat. 10) form a fascinating visual dichotomy. Both portray the house's continuous spiral staircase that extends from basement to attic and can be entered from many different doors. *Stairs from Below* situates the viewer inside the stairwell on the first floor looking up to the second. *Stairwell* represents the implied destination of *Stairs from Below*—the threshold in the southeast corner of the second floor that leads down to the first.

Stairwell, in its fragmentation and spatial ambiguity, is one of the most daringly modernist compositions in the series because it calls into question the most elementary aspects of what it portrays. Obviously, Sheeler has photographed a staircase, but aren't the risers oriented in the wrong direction? Isn't the photograph in fact presented upside down? This misinterpretation seems inevitable at first glance.[47] Although a close examination of the original photograph establishes the correct orientation of risers to floor, an uncertainty remains concerning how to evaluate this puzzling work that seems to insist on confusing the viewer.

Highlighted by intense, artificial light emitted at a low angle, the spiraling risers and flanking walls stand out boldly against the gloom of the shadowy surroundings. Difficult to see in reproductions—but clearly apparent in the actual photograph—is the narrow opening of a partition framing the view to the right and left.[48] An obscure object—probably the top of a chair—rests against the partition to the right. A form hanging above it resembles a musical instrument but is in reality a cubist-inspired assemblage.

In this photograph, areas of confusing spatial ambiguity raise interpretive questions. Presumably the stairwell is volumetric, enclosing enough space to accommodate a human body. Therefore, the dark, L-shaped central shadow should indicate spatial recession of several feet from the stairwell's opening to the white, plastered wall behind. But visually, the L-shaped shadow appears as a flat, abstract shape—essentially nonvolumetric. How can this be possible?

This is a *photograph* after all, not a painting, and presumably the world should resemble the one we know in everyday life. But the work emphatically contradicts this naive assumption by presenting elements that are simultaneously congruent and disjunctive. This challenge to fixed visual and conceptual certainties in *Stairwell* heightens the image's aesthetic power as well as its thematic implications.

Stairwell halts the viewer at the threshold; in contrast, *Stairs from Below* effectively conveys the disorientation induced when moving inside a steep, narrow passageway. The vague, undefined area closest to us is out of focus, and the camera angle severely distorts the unpainted wooden beams that enclose the staircase from the main room. We realize that the whitewashed walls of the stairwell must be at right angles to the ground plane; yet visually they incline inward as they ascend to the top of the composition. Above, the undersides of several fan-shaped risers hang mysteriously overhead. Bright light floods down through the stairwell from the second-story landing, and the vortexlike risers propel the viewer's interest toward that more well-defined area at the top of the stairs.

The photograph prizes ascent over descent. In fact, our sole option is to go up and nowhere else. Yet how are we going to achieve this transit? The photograph positions us in midair, hovering without stable footing underneath. It induces a longing for the bright destination at the end of this passageway, while denying us an obvious way to attain it—at least physically. The goal remains elusive, at the boundaries of the imagination.

In *Stairwell* and *Stairs from Below*, Sheeler focuses similarly on the undersides of the risers as the most visually arresting aspect of the staircase. In addition, the photographer pays careful attention in both to the rough-hewn wood, handcrafted joinery construction, and the whitewashed walls of the passageway. And in each photograph, he masterfully uses the light to create a dramatic, mysterious effect.

Despite these obvious similarities, these two photographs have very different thematic resonances and powerfully demonstrate the range of affective qualities in the series. *Stairs from Below* is simultaneously more disorienting and less ominous than *Stairwell*. Free floating in space character-

izes the former work; claustrophobic compression, the latter. The light-filled, beckoning destination of *Stairs from Below* is completely unlike the threshold presented in *Stairwell*, which is so dark and threatening, one can barely imagine summoning up the courage to cross it. The possibility of ascent in *Stairs from Below* is hopeful if undefined. The implications of descent in *Stairwell* call up deep human fears about falling into subterranean realms.

Stairway with Chair (cat. 13) gives us a more expanded view of the stairway from the first floor than does *Stairs from Below*. Taken from outside of the stairwell, we now see the door hanging open, casting a dark shadow to the left. Along the photograph's left margin appears the edge of the deeply recessed doorway leading outside, and high on the wall is a small mirror in a deep, molded frame. Beyond the mirror is a window, receding about a foot from the surface of the plastered interior walls and extending a bit into the stairwell. The fenestration creates an eerie shadow behind the door, obscuring an unidentifiable form on the window ledge that resembles a pile of mechanical objects.

The unconventional lighting of the scene casts strong shadows similar to those in *Stairwell* and *Stairs from Below*. Yet here Sheeler provides a more comprehensive context for the previously disorienting subject. We now know more about how the stairwell actually functions in the Doylestown house, and it seems less threatening from this expanded perspective. The avenue of vertical transit has become domesticated, made part of everyday experience.[49] When considered as a group, these three images form a subset within the larger series, revealing the creative advantages of serial experimentation. Thematically, each image represents a different embodiment of threshold experience, a different symbol of transit between higher and lower realms. Formally, each merges abstract composition with representational exactness, synthesizing stylistic innovation with the highly descriptive potential of the photographic medium.[50] The cumulative effect endows an antiquated structure with new meanings.

Another subset of images focuses on openness and closure, paralleling the staircase views with their emphasis on ascent and descent. These oppositional elements appear in repeated images of doors and windows, such as *Open Door; Stairway, Open Door;* and *Downstairs Window* (cats. 11, 12, and 17). In *Open Door,* the first-floor stairwell again appears, but now the viewer's position is opposite the southeast wall. Therefore, the composition centers not so much on the stairs but on the door leading to them. Instead of viewing it sideways, as in *Stairway with Chair,* we now face its inside surface with a crude patch just above the bottom brace. A smaller exterior door stands slightly ajar to the left, its wrought-iron fixtures silhouetted against the whitewashed surface of the wooden planks. Between the door and window hangs the same small mirror also visible in *Stairway with Chair*. Because of the camera angle, its mirrored surface is completely blank; no image reflects back at us.

Here again, Sheeler limits his subject to a small corner of the room, yet the composition is characteristically minimal and at the same time thematically complex. The interior door blocks the window behind, and the exterior door neither frames a welcoming vista nor assures comfortable security for the inhabitants within. These two thresholds suggest open-ended possibilities because where they lead remains a mystery; they offer only a dark, undifferentiated void on the other side of the room's doorways.

Equally mysterious is the absence of an image in the mirror. Why doesn't it reflect something from the other side of the room, that part of the house extending beyond the photograph's limited view and including the viewer's space? Since Jan van Eyck's fifteenth-century *Arnolfini Wedding Portrait*, reflected images in pictures have come to symbolize either authorial presence or the concept of art as "the mirror of nature." But in this work, the mirror's blankness cloaks affirmations of artistic agency and destabilizes the viewer's position in the scene as well. Like the spatial ambiguities in *Stairwell*, this motif raises fundamental questions about the relationship of the photographic image to the depiction of actual space. It seems in fact to deny art's role as the mirror of nature. Although the doors suggest a thrillingly indeterminate sense of openness, the mirror hints at aesthetic self-enclosure. *Open Door* is therefore a self-effacing investigation into the status of representation in the modern era. It is as if Sheeler uncovered, through modernist experimentation, a kind of absence at the core of twentieth-century experience.

Several other photographs embody sophisticated reflections on the implications of artistic practice, especially the well-known *Interior with Stove* (cat. 15). In it, a nineteenth-century iron stove occupies the center of the composition, with its long pipe extending to the ceiling. The stove's door hangs open to the right, and a surprisingly elegant urn-shaped finial surmounts its body. Beneath, a worn but ornately patterned metal tray protects the floor's wooden planks. To the left, only a small portion of the classically molded mantel-piece and fieldstone hearth appears. A closet door spans the wall to the right of the hearth, and its wrought-iron latch pro-trudes from a soiled area on the whitewashed boards. Behind the stovepipe is yet another window with blackened panes—the mirror image of the window on the southeast facade—and to the right, a rough-hewn door leads to the outside. A strange circle marks the wall between the window and door, just where the mirror hung on the other side of the room.

Because of its central position and the light emanating from within it, the nineteenth-century stove commands our interest over any other feature of the room. Not part of the original house, the stove nevertheless won Sheeler's favor, and consequently the photograph diminishes the older colo-nial fireplace that a more conventional artist might have used to represent the metaphorical heart of the house. For example, Wallace Nutting, an important turn-of-the-century participant in the colonial revival, asserted that "since men discovered how to make a fire the hearth has been the center of their lives," and Nutting's enormously popular photographs fre-quently showed figures in antiquated garb gathered around an old New England fireplace.[51] Even modernist architects, like Frank Lloyd Wright, made the hearth central to the house. But in a daring negation, Sheeler situates the fireplace largely outside the picture. In this, he not only fragments his subject with unexpected framing but also removes the Doylestown house interior from sentimental associations of domestic life in colonial days and convivial family gatherings around a blazing hearth. Here he firmly asserts his distance from ancestor worship and antiquarianism.

Sheeler also used the stove to make a powerful aes-thetic statement; the lighting flattens it into a largely abstract silhouette. But the stove retains undeniable symbolism. It is uniformly black, yet it contains light and provides an alternative to the total darkness outside the room. It keeps our attention within the interior; nothing inviting distracts us from it; in fact, there seems no viable alternative to the setting within.

In a contemporaneous letter to Walter Arensberg, the artist compellingly personifies this stove:

It is Sunday—but nothing can mar the beauty of this crisp Spring morning. The scene takes place in a little country house—which is filled with the merriment of a week end party—of one—rather two—for the moment I had forgotten the stove which gives out a welcome warmth from its round red opening.

The small dark illusion of a way out is obliterated by the dazzling view through the wide open door—a rectangle of sunlight has the boldness to enter the interior—and another—they playfully overlap. Outside the birds strut about arrang-ing their feathers with telling skill.

One of the characters (the one which is not smoking) light[s] a Benson & Hedges—The stove demands more fuel.[52]

This extraordinary passage provides further evidence of how the house stimulated Sheeler's imagination. It also reveals that he considered the stove as an alter ego—a warm companion and fellow smoker. Despite the artist's denial of the sentimentalized hearth, his attitude toward the stove sug-gests a deep emotional attachment. And most importantly for our understanding of *Interior with Stove*, the letter outlines an opposition between the stove, "the small dark illusion of a way out," and nature, "the dazzling view through the wide open door." By extension, the entire interior is associated with a "dark illusion" into which the playful sunlight—an emissary from nature—is welcome but at the same time strikingly foreign.

Sheeler's letter adumbrates an intriguing dialectic, but the meaning of "a way out" remains obscure. Perhaps it signifies the potential of the imagination—admittedly small and dark compared with the dazzling activity of nature—to provide an alternative to human loneliness and isolation. Sheeler's playful, if self-parodying, anthropomorphizing of

the stove after all converted his solitary weekend party into a comforting twosome.

Interior with Stove provides the most comprehensive view of the inside of the house, but ironically, the sense of closure here remains emphatic. The doors and windows are tightly shut, and the room is thoroughly self-enclosed and complete unto itself. In fact throughout the series of Doylestown house photographs, Sheeler never attempts to replicate "the dazzling view" he mentions in his letter. All thresholds are black and void of lightfalls. He continually cleaves to the smaller and darker illusions, to stoves and stairways, that keep the attention within the interior and away from a direct embrace of nature.

The use of threshold motifs such as doors and windows to explore art's relation to nature became an important theme in early nineteenth-century romantic painting.[53] *Open Window* (cat. 18) continues this long-standing investigation in modernist terms. The photograph presents a close-up view of the second-floor window opened widely from the bottom. Significantly, this is the only window in the series not tightly closed. A wire screen keeps summer insects at bay, and a potted gloxinia on the window ledge sprouts one open blossom and smaller buds surrounding it. The plant is also unique, the only living thing that has appeared in the house. It is the sole emissary in the interior from the natural world beyond its boundaries.

The open window and the plant on the sill suggest new elements that may provide an alternative to the artist's otherwise hermetically sealed, artfully constructed world. Does this photograph therefore suggest—unlike the others in the series—that imagemaking in fact represents a window onto the world? In the end, does Sheeler acknowledge that art—even modernist art—embraces the task of representing nature in the Doylestown house? Perhaps, but the plant is, after all, a potted gloxinia—most likely cultivated in an artificial hothouse environment. And the window, although wide open, resembles the others in the series, because its black panes show us nothing beyond the enclosed interior. Furthermore, the photograph's composition repeatedly guides us back to that paradoxical window—open but not offering access. Pictorially self-referential, the window's

minimal, gridlike structure accentuates the flatness of the photograph's surface. On one level, the image suggests that art is fundamentally a reflection of itself.[54]

In the face of the imagery's complexities, the questions raised by *Open Window* are exceedingly difficult to address. The photograph suggests the same themes that have concerned us throughout this discussion of the Doylestown house series. But here, they emerge in a very concentrated way. In most of the other photographs, an open door counteracts a closed window. *Open Window,* in contrast, represents the simultaneous fusion of openness and closure in a single motif. The window's openness suggests an artistic vision that is submissive to what it represents, that loves the world and seeks to replicate it, that draws toward, in Sheeler's words, the "dazzling view" of nature. The window's opaque panes imply an opposite vision, a self-referential art that effaces the subject in order to celebrate radically new strategies of presentation. Paradoxical as it might seem, the image exists as an artistic expression of both self-reference *and* self-transcendence.

Sheeler's portrait of the Doylestown house is incomplete; many parts of the building stand unrecorded, and the interior remains a collection of fragments. Yet, however elusive and multivalent, the photographs exhibit a meaningful pattern as a group. Sheeler repeatedly reenvisioned the same motifs, themes, and formal structures, making subtly different choices in each image. Visual and thematic continuities link them, weave them together into an integral unit. These images compellingly illustrate Sheeler's creative aspirations during his maturation as an American modernist.

In 1916, Sheeler revealed some of these aims in an exhibition catalogue:

I venture to define art as the perception through our sensibilities, more or less guided by intellect, of universal order and its expression in terms more directly appealing to some particular phase of our sensibilities.

The highest phase of spiritual life has always in one form or another implied a consciousness of, and, in its greatest moments, a contact with, what we feel to be the profound scheme, system or order underlying the universe: call it

harmonics, rhythm, law, fact, God, or what you will....

Plastic art I feel to be the perception of order in the visual world (this point I do not insist upon) and its expression in purely plastic terms (this point I absolutely insist upon).... One, two or three dimensional space, color, light and dark,... all qualities capable of visual communication, are materials to the plastic artist; and he is free to use as many or as few as at the moment concern him. To oppose or relate these so as to communicate his sensations of some particular manifestation of cosmic order—this I believe to be the business of the artist.[55]

Although Sheeler seems on the surface to be an unlikely metaphysician, this statement uncovers an almost mystical strain in his creative thought. He drew inspiration during these years from wide-ranging sources: Wassily Kandinsky, Lao-tzu, and Plato.[56] In the 1930s, Sheeler confided his early metaphysical inclinations to Constance Rourke. She queried him further, mentioning specifically his photograph of an African mask made about the same time as the Worthington house series.[57] Rourke reminded the artist of his intention to convey through this image "a concentration of the idea that the universe is a void."[58] Like other modernists of his generation, Sheeler embraced ahistorical philosophical concerns that united disparate subjects in the artist's mind, such as ceremonial sculpture from Africa and vernacular buildings of preindustrial America.

Considered in light of Sheeler's 1916 statement, the Doylestown imagery suggests new possibilities of interpretation. The photographs' eccentric lighting makes the architectural forms—old, worn, and specifically local—emerge mysteriously from a timeless and undifferentiated black void. This all-encompassing void exists as the house's metaphysical backdrop; out of it, all potential forms emerge. Sheeler selects and gives each form life by casting light in its direction. In this way, the photographs demonstrate how things manifest out of an unseen context and how an artist creates a world through a parallel process. In short, they express Sheeler's notion of "the profound scheme, system or order underlying the universe." This perspective also fundamentally reconceives the subject's identity—from the time-bound and locally specific to the timeless and universal.

Sheeler's metaphysical inclinations account to a large extent, I believe, for the continuing power of these photographs. His images of rooms with blocked exits, black windowpanes, and blank mirrors question but in the end do not completely deny the connection between art and an extrapictorial realm. Indeed, metaphysical associations replace more conventional ones, complementing Sheeler's goal to eliminate the nonessentials in order "to more forcefully present the essentials."[59] Because Sheeler's subject was an old house, the elements he sought to eliminate were not only formal but also those popular, patriotic values associated with colonial architecture at the turn of the century. Seeking to ally himself with the avant-garde, Sheeler aimed to synthesize past and present in a new way.

An examination of work by one of Sheeler's contemporaries will put this issue into a helpful perspective. His erstwhile friend and fellow photographer, Paul Strand, once articulated how the two men similarly developed as modernists: "Sheeler and I were aware that we were beginning to experiment with abstraction. We all talked the same language.... It had to do with understanding a painting like a Villon or a Braque—things in which there is ... no recognizable content as a whole."[60] But despite this statement, important differences separated the two photographers as well, strikingly evident in a radical photographic experiment that Strand undertook in 1916, just prior to Sheeler's Doylestown house series. *Abstraction, Porch Shadows, Connecticut* (cat. 19) exemplifies Strand's efforts to create "contentless" photographs. Without the title, the viewer would struggle to identify the subject—the edge of a round table resting on the planks of a porch. Here strong, natural light controls the pictorial composition, and the diagonal shadows of the porch railing are more important than the objects themselves. Strand rotated the final print ninety degrees from the angle at which he took the photograph, further complicating the recognition of the subject and its context.[61] The image is fundamentally an abstract arrangement of fragmented and startlingly juxtaposed forms, an assertive denial of "recognizable content."

In contrast, we recognize content in all the Doylestown house photographs.[62] Empty windows and doorways, however transformed through a modernist lens,

remain charged with symbolic associations. We also perceive aged wood, cracked plaster, and oblique evidence of long-standing human habitation. Although Sheeler carefully distances his subjects from antiquarian concerns, the photographs still evoke a specific past stemming from an identifiable local tradition. In fact, to someone familiar with Bucks County architecture, Sheeler's photographs clearly allow us to recognize the Worthington house as a typical example of regional architecture. A specialist like Mercer could actually date the building quite accurately from the hardware depicted in *Interior with Stove* (cat. 15). Even the most abstract and disorienting image, *Stairwell* (cat. 9), presents the subject in a recognizable way, although it confuses us about the staircase's correct orientation.

Sheeler maintained extrapictorial references in the Doylestown series, not—I believe—because he lacked the ability to make completely abstract pictures. In earlier drawings and paintings from 1914,[63] he effaced virtually all representational elements. And undoubtedly he knew of Strand's series and could have pursued similar experiments in photography. But by 1917, total avoidance of "recognizable content" did not suit Sheeler's purposes, neither with crayon (see cat. 20), brush, nor camera. By then, he wanted to include, however paradoxically, a native context for his modernist experiments.

Heeding calls for the creation of a usable past, Sheeler, along with such contemporaries as Charles Demuth (fig. 7), invented an American modernism that was identifiably national, even regional, in derivation.[64] But his modernist thinking reconstituted the image of colonial America, making it relevant to contemporary aesthetic concerns. This involved wresting the subject from antiquarians and placing it in the context of the New York vanguard. To maintain his reputation as a modernist, Sheeler had to conceal any nostalgia for the past and any intent to preserve its remains. Therefore, the concern for historical authenticity that emerged, for instance, when he prevented Mercer from removing a lock from the Worthington house, is not immediately evident when viewing his photographs. In fact, throughout his career, Sheeler often veiled his personal investment in his subjects. He once described his self-effacing approach, "I

favor the picture which arrives at its destination without the evidence of a trying journey rather than one which shows the marks of battle. An efficient army buries its dead."[65] The meaning of this quote extends beyond mere stylistic considerations. The artist excelled at personal as well as technical self-effacement, so much so that the complex nature of the artist's intense attachment to the past is difficult to decipher. And in fact, only through a reconstruction of his artistic context do such hidden elements fully emerge.

Yet even with rigorous efforts at contextualization, aspects of the photographs' meanings remain intriguingly open-ended. Formalist self-reference vies with extrapictorial associations. The old and abandoned transform themselves into the new and relevant. That which at first seemed confining and fearful—the black void at the outer reaches of the depicted reality—alternatively suggests an expansive, generative context of universal significance. These ambiguities and inversions result from the complicated and ambitious motives Sheeler brought to bear on his subject. The "something personal" in the series spawned a polarity of tensions, bringing the past close while simultaneously keeping it distant. This peculiar fusion of opposites endows the images with tangible power.

SCHAMBERG'S ABSENCE

Although Sheeler associated the Doylestown house with inspiration, renewal, and escape from anxiety, his photographic series also reflects a searching, conflicted consciousness. As time went on, the house—as a country retreat and as an artistic subject—became inextricably linked to the most troubling events of his life.

The first trauma involved the loss of his most intimate friend during his early years in Doylestown. Schamberg's sudden and tragic death from the flu epidemic in October 1918—he fell ill and died within three days—abruptly deprived Sheeler of a treasured companion. He never fully recovered from Schamberg's sudden demise. Four years after the event, Sheeler wrote to Stieglitz, "I have learned that your brother has passed away. This experience is still a vivid one with me."[66] Even late in life, Sheeler described it as "an overwhelming blow."[67]

Sheeler used the Worthington house much less frequently after Schamberg's death, in part because after he moved to New York City in 1919, the trip from there to Doylestown was longer than from Philadelphia. But also, as the artist told one interviewer, the house reminded him of time spent with Schamberg in Bucks County and his friend's untimely death.[68]

Perhaps for this reason, he avoided discussing his memories of Doylestown in an interview with Martin Friedman in 1959. Sheeler's second wife, Musya, urged him to tell Friedman about a recent trip they had made to Doylestown to relive that part of the artist's past. But Sheeler remained evasive about his true motives for the journey:

Musya Sheeler: "Where we went [back last spring] … we tried to find a place where you used to hunt for material … and things like that. Tell that story."
Charles Sheeler: "Well, I don't know what the story is except I just looked around, I mean I didn't have a diagram or any plot to uncover or to project.…"
MS: "It was so dear to your heart because you were with your very dear friend. Go on now."
CS: "I was always looking when I was out there."[69]

When the discussion moved to Schamberg, Sheeler abruptly ended consideration of the topic. He resisted his wife's efforts to make public his motives for trying to reconnect with his Doylestown past. To the end of Sheeler's life, Schamberg's death remained too sensitive for casual comment.

Although Sheeler visited the house less often after 1917, he still maintained a proprietary, even passionate attachment to it. In January 1922, Sheeler wrote an agitated letter to Mercer:

I have just learned indirectly, of the intrusion of Gilbert Schamberg [Morton's brother] into the privacy of your citadel, with, as the information comes to me, the suggestion that you purchase the little house. I fail to see in what way he could possibly consider himself concerned in the matter. Further I have heard that he is very anxious to purchase the place for his own use (may heaven forbid that he shall ever be permitted to polute [sic] the place by inhabiting it).

My side of the story is, that I have no intention of voluntarily relinquishing the place—I still adore it—and it is my hope when sufficiently established, to spend several months each year out there. At that time I should of course want to buy it and make such repairs as are necessary including the log part.… These are the facts regardless of what the above mentioned party may have said to you to the contrary.[70]

This passage not only confirms Sheeler's continuing commitment to the house well into the 1920s, but also further illustrates the artist's deep attachment to Morton Schamberg. Sheeler's parents had always supported his career as an artist, but Schamberg encountered intense opposition to his creative activities. Much later, Sheeler told art historian Frederick Wight, "His family was ashamed of him and he went to Paris."[71] Perhaps Sheeler's intense hostility toward Gilbert Schamberg stemmed from the ill-treatment his friend had received from his relatives.[72] By protecting the house from Schamberg's brother, Sheeler may have felt that he was preserving Schamberg's memory as well. The intensity of Sheeler's response indicates that he conceived of the house as a kind of shrine to his lost friend.

KATHARINE SHAFFER AND THE RENEWED IMAGE OF THE HOUSE

Despite Sheeler's continuing interest in the Worthington house, he did not portray it for about five years after the photographic series in 1917. At that time, Sheeler shared the house with another beloved intimate, his first wife, Katharine Shaffer (cat. 21), who was a music student in Philadelphia, where she first met the artist. In the late 1910s she moved to New York to take care of her brother's household, about the same time Sheeler relocated there.[73] But the couple may have been intimate as early as 1916.[74] After Sheeler married Katharine in 1921,[75] the artist probably spent more time at the Doylestown house than in previous years. The couple used a small print of *Doylestown House: Exterior View* for their Christmas card of 1924 (cat. 22). This indicates that by the mid-1920s, the house was something that the two shared.

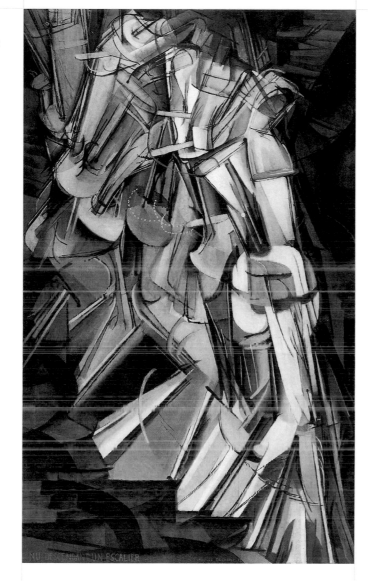

Sheeler produced few paintings during this decade because commercial photography, as well as managerial duties at the De Zayas Gallery and the Whitney Studio Club, occupied most of his time.[76] But in 1925, he again drew inspiration from the earlier photographic series for a major work in oil, *Staircase, Doylestown* (cat. 23). The painting's composition closely corresponds to the photograph *Stairs from Below* (cat. 10), particularly on the left side. According to art historian Susan Fillin-Yeh, Duchamp's *Nude Descending a Staircase* (fig. 3)—the most notorious work

in the Armory Show—may have introduced Sheeler to the aesthetic potential of staircase imagery.[77] In 1924, Sheeler included *Nude Descending a Staircase* in an exhibition he organized for the Whitney Studio Club—perhaps rekindling his deep admiration for the French artist's painting.[78] Sheeler may have been intrigued by the fact that Duchamp's sequential views of a male nude traversing space refer to nineteenth-century stop-action photography.[79] For both artists, creative ideas permeated the boundaries between photography and painting.

 Staircase, Doylestown exemplifies important developments in Sheeler's art since the earlier photographic series, as well as highlighting differences due to the subject's translation into another medium. Exhibiting painting's ability to synthesize, in Sheeler's words, "a plurality of images,"[80] it expands horizontally to encompass more of the interior than can be seen in *Stairs from Below*. To the right, we glimpse the ground-floor room with a small gateleg table and a bed—further examples of Sheeler's taste in vernacular furnishings. But the arresting staircase continues to dominate the viewer's attention, compressed and distorted even more radically than in the photograph. The artist also added accordionlike beams to the right and inserted the bottom risers in the stairwell. The observer still seems to hover in midair, however, and the same mysterious light at the top of the stairs beckons us upward. Now the illuminated walls glow with rose and golden hues. As in a patchwork quilt, each compositional element interlocks with every other. On the one hand, the work's size and scale endow the subject with greater monumentality than the corresponding photograph;[81] on the other, the painting's warm, appealing colors make the Worthington house a welcoming and homey—if still puzzling —dwelling. Compared to the earlier photographic series, *Staircase, Doylestown* suggests a more secure rootedness in a beloved place.

 In real life, this sense of belonging did not last. The year after this work was painted, Sheeler terminated his tenancy of the Doylestown house. The property had been sold for a tract housing development, and for Sheeler, the imminent encroachment of suburbia radically diminished the house's value as a retreat. The artist explained his motives to Mercer:

"Of course the place would be killed so far as I am concerned —with the flock of inevitable bungalows around there. I don't want to buy it for this reason…." [82] Sheeler severed his lease, and perhaps also his relationship with Mercer. (See cat. 24.) No evidence exists of a continuing communication between the two men. Sheeler and his wife vacated the Doylestown house and moved to rural South Salem, New York, by the end of 1926. [83]

NOTES

1. The most authoritative account of Sheeler's biography is in Troyen and Hirshler, *Charles Sheeler.*

2. Ben Wolf, *Morton Livingston Schamberg* (Philadelphia: University of Pennsylvania Press, 1963), 21.

3. Rourke, *Charles Sheeler*, 32.

4. Quoted in Rourke, *Charles Sheeler*, 27–28.

5. Autobiographical notes, AAA, Sheeler Papers, Roll Nsh 1, frame 65.

6. In his autobiographical notes, Sheeler in fact has no praise for any academically trained American artist of the nineteenth century and even criticizes the native school of realist painting. See Sheeler's account of watching Eakins paint, as well as his unfavorable comparisons of Homer, Eakins, and the Hudson River School artists to European old masters. He assesses Ryder's art more neutrally. Ibid., frames 32–33, 125–133.

7. Ibid., frame 48.

8. For a book-length discussion of Mercer's life and work, see Cleota Reed, *Henry Chapman Mercer and the Moravian Pottery and Tile Works* (Philadelphia: University of Pennsylvania Press, 1987).

9. See Rourke, *Charles Sheeler*, 31. According to George M. Craven, who conducted an interview with Sheeler in 1957, Schamberg had introduced Sheeler to early Americana and discovered the house before Sheeler. Schamberg's "interest in small, useful household items of colonial craftsmanship rubbed off, to a great degree, on Sheeler as a result of their close friendship." Craven, "Charles Sheeler, A Self-Inventory in the Machine Age" (term paper, Ohio State University, 1957), in Sheeler Papers, AAA, Roll Nsh 1, frame 160. Sheeler's recollections to Martin Friedman (see below) indicate that he found the house by himself.

10. Charles Sheeler interview by Martin Friedman, 18 June 1959, AAA, Tape 2, pp. 4–6.

11. Joyce P. Barendsen, "Wallace Nutting, an American Tastemaker: The Pictures and Beyond," *Winterthur Portfolio* 18 (Summer/Autumn 1983): 195.

12. The most extensive treatment of these artists is in Thomas Folk, *The Pennsylvania School of Landscape Painting: An Original American Impressionism* (Allentown, Pa.: Allentown Art Museum, 1984). See also an illustration in C. Valentine Kirby, *A Little Journey to the Home of Edward W. Redfield*, This is Bucks County Series (Doylestown, Pa.: Public Schools of Bucks County, n.d.), unpaged, which shows the interior of Redfield's house. According to the caption in this publication, Redfield made his own gateleg tables and Windsor chairs, modeled on the preindustrial vernacular tradition.

13. "With the arrival of spring we went out into the country around Philadelphia to paint farmhouses in the midst of fields, buildings reflected in the placid water of a canal, or bits of woodland." Quoted in Rourke, *Charles Sheeler,* 22.

14. According to his own retrospective assessment, the Pennsylvania Academy was a gloomy, uninspiring place because "Redfield was prevalent." Quoted in Wight, "Charles Sheeler," 11.

15. Part of the information on Sheeler's house and his relationship to Henry Chapman Mercer first appeared in an article by Karen [Lucic] Davies, "Charles Sheeler in Doylestown and the Image of Rural Architecture," *Arts Magazine* 59 (March

1985): 135–39. Sheeler's account of the meeting is as follows: "[Mercer] wasn't interested in painting at all but he was interested in Americana and he was a pioneer in collecting it in a big way, objects of domestic utility, farm implements … and things like that. He had amassed an enormous collection. Also he built himself an enormous house of concrete, even the window frames were concrete, the whole thing was poured except the roof. And he had a pottery within walking distance of his own castle. Well, somehow we managed to get entrée and he was a very delightful person, very outgoing and we were received on first meeting as though we were old friends and so forth. And of course he liked meeting people that had the same interest as he had, namely an acquaintance with Americana.… And this little house that I noticed, it was just in the next large field to his land and I asked him about it, what he knew about it and did he think it might be available for rent and so forth. Well, he couldn't say that but he told me the man's name who was the present owner of the farm. Well, I went over there and asked. Well, first the fellow didn't—wasn't interested and then I reported that back to Dr. Mercer and—well, he called him up and said that, well he wished he'd rent it to me as a personal favor to him. Well, he was an uncrowned king and a very benign one but Dr. Mercer sat up on the top of the totem pole in Doylestown in a very, very nice way, always for the good of the town, and being a wealthy man as well as a very intelligent one in his specific interest which contacted mine he was very influential. So the fellow … before he hung up the fellow had consented to … rent it to me just on Dr. Mercer's request." Sheeler interview by Friedman, AAA, Tape 2, pp. 4–5.

16. Bucks County Historical Society, *The Mercer Mile* (Doylestown, Pa., 1972), 1–3, 7.

17. In a lecture of 1907, he summarized the value of his collection: "Here we have history presented from a new point of view…. You may go down into Independence Hall in Philadelphia, and stand in the room in which the Declaration of Independence was signed and there look up at the portraits of the signers. But do you think you are any nearer the essence of the matter there than you are here when you realize that ten hundred thousand arms, seizing upon axes of this type, with an immense amount of labor and effort made it worth while to have a Declaration of Independence by cutting down one of the greatest forests in the North Temperate Zone?… [A] sight of the actual object conveys an impression otherwise indescribable." Bucks County Historical Society, *Mercer Mile*, 5–6.

18. Ibid., 5-6, 21–23.

19. During the 1910s and 1920s, Mercer developed a method of dating based on analysis of nails and other hardware. See Henry Chapman Mercer, "The Dating of Old Houses," *Bucks County Historical Society Papers* 5 (1924; reprint, Doylestown, Pa.: Bucks County Historical Society, 1976).

20. For information about Mercer's markers, see Wilma Rezer, "The Old Worthington House," unpublished manuscript, unpaged, courtesy of Susan and David Mulholland; and Warren S. Ely, "The Old Worthington House," (n.p., c. 1908): 2, in "Miscellaneous Papers Relating to Bucks County," BCHS.

21. Mercer's interest may have inspired the librarian of the Bucks County Historical Society, Warren S. Ely, to research the genealogical associations and local history of the structure. In a six-page pamphlet published about 1908, Ely described the house: "The present stone structure of two and a half stories, with two rooms on the first floor has on the southwest gable a datestone with the inscription: 'J. W. A.' 1768. Representing the initials of Jonathan Worthington, the builder and that of his first wife and the date of erection. At the southwest end of the stone house may be still seen the remains of the ancient log dwelling which antedated the stone structure many years, and has been torn down within the last twenty-five years. The old flat door-step over which the Colonial owner entered his primitive palace is still in place and forming part of the southwestern wall of the present house is the immense fire-place, now open to the elements that was originally enclosed by the log house. The old house with the remnants of its ancient neighbor and parent form an interesting landmark of Colonial times. Over the two outer doors one looking southeasterly and the other northwesterly were quaint little hood roofs supported on timbers secured in the wall and extending out some six feet to form a porch, without pillars, the little peaked shingle-covered roof being entirely supported by the horizontal timbers imbedded in the wall." Ely, "Old Worthington House," 6.

22. For a description of this kind of housing type, see Charlotte Stryker, "The Colonial Architecture of Bucks County, Pennsylvania," unpublished manuscript in BCHS, 34.

23. Rezer, "Old Worthington House," unpaged.

24. Compare Steven Conn, "Henry Chapman Mercer and the Search for American History," *The Pennsylvania Magazine of History and Biography* 116 (July 1992): 335. My thanks to Nicholas Adams for this source.

25. Ely, "Old Worthington House," 1.

26. Rezer, "Old Worthington House," unpaged; Henry Chapman Mercer to Charles Sheeler, 19 March 1924, BCHS. My thanks go to Susan Fillin-Yeh for providing me with copies of the Mercer/Sheeler correspondence in the Bucks County Historical Society.

27. See Bucks County Deed Book, no. 382, pp. 50–51; no. 408, pp. 480–81; no. 441, p. 348; and no. 534, pp. 84–85, Bucks County Courthouse, Doylestown, Pa.

28. Fillin-Yeh, *Charles Sheeler*, 12.

29. Mercer to Sheeler, 25 January 1922, BCHS.

30. Sheeler to Mercer, [January 1922], BCHS.

31. Mercer to Sheeler, 19 March 1924, BCHS.

32. Conn, "Henry Chapman Mercer," 344, 348.

33. In 1917, Stieglitz wrote: "New York seems far away and I assure you I don't miss any part of it—If I never saw it again I don't think I would hear its Call." Stieglitz to Paul Strand, 14 August 1917, Paul Strand Archive; quoted in Naomi Rosenblum, "Paul Strand: The Early Years, 1910–1932" (Ph.D. diss., City University of New York, 1978), 53. In a letter to Stieglitz, Strand summed up an attitude surprisingly prevalent in the 1910s and 1920s: "New York a distant and disagreeable ant heap—everybody crawling over each other.… As one travels away from N.Y., one is always finding potentially N.Y.—its deadness and cheapness, standardized mediocrity—in towns and towns trying to be cities.… I am sure the Americans have already introduced Coney Island into heaven. It would take more than God and all the saints to stop em." Strand to Stieglitz, 28 November 1926, Alfred Stieglitz Archive, Collection of American Literature, Beinecke Rare Book and Manuscript Library, Yale University (hereafter BRBML).

34. Charles Sheeler to Walter Arensberg, 28 August [c. 1917–18], Charles Sheeler Papers, Arensberg Archives © Philadelphia Museum of Art (hereafter AA).

35. Sheeler to Stieglitz, 13 June 1917, BRBML. I have found no evidence to indicate that Stieglitz ever accepted Sheeler's invitation.

36. Ibid.

37. For reproductions of this kind of work, see Theodore E. Stebbins, Jr., and Norman Keyes, Jr., *Charles Sheeler: The Photographs* (Boston: Museum of Fine Arts, 1987), figs. 3, 10, 11, and 13.

38. Found in an envelope identified in Sheeler's hand as "Doylestown House," these photographs were printed from 2 ¼ x 3 ⅜ inch negatives. One exterior view of the house exists only in the form of a negative in the Lane Collection, the repository of photographs from Sheeler's estate; no corresponding print is known to exist. The original project may have been more extensive. For other prints not illustrated here, see Stebbins and Keyes, *Charles Sheeler,* figs. 15, 17, cats. 10 and 18. I extend sincere thanks to Karen Quinn for information about Sheeler's negatives.

39. Charles Millard proposes that the Doylestown house series was produced over several years from 1914 to 1917. He pinpoints 1914 as the beginning of the series because *Stairwell* was published in the catalogue of Sheeler's retrospective exhibition at the Museum of Modern Art in 1939 with that date. Millard presumes that the museum staff consulted Sheeler as to details about dating. But Millard also notes that Sheeler's own copy of the photograph has a later date—1915—inscribed on the back. Millard, "Charles Sheeler: American Photographer," *Contemporary Photographer* 6 (1967): unpaged. My research indicates that Sheeler's memories of his early career were often hazy and approximate, and are therefore unreliable without some external evidence for confirmation.

40. Stebbins and Keyes, *Charles Sheeler,* 8–9.

41. Sheeler to Stieglitz, 22 November 1917, BRBML.

42. Ibid.

43. Sheeler responded with elation to a letter from Stieglitz expressing appreciation for the Doylestown images. In his reply, Sheeler proposes a swap of their work—several of Sheeler's photographs of the house for one by Stieglitz. Sheeler to Stieglitz, 2 December 1917, BRBML. Undoubtedly, the photographs that Sheeler gave Stieglitz eventually came to the Metropolitan Museum of Art; four vintage Doylestown prints are included in the Alfred Stieglitz Collection now housed there. Sheeler may have in the end received more than one photograph as a result of his trade with Stieglitz. In 1942, he gave four platinum prints by Stieglitz to the Museum of Modern Art. "Photography—New Acquisitions," *The Bulletin of The Museum of Modern Art* 9 (February 1942): 12. All dating from 1914–15, these were works probably given to the artist by Stieglitz.

44. See "Modernist Photographs," *American Art News* 16 (15 December 1917): 3.

45. Stebbins and Keyes, *Charles Sheeler,* 9.

46. Weston J. Naef, *The Collection of Alfred Stieglitz: Fifty Pioneers of Modern Photography* (New York: Metropolitan Museum of Art, 1978), 438.

47. Therefore I am never surprised to find the image inverted in publications, even in such authoritative texts as Milton Brown, and others, *American Art: Painting, Sculpture, Architecture, Decorative Arts, Photography* (New York: Harry N. Abrams, 1979), fig. 415.

48. This is especially true in Sheeler's later printings from the original negatives, such as the ones owned by the Museum of Modern Art and the George Eastman House.

49. For an expanded discussion of the Doylestown photographs' psychological implications, see Karen Lucic, "On the Threshold: Charles Sheeler's Early Photographs," *Prospects* 20 (1995): 227–55.

50. Sheeler wrote, "Among other qualities peculiar to it, photography has the capacity for accounting for things seen in the visual world with an exactitude for differences which no other medium can approximate." Autobiographical notes, AAA, Roll Nsh 1, frame 66.

51. Wall label, Wadsworth Atheneum, Hartford, Conn. For a more detailed comparison of Sheeler and Nutting, see Karen Lucic, "The Present and the Past in the Work of Charles Sheeler" (Ph.D. diss., Yale University, 1989), 105–09. See also Barendsen, "Wallace Nutting, an American Tastemaker," and Marianne Berger Woods, "Viewing Colonial America through the Lens of Wallace Nutting," *American Art* 8 (Spring 1994): 67–86.

52. Sheeler to Arensberg, [c.1918], AA.

53. See Carol Troyen, "The Open Window and the Empty Chair: Charles Sheeler's *View of New York,*" *American Art Journal* 18 (1986): 24–41, and Lucic, "On the Threshold," 246–7.

54. A similar interpretation of Sheeler's Doylestown imagery appears in Fillin-Yeh, *Charles Sheeler,* 12.

55. Charles Sheeler, statement in *Forum Exhibition of Modern American Painters* (New York: Anderson Galleries, 1916), unpaged.

56. Rourke, *Charles Sheeler,* 86.

57. Marius de Zayas asked Sheeler to provide photographs of African objects for a book he published, *African Negro Wood Sculpture,* early in 1918. See Stebbins and Keyes, *Charles Sheeler,* 4–6. The image Rourke mentioned was reproduced in the biography and presumably resulted from de Zayas and Sheeler's collaboration.

58. Rourke to Sheeler, 1 March 1937, Sheeler Papers, AAA, Roll 1811, frame 115. In another letter, she teased the artist: "I think maybe after the page proof is all finished I'll slide in the observation that you are a mystic." Rourke to Sheeler, 21 January 193[8], ibid., frame 169.

59. Sheeler to William Macbeth, 26 September 1910, quoted in Garnett McCoy, "Charles Sheeler: Some Early Documents and a Reminiscence," *Journal of the Archives of American Art* 2 (April 1965): 2.

60. Quoted in Rosenblum, "Paul Strand," 67; cited in Stebbins and Keyes, *Charles Sheeler,* 10.

61. Rosenblum, "Paul Strand," 55–57; William Innes Homer, *Alfred Stieglitz and the American Avant-Garde* (Boston: New York Graphic Society, 1977), 247–49.

62. Stebbins and Keyes, *Charles Sheeler,* 10.

63. See Troyen and Hirshler, *Charles Sheeler,* cat. 5, for an example.

64. Even Strand did not continue to experiment with a high degree of abstract picturemaking. He returned to more representational photographs shortly after the brief experimental phase that produced *Abstraction, Porch Shadows, Connecticut.* For the usable past in American art, see Wanda Corn, *In the American Grain: The Billboard Poetics of Charles Demuth* (Poughkeepsie, N.Y.: Vassar College, 1991); Matthew Baigell, "American Art and National Identity," 48–55; and Rubin, "A Convergence of Vision."

65. Quoted in Rourke, *Charles Sheeler,* 144.

66. Sheeler to Stieglitz, 13 November 1922, BRBML.

67. Sheeler interview by Friedman, AAA, Tape 2, pp. 17–18.

68. "There were too many memories of those exciting creative summers … working together and discovering, during long hikes, the Pennsylvania German countryside and architecture." Wolf, *Morton Schamberg,* 22.

69. Sheeler interview by Friedman, AAA, Tape 2, pp. 3–4.

70. Sheeler to Mercer, [January 1922], BCHS.

71. Wight, "Charles Sheeler," 16.

72. Sheeler's devastation at the loss of Schamberg raises the possibility that they were lovers, but I have found no evidence to suggest that their relationship was actively homosexual.

73. Richard Kyle, Katharine Shaffer's nephew, interview by author, 9 October 1984, Old Saybrook, Connecticut.

74. In 1916, Stieglitz wrote to Sheeler: "Katharine's poetry will be sent to you shortly. Marie [Stieglitz's secretary] just says she has finished them, so they will go with this. I am glad to have copies." Stieglitz to Sheeler, 1 December 1916, BRBML. This brief passage does not indicate whether or not Stieglitz refers to the same Katharine that Sheeler eventually married, but it seems likely.

75. The date of Sheeler's first marriage has often been mistakenly given as 1923. See Troyen and Hirshler, *Charles Sheeler*, 12, n. 27.

76. Autobiographical notes, Sheeler Papers, AAA, Roll Nsh 1, frame 90.

77. Fillin Yeh, *Charles Sheeler*, 9. Sheeler wrote admiringly of Duchamp's painting and photographed it as well. See Stebbins and Keyes, *Charles Sheeler*, 10.

78. Duchamp reportedly reciprocated Sheeler's regard; of Sheeler's 1923 *Self-Portrait* (Museum of Modern Art, New York), he remarked, "I like it." Rourke, *Charles Sheeler*, 94–95.

79. Arturo Schwarz, *The Complete Works of Marcel Duchamp* (New York: Harry N. Abrams, 1969), 49.

80. In contrast, photography "records inalterably the single image," according to Sheeler. Autobiographical notes, Sheeler Papers, AAA, Roll Nsh 1, frame 94. But photographic techniques such as montage can produce multiple images, and in later career, Sheeler himself experimented with more than one negative to create layered photographic compositions.

81. Troyen and Hirshler, *Charles Sheeler*, 104.

82. Sheeler to Mercer, 4 March 1926, BCHS. In a 1959 interview by Friedman, Sheeler recounts the story of giving up the house, but his memory of dates is inaccurate. He states he held on to the lease for only a few years instead of the approximately sixteen that he was actually a tenant of the house: "… I had [the lease] for—I don't know—four or five years I guess and in the latter part I had already moved to New York, well then the chance of using it was so very slight that I just gave it up. Also … the farm had changed hands and they were planning to make a development of small houses on the farm … instead of in a nice open 12-acre field it would have been right in the midst of the development. And principally, as I say, I just didn't get over very often, maybe three times a year I'd get over for a week or something like that. Well, it wasn't worth maintaining it for that." Sheeler interview by Friedman, AAA, Tape 2, pp. 5–6.

83. Troyen and Hirshler, *Charles Sheeler*, 16, 138.

1

Self Portrait
c. 1913–18
Gelatin silver print
3 ¼ x 2 ⅛ in.
The Lane Collection
Courtesy of the Museum
of Fine Arts, Boston

Taken in his Chestnut Street
studio, this photograph shows
a self-protective Sheeler warily
peering out of his shadowy
architectural enframement. Its
small size, like that of cat. 2,
suggests a personal memento
rather than an object for public
display. The artist was actually
restless and discontent in his
native city during this era,
explaining that "… following
the Armory Show, life in
Philadelphia seemed much
like being shipwrecked on a
deserted island. Whatever was
happening that was stimulating
and condusive [sic] to work was
taking place in New York." [1]
Sheeler was perhaps too hard
on the Quaker city. In 1916, the
artist's work was included in
an exhibition of "Advanced
Modern Art" at the McClees
Galleries, and the "Exhibition
of Paintings and Drawings
Showing the Later Tendencies
in Art" at the Pennsylvania
Academy displayed two of his
Bucks County barns in 1921. [2]

[1] Autobiographical notes, Sheeler Papers,
AAA, Roll Nsh 1, frame 83.

[2] See Sylvia Yount, "Rocking the Cradle
of Liberty: Philadelphia's Adventures
in Modernism," in *To Be Modern: Amer-
ican Encounters with Cézanne and
Company* (Philadelphia: Museum of
American Art of the Pennsylvania
Academy of the Fine Arts, 1996).

2

Morton Schamberg
c. 1913–18
Gelatin silver print
3 ⅝ x 2 ⅜ in.
The Lane Collection
Courtesy of the Museum
of Fine Arts, Boston

Sheeler captures his suave,
elegant friend in a pensive
moment, resting languorously
on a Victorian couch. Although
he rarely produced work in this
genre, here Sheeler shows unex-
pected skill at portraiture. Notice
the expressive placement of the
hands and the way Schamberg's
wavy hair fuses with the couch's
sinuous carving.

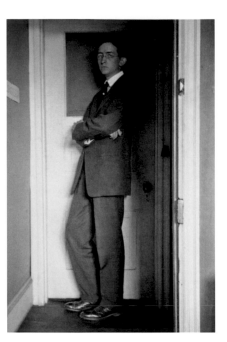

3

Unknown Photographer
Jonathan Worthington House
1920
Gelatin silver print
5 ⅜ x 3 ⅛ in.
Spruance Library, Bucks
County Historical Society,
Doylestown, Pennsylvania

Henry Chapman Mercer
shared Sheeler's fascination
with the Worthington house
and undoubtedly arranged
for this photograph to be
taken. It documents the typical
regional characteristics of the
eighteenth-century structure:
fieldstone walls, cantilevered
overdoor hoods, and steep
gabled roof. The unknown
photographer also carefully
included the hearth from an
earlier log house, then in ruins.

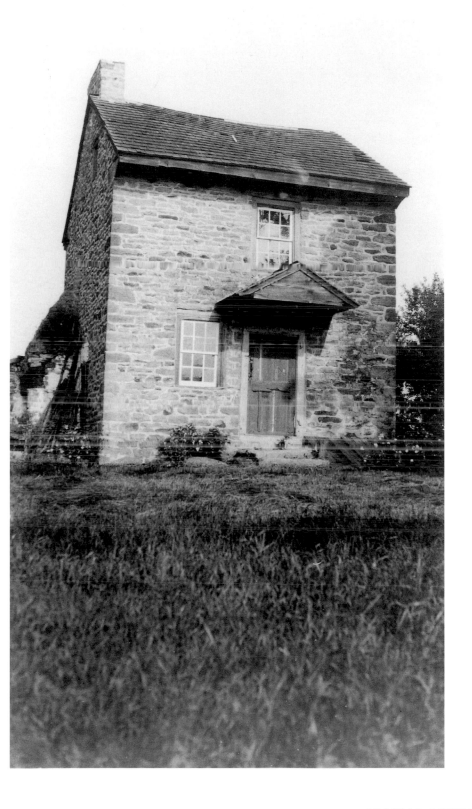

4

Landscape, Abstraction
c. 1915
Oil on canvas
12 ⅞ x 13 ¾ in.
Private Collection, New York

From 1913 to 1916, Sheeler painted nothing but landscapes, which reveal the inspiration of Cézanne, Braque, and Picasso's experiments in that genre. This work well represents that phase of the artist's development and was probably exhibited in 1916 at the Forum Exhibition in New York.[1] Here Sheeler minimally represents nature while primarily pursuing an abstract system of pictorial construction. The depicted objects are generic, their origins effaced. Although Sheeler undoubtedly composed this picture from observation of the countryside around Doylestown, at this point he did not explicitly reveal the architecture's regional characteristics.

[1] Troyen and Hirshler, *Charles Sheeler*, 6.

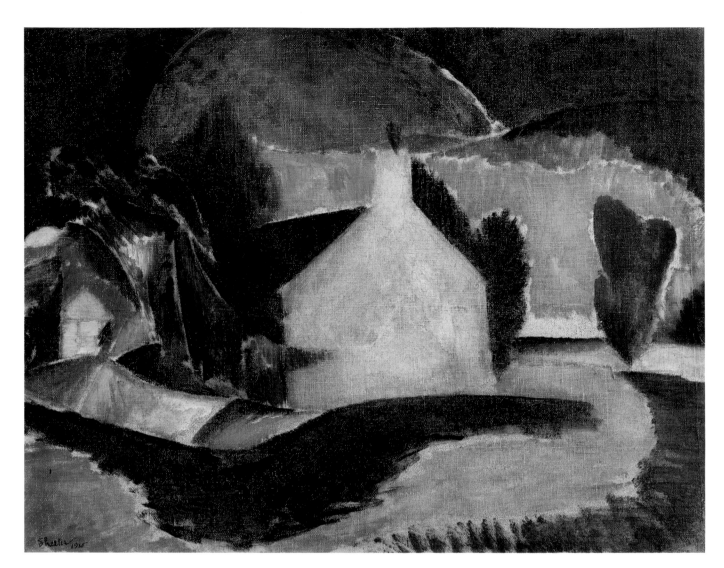

5

Morton Livingston Schamberg
(American, 1881–1918)
Landscape, Bridge
1915
Oil on panel
13 ¾ x 10 in.
Philadelphia Museum of Art
Gift of Dr. and Mrs. Ira Leo
Schamberg (69-228-1)

Compared to Sheeler's contemporaneous painting (cat. 4), this picture reveals how the two artists worked in tandem during this era. Exhibiting highly textured brushwork, abbreviated forms, and flattened, ambiguous space, both paintings display a cubist-inspired interlocking construction of abstract planes.

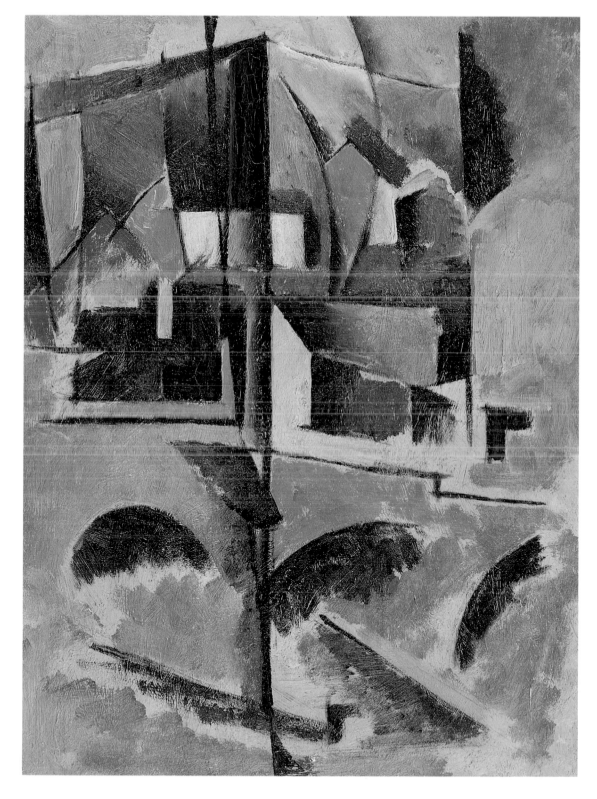

6

Aaron Siskind
(American, 1903–1991)
An Overdoor Hood
c. 1935
Gelatin silver print
10 x 8 in.
Spruance Library, Bucks
County Historical Society,
Doylestown, Pennsylvania

This image of the Worthington
house derives from a project
undertaken in the early 1930s
by Charlotte Stryker, a student
at Columbia University, to write
the history of colonial architec-
ture in Bucks County. Through
mutual friends in New York,
Stryker met the photographer
Aaron Siskind who agreed to
illustrate her text. Her manu-
script was never published but
Siskind's photographs appeared
much later in a book authored
by him and William Morgan.[1]
Focusing on the hooded door-
way, this photograph also
includes Mercer's concrete
plaque attesting to the historic
significance of the structure.
The Worthington house has had
many subsequent exterior and
interior alterations over the
years; Mercer's marker is no
longer in place.

[1] Aaron Siskind and William Morgan,
*Bucks County: Photographs of Early
Architecture* (Doylestown, Pa.: Horizon
Press and Bucks County Historical
Society, 1974).

7

Unknown Photographer
*Exterior Latch,
Worthington House*
1920
Gelatin silver print
5 7/16 x 3 1/8 in.
Spruance Library, Bucks
County Historical Society,
Doylestown, Pennsylvania

The rare escutcheon-lift latch
from the front door of the Wor-
thington house excited Mercer's
attention. He wrote to Sheeler
in 1924:

*If you agreed I would have the
latch copied exactly, put the
original in the Museum and the
copy on the door so that in case
of latch thieves who might slip
over there any night and help
themselves as the craze for
antiques increases, we would
be protected.... I hope you realize
that my motive is love for the
Past, and desire to save things at
the eleventh hour for posterity.*[1]

Sheeler initially responded
negatively to Mercer's request
because, as he wrote, "The
chief reason for my enthusiasm
for the little house is that it
remains so nearly intact, even to
such details as the ironwork."[2]
But after he relinquished his
tenancy of the house in 1926,
Sheeler agreed to Mercer's plan
to remove the lock and place it
in the Bucks County Historical
Society, where it remains.[3]

[1] Mercer to Sheeler, 19 March 1924, BCHS.

[2] Sheeler to Mercer, 26 March 1924, BCHS.

[3] Sheeler to Mercer, 4 March 1926, BCHS.
See [Lucic] Davies, "Charles Sheeler in
Doylestown and the Image of Rural Archi-
tecture," 136, and Cory M. Amsler, "Henry
Mercer and the Dating of Old Houses,"
Mercer Mosaic 6 (Winter 1989): fig. 20.

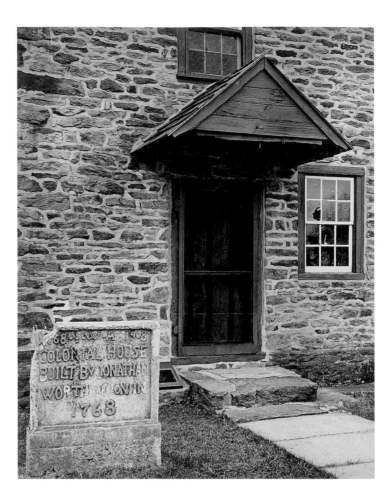

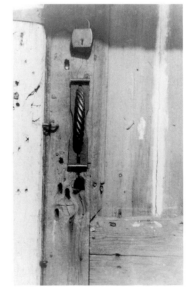

8

Doylestown House:
Exterior View
c. 1917
Gelatin silver print
8 x 9 ⅞ in.
The Lane Collection
Courtesy of the Museum of
Fine Arts, Boston

Unlike Siskind (see cat. 6),
Sheeler apparently never pho-
tographed the northwest side
of the building where Mercer's
plaque stood. Perhaps this
avoidance indicates the artist's
attempt to disassociate his aes-
thetic interest in the house from
early twentieth-century antiquar-
ianism. Contemporary reviews
confirm that the artist succeeded
in emphasizing form over associ-
ations. When the series was first
exhibited in 1917, one reviewer
wrote, "The examples shown
represented the exterior and
interior of the artist's home and
reproduced in a series of pho-
tographs the cold, hard realities
of stone, wood or iron so graphi-
cally that the 'sensorial signifi-
cance' of matter was vividly
conveyed."[1]

[1] "Modernist Photographs," 3.

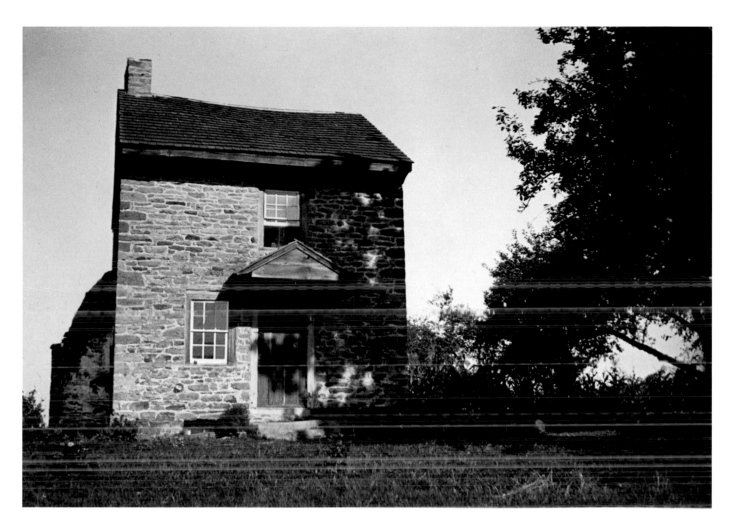

9

Doylestown House: Stairwell
c. 1917
Gelatin silver print
9 ⅛ x 6 ½ in.
The Lane Collection
Courtesy of the Museum
of Fine Arts, Boston

Sheeler's photographic work is known for its acute precision and metallic crispness, qualities that powerfully express the values of the Machine Age. Throughout his career, he produced "straight" gelatin silver prints, avoiding the platinum paper and softly focused, diaphanous images preferred by earlier pictorialist photographers. Yet the Doylestown series is surprisingly subtle in its tonalities and definition of forms. Vintage prints display soft contours and a muted sepia cast, evoking a warm sensuousness that is not evident in most reproductions nor in the photographer's own later printings from original negatives. In these reprintings from the 1930s and 1940s, Sheeler shifted his aesthetic preferences and made steely gray, hard-edged images with sharper tonal contrasts.

An earlier photograph by Sheeler, *Doylestown Interior*, c. 1916,[1] shows a cubist-inspired assemblage among other objects. Perhaps a lost work by Schamberg, this object is identical to the one seen on the partition in *Stairwell*.

[1] Stebbins and Keyes, *Charles Sheeler*, 13, fig. 22.

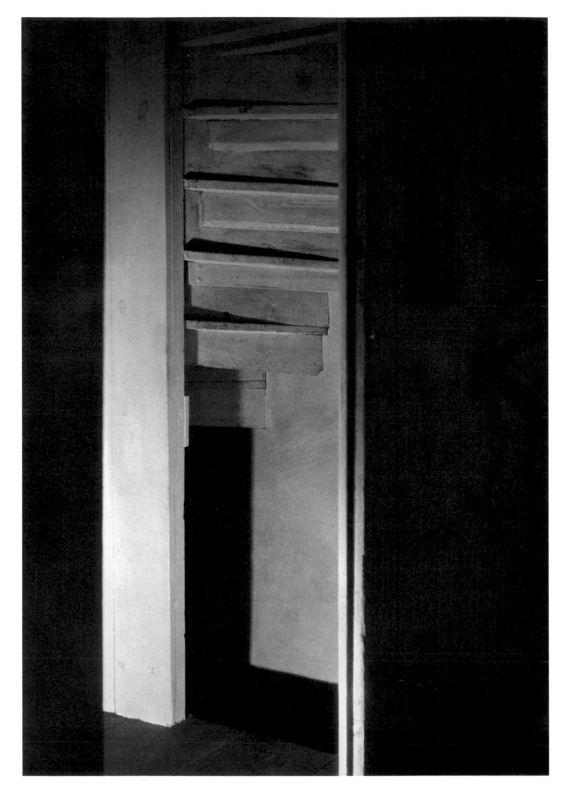

10

Doylestown House:
Stairs from Below
 c. 1917
Gelatin silver print
8 ⁵⁄₁₆ x 5 ⅞ in.
The Lane Collection
Courtesy of the Museum
of Fine Arts, Boston

In *Stairs from Below*, intense
contrasts define the light and
dark areas of the stairwell, but
the highest values are mellow
and softly luminous rather than
starkly white. This quality medi-
ates the strikingly avant-garde
photographic composition—
as if to underscore the subject's
antiquity even though encapsu-
lated within the modernity of
Sheeler's vision.

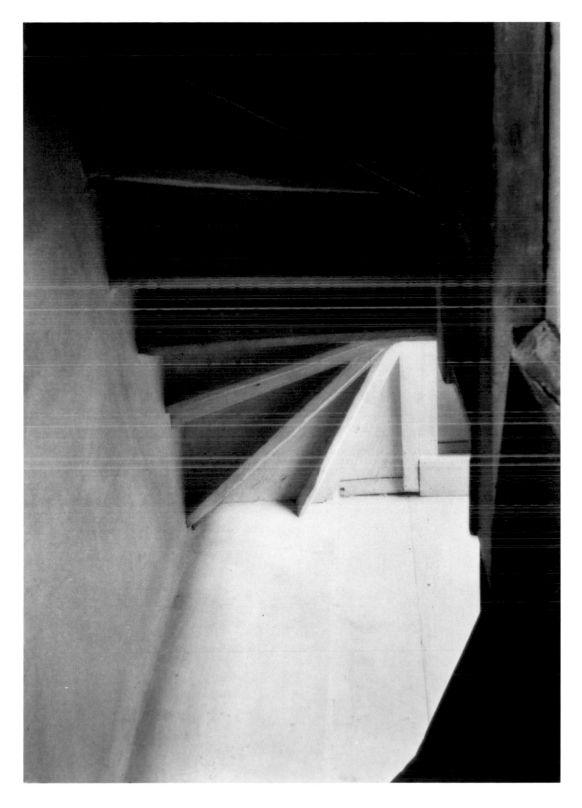

11

Doylestown House: Open Door
c. 1917
Gelatin silver print
9 ⅝ x 6 ⅝ in.
The Lane Collection
Courtesy of the Museum
of Fine Arts, Boston

Open Door is one of the most
evocative of the Doylestown
house photographs. *Vanity Fair*
published it in 1923 with a cap-
tion reading: "Sheeler is an
American painter who has lately
interested himself in photograph-
ing certain Pennsylvania interiors
of the early eighteenth century.
In this example of his camera
work the painter is everywhere
evident—as well as the tranquil
and simplified beauty of the
Dutch [sic] interior."[1]

[1] *Vanity Fair* 20 (April 1923): 47.

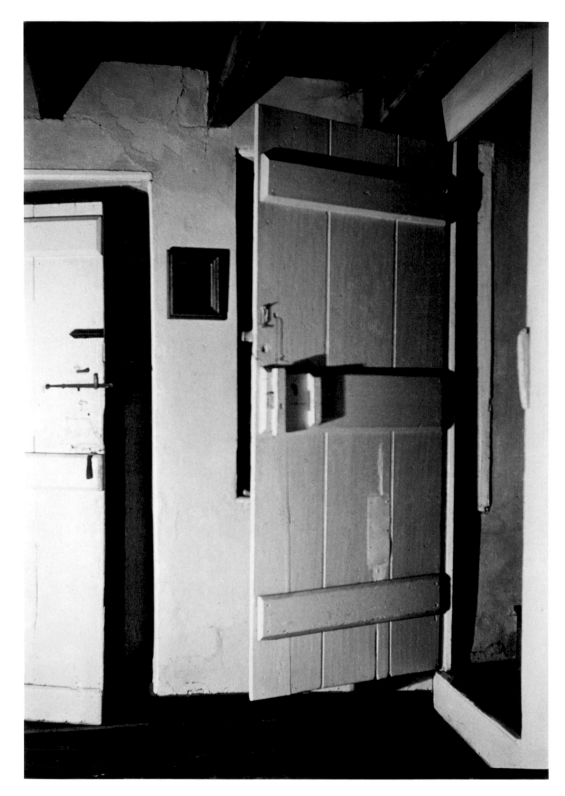

12

*Doylestown House: Stairway,
Open Door*
c. 1917
Gelatin silver print
9 ⅜ x 6 ¹¹⁄₁₆ in.
The Lane Collection
Courtesy of the Museum of Fine
Arts, Boston

This photograph is an alternative version of *Open Door* (cat. 11). Overall illumination characterizes this image, and the light source is neither high nor low. As a result, the photograph lacks the idiosyncratic pattern of bright highlights and deep shadows found in *Open Door*. Here the mirror's surface is not blank, it reflects a pattern of geometric shapes. But they form no recognizable entity, only an abstract configuration. The comparison demonstrates how subtle variations in angle and lighting create fundamentally different aesthetic effects in Sheeler's series.

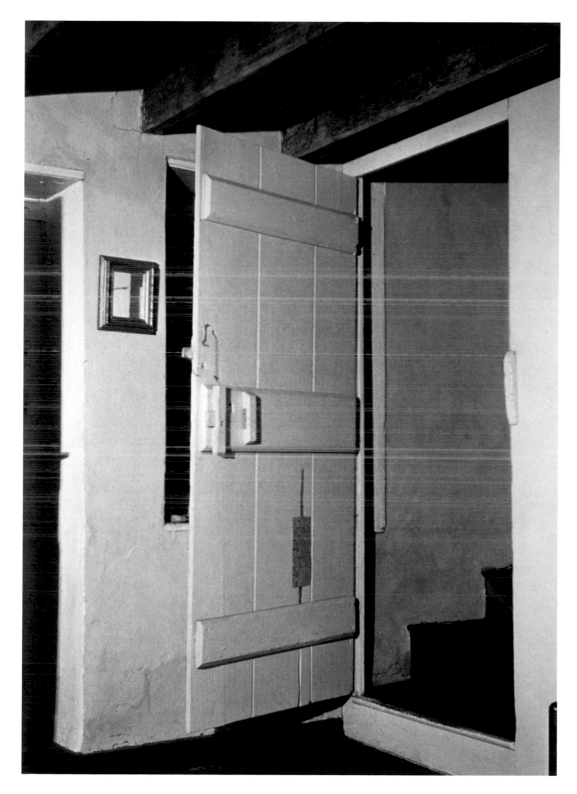

13

Doylestown House:
Stairway with Chair
c. 1917
Gelatin silver print
9 ⅜ x 6 ½ in.
The Lane Collection
Courtesy of the Museum of
Fine Arts, Boston

Eighteenth-century house
builders in Bucks County devel-
oped an ingenious method of
lighting the stairwell by extend-
ing a window into it. This feature
contributes to the interesting
pattern of light seen to the left
of the door in this photograph.
Such a practical local tradition
must have enhanced Sheeler and
Mercer's appreciation of the
pragmatic intelligence, as well
as the aesthetic excellence, that
went into the construction of
the Worthington house.

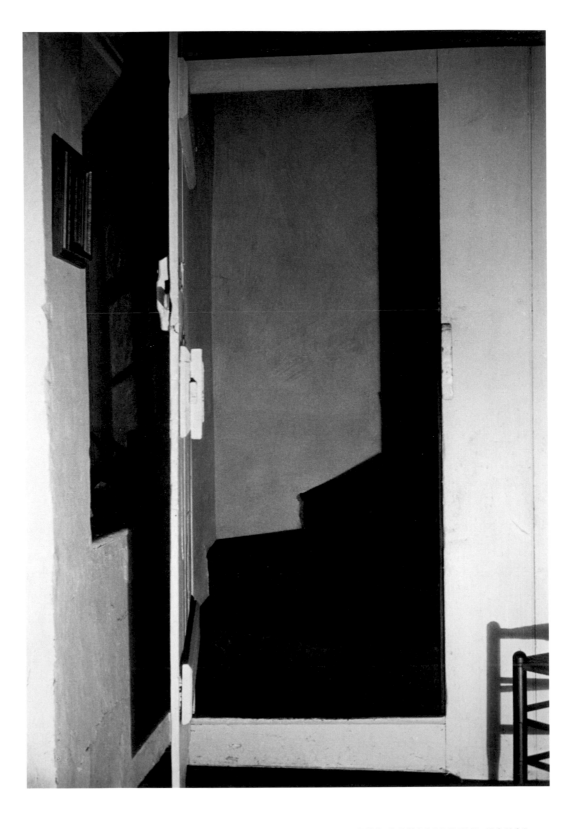

14

Doylestown House:
Door with Scythe
c. 1917
Gelatin silver print
9 ½ x 6 ¾ in.
The Lane Collection
Courtesy of the Museum of
Fine Arts, Boston

This photograph reveals several
objects on the fireplace mantle—
a striped teacup and a spatterware
plate—as well as an intriguing
shadow of a candlestick bisected
by the right edge of the frame.
The handle of a sinuous scythe
rests against the partition to the
left of the fireplace along with a
thin stick, larger logs, and what
appears to be a tool. To the left
and standing slightly ajar, a worn
and soiled door leads to the
ruined log structure. This image
in fact includes an unusual
amount of personal possessions.
In the other photographs, only
a few isolated objects—a mirror
on the wall or a chair near the
doorway—give any signs of
human habitation. *Door with
Scythe* presents revealing evi-
dence of the kinds of artifacts
that Sheeler and Schamberg
collected during this period—
useful tools and vividly decorated
ceramics.

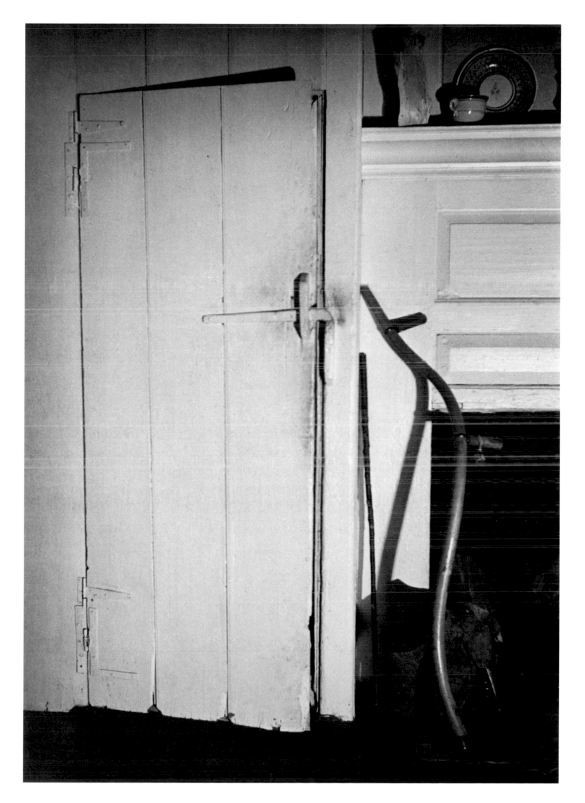

15

Doylestown House:
Interior with Stove
c. 1917
Gelatin silver print
9 ⅛ x 6 ⅜ in.
The Lane Collection
Courtesy of the Museum of
Fine Arts, Boston

Unlike the other images already
discussed, the light source here
is contained within the picture.
Intense illumination emanates
from the composition, giving the
illusion of a fire burning within
the stove. But the intensity and
evenness of the light indicates
that the actual source is a bright
photographer's or kerosene
lamp behind the stove. This sub-
stitution of artificial for natural
light emphasizes Sheeler's self-
conscious control and manipula-
tion of the illumination, one of
the artist's most effective formal
devices in the series.

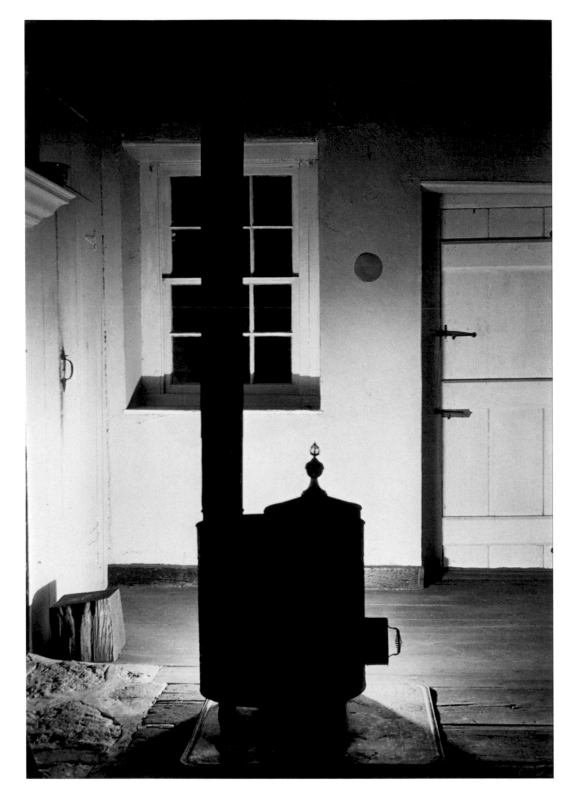

16

Doylestown House: Stove
c. 1917
Gelatin silver print
6 ⅜ x 9 ⅛ in.
The Lane Collection
Courtesy of the Museum of Fine
Arts, Boston

Sheeler here focuses on the
same motif featured in *Interior
with Stove* (cat. 15). Seen closer
and at a more oblique angle, the
stove in this photograph fills
almost the entire frame and
curiously lacks a door handle.
Its form is flatter, starker, and
more reductive. As we have
seen in comparing other related
photographs, *Stove* exists as an
experimental alternative to the
more comprehensive *Interior
with Stove*.

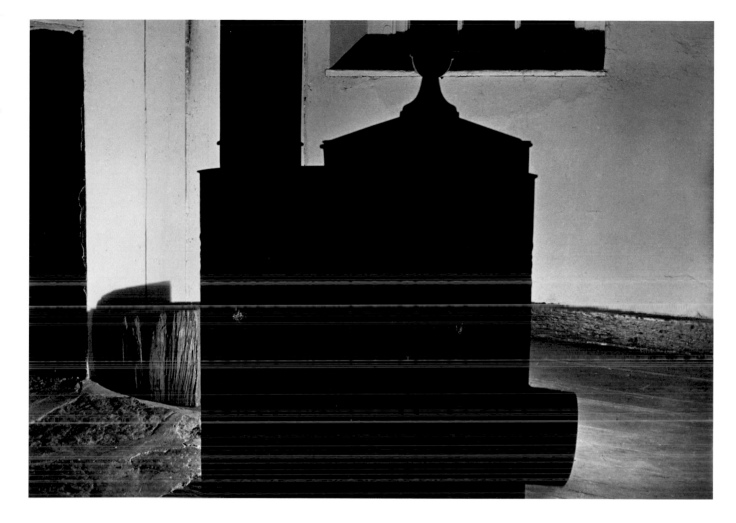

17

Doylestown House:
Downstairs Window
c. 1917
Gelatin silver print
9 ⁷⁄₁₆ x 6 ³⁄₈ in.
The Lane Collection
Courtesy of the Museum
of Fine Arts, Boston

This photograph presents the interior as a self-enclosed, self-protected fortress. Here the camera angle is approximately the same as in *Open Door*—directly opposite the southeast wall—but now the stairwell door is closed, and the view reveals a greater portion of the room. We finally see what *Open Door* denies us—an unimpeded view of the window. But its gridlike panes of glass still reveal nothing but darkness beyond them. The movable items that appeared in the other views of this corner—the chair, mirror, and the obscure pile on the window ledge—have all disappeared. *Downstairs Window* is austere and minimal, even in comparison to other images in the series, suggesting a more complete sense of enclosure than in any of the previously discussed photographs.

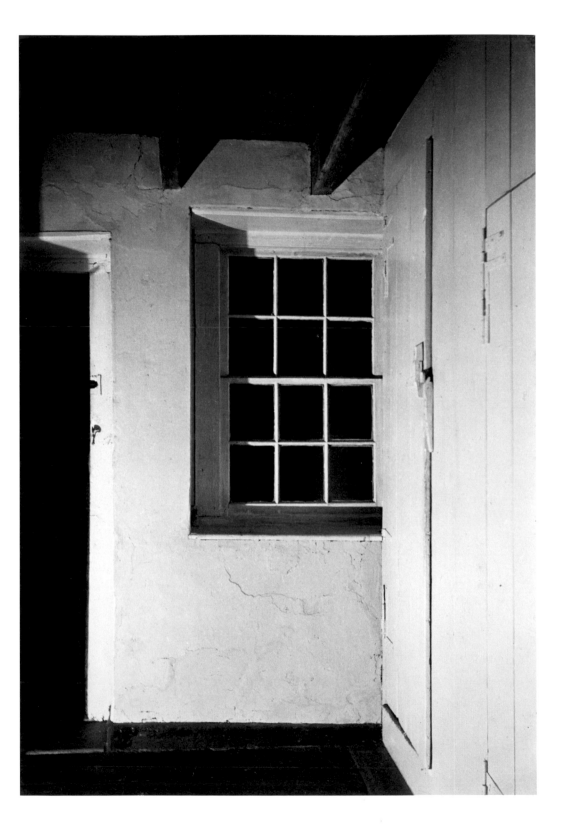

18

Doylestown House:
Open Window
c. 1917
Gelatin silver print
9 ½ x 7 in.
The Lane Collection
Courtesy of the Museum of
Fine Arts, Boston

Open Window must have
belonged to the original set of
twelve Doylestown house pho-
tographs because Sheeler exhib-
ited it shortly after the series was
completed. It won first prize in
the Thirteenth Annual John
Wanamaker Photography Exhi-
bition in 1918.[1]

Despite Sheeler's unifying
aims in his cumulative portrait
of the Worthington house, the
interrelatedness of the series
diminished after the initial show-
ing at the Modern Gallery when
the artist began exhibiting and
selling the photographs indi-
vidually. Stebbins and Keyes,
in discussing the mounts of the
original photographs from the
series, note that the artist did not
even retain a complete set with
matching mounts for himself.[2]
Beginning in the 1920s, some
of the images acquired shorter
titles such as *Stairwell*, *Open
Door*, and *Open Window*. Exhib-
ited and sold as self-sufficient
entities, these became well
known. Sheeler kept others
private, and these remained
unavailable for public viewing
for seventy years until the artist's
retrospective exhibition in 1987,
organized by the Museum of
Fine Arts, Boston.

[1] W. G. Fitz, "A Few Thoughts on the
Wanamaker Exhibition," *The Camera* 22
(April 1918): 204; Naef, *The Collection of
Alfred Stieglitz*, 438.

[2] Stebbins and Keyes, *Charles Sheeler*, 9.

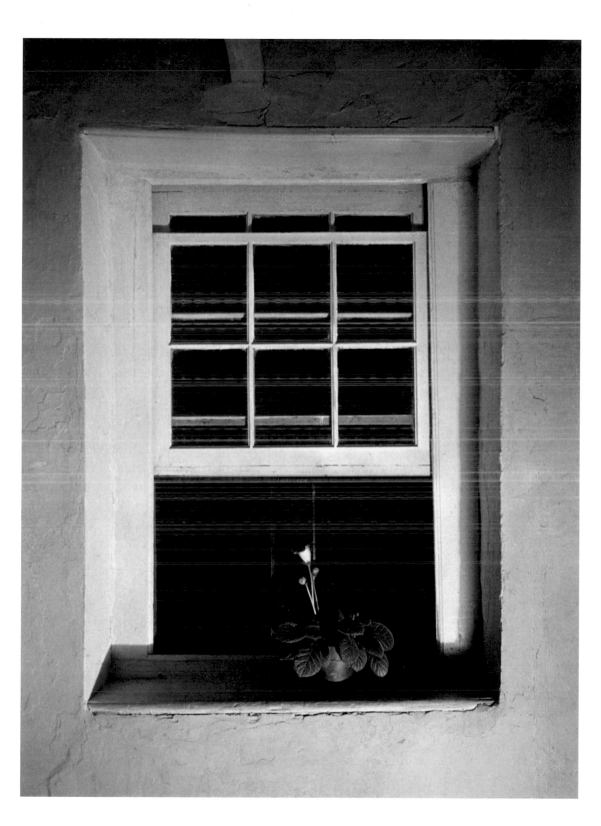

19

Paul Strand
(American, 1890–1976)
Abstraction, Porch Shadows, Connecticut
c. 1916
Photogravure
11 ⅝ x 8 ¹⁵⁄₁₆ in.
Philadelphia Museum of Art
Gift of Carl Zigrosser
(66-205-49/50 [10])

Strand experimented with abstract photography at his rural retreat in Twin Lakes, Connecticut. This image appeared in the last issue of Stieglitz's *Camera Work*, in June 1917. Stieglitz had apparently planned to publish some photogravures of Sheeler's work for an issue that would have come out later in 1917, but *Camera Work* folded before it materialized.[1]

[1] See Naef, *The Collection of Alfred Stieglitz*, 218, and Stebbins and Keyes, *Charles Sheeler*, 8.

20

House and Stairs
1917
Conté crayon on paper
20 ¼ x 15 ½ in.
Collection of Hirschl & Adler
Galleries, Inc., New York

Sheeler's experiments in photographing the Doylestown house no doubt inspired innovations in his paintings and drawings. Although this conté crayon work does not depict Sheeler's home (notice the straight rather than spiral staircase), it does resemble the Worthington house in several respects: a large hearth on the first floor, two small partitioned rooms on the second, and a basement entrance below the staircase. Large planar divisions have replaced the smaller facets of Sheeler's pre-1917 drawings. Especially prominent are the stark contrasts of light and dark areas, similar to the expressive artificial lighting in the Doylestown house photographs.

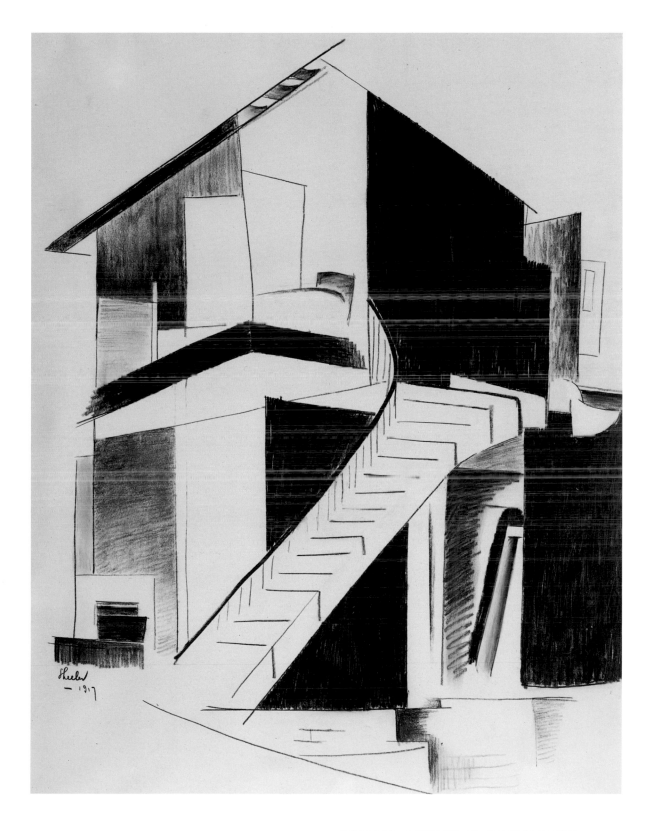

21

Katharine
1918–19
Gelatin silver print
4 ¼ x 4 ¹⁵⁄₁₆ in.
The Lane Collection
Courtesy of the Museum of Fine
Arts, Boston

This portrait of Katharine Baird
Shaffer is one of thirteen stills
taken from a short film the artist
made of the woman he would
later marry in 1921. In eleven of
the stills, Sheeler experimented
with fragmenting the form of
Katharine's nude body; in these,
her face never appears. But here,
we see her fully clothed with a
faraway, wistful expression, indi-
cating an emotionally complex
and appealing character.[1]

[1] Stebbins and Keyes, *Charles Sheeler*,
15–16.

22

*Christmas Greetings
(Doylestown House:
Exterior View)*
1924
Gelatin silver print mounted
on card stock
2 ¼ x 3 ¼ in. photograph
7 ¹⁄₁₆ x 5 ¼ in. card
Philadelphia Museum of Art
Archives of American Art from
the Carl Zigrosser Collection
(95-122-1)

Sheeler sent one of these cards
to fellow artist Henry Schnaken-
berg; it displays a miniature
image of *Doylestown House:
Exterior View*, c. 1917, and a
greeting from the Sheelers in
elegant, sans serif typeface. Over
the years, Sheeler adapted other
Bucks County photographs for
greeting cards, including *Interi-
or with Stove* and *Buggy*.[1]

[1] Stebbins and Keyes, *Charles Sheeler*, 9,
n. 12.

1924

CHRISTMAS GREETINGS

CHARLES & KATHARINE

SHEELER

Bucks County Barns

While Sheeler was in Doylestown, he created an important series of photographs, paintings, and drawings depicting Bucks County barns. These impressive structures were a prominent feature of the entire southeastern Pennsylvania region during the artist's time there. From the days of its earliest settlement by European immigrants, Bucks County had an economy based on agriculture, and farmers needed monumental barns to thresh grain, shelter animals, and store crops. First built during the late eighteenth and early nineteenth centuries, these structures are obscure in origin. Most architectural historians believe they derived from Germany and Switzerland, but some research indicates precedents in the Lake District of England. Especially in areas around Philadelphia, a fusion of German and British traditions most likely occurred.[1]

Characteristically constructed of fieldstone, clapboard, or board-and-batten siding, the Pennsylvania barn is usually surrounded by a complex of buildings, including a perpendicular ell and smaller outbuildings that provide storage for tools, wood, and crops, as well as shelter for animals. The main barn is either banked against a preexisting hill or a bank is constructed on the north side. This allows a loaded hay wagon to enter from the banked side onto a

second-story threshing floor. On the inside, two-story hay-mows provide for abundant grain storage. Often the barn's interior resembles a grandly proportioned English medieval hall, with a steeply pitched roof and complexly crafted ceiling of exposed tie beams and rafters. The building's main facade faces south, ensuring that cattle stalls on the lower floor and the barnyard receive maximum light and warmth. The barn's most distinctive regional feature is a cantilevered forebay opening out to the yard, which shelters the animals in bad weather.[2]

This subject matter may seem perfectly appropriate to us today, but when Sheeler first engaged it in the mid-1910s some observers dismissed it as ill-placed in a "fine arts" context. Conversely, sympathetic viewers judged the subject highly suitable for modernist experimentation; they also claimed that Sheeler's Bucks County barn series revived the spirit of American folk art and preindustrial vernacular crafts. Early commentators often linked modernism and tradition in Sheeler's art as if they were inevitably connected. But from our retrospective position, we can identify such a linkage as an "invented tradition" that served those trying to establish an independent identity for the American van guard.[3] And indeed these works, along with his images of New York skyscrapers, helped the artist solidify his position as a leading modernist in this country.

THE PHOTOGRAPHS

Sheeler's photographs of Bucks County barns closely parallel those of the Worthington house in the artist's formal and thematic concerns.[4] Like the house photographs, they fix the subjects in symbolic permanence while simultaneously advancing a modernist agenda. By representing rural architecture in a vanguard context, the artist also contributed to a reevaluation of its meaning.

According to Charles Millard, one of the earliest scholars of Sheeler's photographs, the artist began the series in 1915.[5] However, scanty documentation hinders the precise dating of the images. On stylistic grounds, Stebbins and Keyes believe that he produced them somewhat later—during 1916 and 1917.[6] The photographs most likely predate slightly or appeared contemporaneously with a series of drawings

Sheeler made of identical subjects, which commenced in 1917.

As with the Doylestown house series, the original number of barn photographs also remains a mystery. At least seven views survive, but evidence from works in other media suggests that Sheeler originally produced several more. A few are well known: *Bucks County Barn (Vertical)* (cat. 25), *Buggy (Interior, Bucks County Barn)* (cat. 26), and *Side of a White Barn* (cat. 27).[7] These photographs have been frequently published, and many prints exist in private collections and public institutions. Others, such as *Bucks County Barn (with Chickens)* (cat. 28), are much less familiar. *Bucks County Barn (with Wall)* (cat. 29), *Bucks County Barn (with Tree)* (cat. 30), and *Bucks County Barn (with Gable)* (cat. 31) have been rarely, if ever, published or exhibited.

Ingeniously built, highly textured, and interestingly variegated, Bucks County barns obviously fascinated Sheeler during his years in Doylestown, but his approach to depicting this subject covered a wide range. Two of the photographs, *Side of a White Barn* and *Buggy*, resemble the interior shots of the Doylestown house. The other more comprehensive views recall the exterior shots of Sheeler's home (cat. 8)—not surprisingly, given the necessity of working in natural daylight. Most of the images are sharply focused, carefully detailed, and illustrative of rural life in Bucks County. But close study reveals them to be far more than mere documents.

Bucks County Barn (with Chickens) (cat. 28), for example, renders its subject clearly and comprehensively. We see the entire three-building complex situated on hilly land with barren trees on either side. A typical Pennsylvania barn dominates the complex, with fieldstone walls and unpainted wood siding. This photograph straightforwardly depicts a working agricultural setting in rural Bucks County, with the plowed land and flock of chickens placidly feeding in the foreground surrounded by a silo, outbuildings, tractor, and other farm implements. But the composition also emphasizes distinct formal elements. The angle of view accentuates the blocky, asymmetrical relationship between the buildings and the repeated forms of their triangular gables. Similarly, the contrast of dark roofs to white siding creates a rhythmical pattern, uniting one building to another. The photograph also highlights the contrasting masonry

walls, shingled roofs, and unpainted wood. The modernist emphasis on textures and forms presents the barn as worthy of aesthetic contemplation.

Bucks County Barn (with Wall) (cat. 29) also seems primarily descriptive at first glance but grows more formally and thematically complex with sustained viewing. Sheeler shows this barn frontally, but again, smaller outbuildings flank the central fieldstone structure. A plastered wall surrounds the barnyard; lacking a gate, it binds all the structures into one unit. Aged board-and-batten siding covers the second story of the barn, but the roof looks surprisingly new, undoubtedly recently repaired with a smooth industrially produced material that contrasts with the irregular cedar shingles on surrounding buildings. Small, asymmetrically placed windows and doors on the facade provide light to the interior and ventilation for the hay and animals housed within. Other doors open to cattle stalls in the dark recess below the cantilevered forebay.

Probably taken during the harvest season, the photograph shows trees in full foliage and mows filled to the brim with hay. This suggests the natural fruitfulness of the Bucks County farmland and a seemingly viable way of life based on cultivating its resources. The building's self-enclosure denies the viewer's access to such bounty, however. A gateless fieldstone wall and barbed-wire fence doubly bar us from entry into the protected space of the barnyard. The barn's facade offers access in its numerous open doors and windows, but the insurmountable impediments in the picture's middle ground complicate the possibility of actual entry. Quite subtly, this photograph thematizes the same conflicts we first encountered in considering images of the Doylestown house. Here, as earlier, an imaginative possibility beckons while, simultaneously, an impediment looms before us.

Yet threshold anxiety is easily overlooked in this photograph, and the presentation does not surprise or disorient us aesthetically. In fact, the buildings in *Bucks County Barn (with Chickens)* and *Bucks County Barn (with Wall),* although showing signs of age, give comforting evidence of human use and care. Chickens peck in the yards; roofs stand in good repair; and although no human actors appear, the gathered hay indicates work recently done. In contrast, *Bucks*

County Barn (with Tree) (cat. 30) shows signs of complete neglect and decay.

This view of the building deceives those unfamiliar with Bucks County barns into thinking that the structure is a long, low shed. But we actually see the top floor of a two-story barn banked against a hill. The building's ramshackle facade exhibits various textures, with board-and-batten siding to the right, smooth white plaster in the middle, and coarse rubble masonry at the left. Behind a wooden gate, large doors once admitted loaded hay wagons into the interior, but tall grass in the foreground covers the path that formerly brought them into the barn. No chickens, tools, or other evidence of human presence appear. The decayed barn's abandonment seems long-standing, and the building appears on the verge of extinction.

Bucks County Barn (Vertical) (cat. 25) also shows a neglected structure. The tall barn is banked against a grassy hill, flanked by leafless trees. A dirt road fills the foreground, curves in front of the barn's ell, and disappears to the right. The barn faces a more ornate fieldstone house across the road. We see only a small portion of this foreground building, with sash windows and scalloped woodwork on the gable end. In comparison to this house, the barn looks especially disheveled, with its doors hanging open, its roof missing several shingles, and its fence in the foreground lacking a gate.

The building's profile, crisply delineated against the sky, encloses a large, empty space in the center of the composition. Within that darkness, we only dimly perceive the details of the building's facade. Virtually every door hangs open, yet these thresholds do not invite access into the barn's interior; they merely frame dark holes in the barn's outer shell. Although the road in the foreground leads us directly to the barn, once there, we are confronted by a black void that discourages further movement within.

The environment depicted in *Bucks County Barn (Vertical)* is almost unnaturally still. No livestock or stored crops appear; nothing suggests the earthy smells and sounds of farm life. In fact, the shabby pen in the foreground is incapable of retaining animals. It contains only dry, dead plants. The barn's numerous open doors are especially haunting. As they hang precariously from their hinges, they belie the

intended purpose of the barn to protect livestock and crops. This intimates the imminent eclipse of the agrarian life that once flourished in the region.

Each of these four photographs evokes a different empathic response, and despite their apparent straightforwardness, all depict their subjects in a subtly unconventional way. Sheeler's focus on voids, textured surfaces, and asymmetrical planes reveals an understated but rigorous formalism underlying the images. The four pictures are also all strangely depopulated—no people ever appear in proximity to these buildings. Every tool is abandoned, and all the doors— whether open or shut—discourage access. Even *Bucks County Barn (with Chickens)* and *Bucks County Barn (with Wall)*, which depict working farms, convey the sense that the farmers have suddenly vanished in the midst of their seasonal work. As with the Worthington house, these photographs indicate Sheeler's fascination with indigenous artifactual traditions, but an unsettling absence complicates the deepest significance of the images.

Side of a White Barn (cat. 27) exhibits many of the same qualities found in the other photographs—human absence, decaying materials, and denied access to the barn's interior. But this image is also audaciously modern stylistically, which Sheeler achieved through proximity and framing. The photograph brings the viewer extremely close to the building's facade. From this intimate distance, the highly textured surfaces—irregular, crumbling plaster, knotted and cracked board-and-batten siding, patterned cedar shingles dominate the composition. Three door openings and one small window appear asymmetrically on the flat, planar facade. The eaves of the roof emerge just below the composition's upper edge, casting a long horizontal shadow below. On ground level, a wooden fence with three tall posts extends back diagonally toward the barn. A pile of hay rests below the double doors. Easily overlooked, a chicken perches on top of this pile, its tiny body contorted as if pressured by the monolithic wall behind it. The truncated head of another chicken is barely visible to the left.

In its boldly minimal composition, this photograph, like *Stairwell* or *Stairs from Below* (cats. 9–10), resulted from Sheeler's investigation of new approaches to the photographic medium. The flattened space and unconventional framing make the highly textured, rectilinear forms—doors, windows, siding—seem pasted on the picture plane, accentuating the inherent two-dimensionality of the supporting medium. Two recent scholars of Sheeler's work, Carol Troyen and Erica E. Hirshler, underscore his stylistic achievement in *Side of a White Barn* by observing, "This is perhaps the first photograph in which the subject is absolutely identified with the picture plane...."[8] Such claims to originality are hard to verify; nevertheless, the image well deserves its status as a landmark in the development of modernist photography.

Like the blocked windows and blank mirrors in the Worthington house photographs, the monolithic facade in *Side of a White Barn* seems to posit modernist aesthetic practice as an end in itself. Its impenetrability, and the subject's nearly complete congruence with the picture plane, embody modern art's concern with "how" a picture comes into being rather than "what" it depicts. It undercuts photography's traditional role of describing its subjects. The image's apparent refusal to gesture beyond itself invites us to think of formal issues over associated meanings, of surface, texture, and pictorial structure over the farmers and animals for whom this building was made.

As we have come to expect in Sheeler's work, however, a deep psychological investment in the subject mediates the artist's modernist experiments. Here the two chickens are curiously anecdotal in the context of the artist's rigorous formalism. In fact, they are virtually forced out of the image, yet—as if contrary to the artist's will—they remain liminal signs of something beyond purely formal concerns. Their presence obliquely suggests that the barn does indeed have a function, that the photograph in the end has something to say about agricultural life in Bucks County.

Side of a White Barn therefore contains two seemingly contradictory impulses: self-reflexive formalism and extrapictorial reference. Some early critics recognized this duality in Sheeler's barn photographs. In 1920, Henry McBride praised their modernity, distinguishing Sheeler's work from that of the pictorialist photographers:

Mr. Sheeler is an out and out modernist.... It is of course possible that the artist may win some applause from totally uninstructed persons, who will see that Mr. Sheeler's barns are genuine Bucks County barns in spite of something in the work that the instructed will call "cubism," but these same uninstructed persons, while admitting that Mr. Sheeler's barns are barns, will doubtless sigh for a few more vulgar details.... He has a relentless eye, it seems, when it comes to focussing; a personal feeling toward textures and values.... All who look on photography as a means of expression should see these photographs of barns. They rank among the most interesting production of the kind that have been seen here, and are all the more important as this artist never forgets for a moment that the camera is a machine, and he emphasizes the things a machine can do better than hands, instead of blurring them into so-called artistic effects, as so many photographers do.[9]

In this passage, McBride emphasizes Sheeler's understanding of a cubist aesthetic while asserting that the artist remains truthful to the photographic medium because the sharply focused images look machine produced, not handmade. On these two points, he can celebrate the artist's work as "out and out modernist."

To most viewers, the fragmentary *Side of a White Barn* could depict a barn almost anywhere. McBride, however, recognized the "genuine" Bucks County elements in the imagery. Born in the rural outskirts of Philadelphia, the critic knew this type of building well, and therefore the fragments possessed local specificity. On this basis, he understood Sheeler's art as a synthesis of Bucks County tradition and modernist aesthetic expression.

The remaining photograph in the series, *Buggy* (cat. 26), embodies a similar synthesis. But in contrast to the others, this image reveals the habitually hidden interior of Sheeler's farm buildings. Instead of an impenetrable facade, *Buggy* shows us the deep, recessive, but still mysterious space within the barn.

A horse-drawn vehicle, the "buggy" of the photograph's title, occupies the center of the composition. Sheeler placed an artificial light behind it, endowing the vehicle with a numinous glow.[10] As in *Interior with Stove* (cat. 15), a kerosene or photographer's lamp masquerades as natural light, intensifying the tonal contrasts in the scene and creating an assertive silhouette. But despite the dramatic backlighting, we can partially discern the buggy's complicated structure—its large spoked wheels, numerous axles, and the interior of the cab. To the left, heavy clothing hangs from a coatrack. Two horizontal planks bar entrance to the stall; splattered paint or bird droppings mark the topmost board.[11]

Obscure, truncated forms bracket the central stall. To the left is another vehicle—perhaps a hay wagon—with a rack on top and chains below. Farm implements rest in a dark recess behind the wagon. An empty loft hovers to the upper left, and at the composition's far edge, shafts of bright sunlight penetrate the wooden frame of the barn. To the right are a ladder and a spoked wheel, perhaps a spare for the buggy. Between two of the ladder's rungs, a window on the far side of the barn forms a tiny rectangle of light. This small area of intense natural illumination presents a visual counterpart to the bright, artificial light shining through the peephole in the buggy's hood.

The objects in *Buggy* seem at first glance haphazardly arranged, as if the artist merely stumbled upon the scene and photographed it as he found it. But the lighting makes clear that the photograph is not an automatic imprint of a preexisting world. As in the Worthington house series, the purposely obscure relationship between artificial and natural light sources confronts us with an unstable boundary between the world as passively perceived and as artistically constructed. A fusion and confusion of nature and culture results from this thematically suggestive and formally compelling dualism.

Furthermore, the rough-hewn wooden planks surrounding the entrance to the stall demarcate a "picture within a picture," like a frame around a painting. This "found" frame serves a twofold purpose. Yet another surrogate for the picture itself, it also emphasizes how the photograph elevates the unpretentious, utilitarian subject into the realm of high art. But the metaphorical frame around the stall also prevents our full empathic entry into the area of greatest fascination. The mysterious light beckons us closer, but the wooden timbers halt us at the threshold. Immediate, concrete contact

with the subject remains just beyond our grasp.

This enforced distance between viewer and subject encourages thoughts about the disappearing way of life that these objects represent. The artifacts once served human needs, yet as in *Bucks County Barn (Vertical)*, their anonymous users seem long absent. Who knows how long the coats have hung on this rack? How many years has this buggy remained in its stall, abandoned perhaps for a new Model T? After this photograph was taken, the neglected environment undoubtedly continued to disintegrate. Sometimes preserved in a museum or private collection, these types of outmoded objects seldom survived in their intended context. In a new setting, they acquired meanings never imagined by their original makers and users.

In the face of its subject's certain decay or dislocation, Sheeler's photograph endows it not only with artistic status, but with symbolic permanence as well. The image will remain long after the depicted objects have passed away. Yet such a gesture of preservation has its limits, which the photographer himself seems to acknowledge. By placing an artistic frame around a formerly utilitarian environment, Sheeler instills consciousness of an unbridgeable gap between the viewer and the things viewed. The aesthetic transformation preserves an imprint of forms but does nothing to protect the context that generated and sustained these objects.

Of all the images in the barn series, *Buggy* most resembles the formal structure of the Doylestown house photographs. The barn's interior is much more cluttered, but the photograph exhibits the same dramatic contrasts of light and dark. It also closely relates to the house series in its themes of denied access and self-referentiality. But other barn photographs similarly echo and reformulate the thematic concerns of the Worthington house images. In *Bucks County Barn (Vertical)*, for example, virtually every threshold is carelessly open. Like *Open Door* (cat. 11), these dark portals induce anxiety, but whereas in the Worthington house photograph, we fear to step outside, in the barn images, we hesitate to move within. *Side of a White Barn*, like *Downstairs Window* (cat. 17), inverts the problem of the threshold by aggressively asserting closure. Both series therefore represent an investigation into indigenous tradition molded by an unconventional

modernist sensibility. And both contributed to Sheeler's private archive of Bucks County imagery that preserved memories while sustaining his creative imagination.

PRESERVATION THROUGH ART

No contemporaneous letters or statements have surfaced to give evidence of Sheeler's original thoughts about his barn subjects. In the 1930s, the artist made his first extended comment on their significance:

Forms created for the best realization of their practical use may in turn claim attention of the artist who considers an efficient working of the parts toward the consummation of the whole of primary importance in the building of a picture. Evidence of this accomplishment aroused my interest in the early barns ... in Bucks County, Pennsylvania. Their shapes were determined by their practical use and by the combination of materials, wood, stone, plaster,... their construction anticipated by a considerable time the interest of the contemporary artist in the relation of contrasting surfaces as an important contribution to the design of a picture.[12]

Sheeler elaborated on these ideas in a later interview:

[T]he community built the barns for the individual and they always had first of all its utility in mind; and that wasn't accidental because they knew ... how the barn had to function for their purpose; they weren't building a work of art. If it's beautiful to some of us afterwards it's beautiful because it functioned—the functional intention was very beautifully realized.[13]

In the first statement, Sheeler's appreciation of the barns' contrasting surfaces helps explain his original attraction to the material. Also, the equivalence of the historic vernacular and contemporary art characterized his thinking during his early career. But Sheeler's analysis of the barns' "beautifully realized functional intention" requires further analysis.

At the time Sheeler first photographed Bucks County barns, architects and design theoreticians often expressed the idea that beauty necessarily results when form derives

from function.[14] But none of the artist's statements from the 1910s indicates an interest in functionalist theory. Furthermore, his photographs do little to demonstrate how the forms of the barns express their function. We seldom see the storage areas within the barns; no humans demonstrate how these structures work. Instead, most of the barns appear abandoned, reflecting a *loss* of usefulness. A newly manufactured automobile or an operating grain elevator would have demonstrated functionalist principles better than an old-fashioned buggy in a decrepit barn. The artist did subsequently embrace functionalism, however. His factories and skyscrapers of the 1920s and 1930s reflect this later enthusiasm, which undoubtedly colored his retrospective explanations for his interest in Bucks County barns. But his art suggests that his major concerns in the 1910s were simultaneously with formal experimentation and symbolic preservation.

Pennsylvania barns had once been ingeniously functional, with their cantilevered forebays and two-story haymows. But efficiency was a relative, rather than absolute, feature of their design. Innovations in farming, such as mechanized threshing, automatic hay bailing, and silo storage, had rendered these monumental buildings considerably less practical in Sheeler's time than when originally built. In addition, farmers increasingly abandoned the time-consuming handcraft necessary to maintain the buildings. Bucks County farmland gave way to tract housing similar to the development that engulfed the Worthington house. As a result, these barns rapidly disappeared from the Bucks County countryside during Sheeler's time there.[15] The dilapidated condition of these buildings in his photographs conveys their endangered status at the turn of the century.

In their transition towards obsolescence, these unpretentious barns revealed themselves to Sheeler as subjects worthy of artistic presentation. This involved an aesthetic reevaluation common in the late nineteenth and early twentieth centuries. As Marshall McLuhan writes:

When machine production was new, it gradually created an environment whose content was the old environment of agrarian life and the arts and crafts. The older environment was elevated to an art form by the new mechanical environment.... Each new technology creates an environment that is itself regarded as corrupt and degrading. Yet the new one turns its predecessor into an art form.[16]

Herwin Schaefer elaborates on McLuhan's insight: "A functioning environment is invisible and is perceived as an art form only after it has become obsolete and ceased being a viable, practically functioning entity...."[17]

According to McLuhan and Schaefer, truly functional artifacts are invisible aesthetically. To ignore or discard them is therefore of little consequence. But the reevaluation of utilitarian artifacts as art separates them from this invisible environment. They are then collected, photographed, recorded, put in museums, or in the case of Bucks County barns, converted into artists' studios or fashionable housing for elite professionals who commute to Philadelphia.[18] This aestheticization process usually results in the preservation of such artifacts on some level. As newly defined works of art, many examples survive that would not otherwise, but with their meanings irreversibly altered.

Beginning in the nineteenth century, artists used barns as picturesque country studios; some even depicted them as artistic subjects.[19] But few before Sheeler saw the potential of this material for modernist experimentation.[20] When Sheeler's barn photographs appeared at the De Zayas Gallery in 1920, a critic sneered at the artist's "uninteresting models."[21] Artifacts of agricultural life were popular symbols, but before the 1910s they represented historical (as we saw in Mercer's case) rather than aesthetic concerns. In contrast, Sheeler's photographs present "the combination of materials" in Bucks County barns—wood, stone, plaster—as inherently beautiful and artfully arranged. These images therefore made visible a previously ignored environment through the kind of aesthetic reevaluation McLuhan and Schaefer describe. Thus aestheticized, the subject received a new, if decontextualized, life. And after seeing Sheeler's images in galleries and in avant-garde journals,[22] an initiated group of art viewers eventually came to appreciate these structures as Sheeler did—as "found" art objects and appropriate models for modernist experimentation.

In the associational drift from the utilitarian to the aesthetic, the object survives primarily in the symbolic realm. Sheeler no doubt recognized that the antiquated artifacts of Bucks County would soon pass away, and his photographs seem to acknowledge the limits of such a metaphorical gesture in the face of actual loss. The void at the center of *Bucks County Barn (Vertical)*, the barrier in *Buggy*, the contorted chicken in *Side of a White Barn*, all seem to confess a sense of incomplete resolution to a situation in which an image substitutes for a once vital and sustaining way of life.

THE DRAWINGS

Sheeler's barn photographs stimulated and reinforced his development in other media, and cross-fertilization between his photographic and drawing practices began almost immediately. During 1917 and 1918, Sheeler produced at least seven conté crayon drawings (cats. 32–35; fig. 4) and about the same number of larger mixed-media works on paper (cats. 37–39, fig. 5).[23] Some of the drawings directly relate to contemporaneous photographs; others do not now have any surviving photographic analogues. *Barns (Fence in Foreground)*, 1917 (cat. 34), and another *Bucks County Barn*, c. 1918,[24] fall into the latter category. These two works are unusual because they do not belong to a series of variant presentations of the same structure. More typical is *Barns*, 1917 (cat. 35), which relates to three other drawings that all represent an identifiable complex of buildings. This subseries includes two additional conté crayon works, *Side of a Barn*, 1917,[25] and *Barns*, c. 1917–18,[26] and a larger gouache, *Bucks County Barn*, 1918 (cat. 38). Another subseries consists of the famous *Barn Abstraction*, 1917 (fig. 4), which Sheeler replicated in a lithograph (cat. 36). The artist executed a more comprehensive view of the same building in 1918,[27] and yet another in the same year entitled *Bucks County Barn* (cat. 37).

The drawings with photographic analogues offer fascinating comparisons across media and shed special insight into the artist's creative thinking during this era. Sheeler's experiments in framing and stark tonal contrasts no doubt revealed the aesthetic possibilities in drawings of larger, more simplified shapes. The photographs Sheeler kept private in his later career were often the most useful models. *Bucks County Barn (with Wall)* (cat. 29) relates to a mixed-media work, *Bucks County Barn* (cat. 39), done in 1918. *Bucks County Barn (with Chickens)* (cat. 28) inspired several paintings and drawings, most notably the oil painting *Bucks County Barn* (cat. 54) of 1932.

The barn represented in *Bucks County Barn (with Gable)* (cat. 31) similarly gave rise to a number of related drawings and paintings. Sheeler depicted it in at least three small conté crayon works of 1917: two identically titled *Barn* (cats. 32–33), and another drawing named *Barns*.[28] Although no known photograph exactly corresponds to *Barn Abstraction*, 1918 (fig. 5), the building it portrays appears in *Bucks County Barn (with Gable)* but from a different angle. Two later oils, *Bucks County Barn*, 1940 (fig. 11), and *Barn Abstraction*, 1946 (cat. 55), also represent the same complex of buildings. In all likelihood, an identical photographic source once existed for these three works.

Such groups of interconnected imagery generated over decades indicate many features of Sheeler's artistry: the importance of serial experimentation throughout his career, the interdependence of various media in his creative projects, the periodic alternation of realism and abstraction as viable stylistic options, and the role of photography in preserving memories of the Doylestown period.

Rourke describes the images as "some eight works in tempera, oil, crayon, of Pennsylvania barns called 'Barn Red,' 'Barn Contrasts,' or bearing similar abstract titles." She elaborates:

Some of these are two-dimensional except as the third dimension is produced by the firm texture of stone or the curve of a silo. All of them are presented in space, without surrounding contexts, and they are extraordinarily beautiful in color, with reds of great clarity and depth, with the many colors of the limestone playing their refractions; the blacks and whites are both positive and exquisite. These works are all partially abstract. In them all,... the basic concern is with form. Their secrets lie in the undiscoverable ways in which the oblongs and squares and cylinders containing stone or clapboarding or shingles are placed so as to result in a continuously flowing balance.[29]

Fig. 4
Barn Abstraction
1917
Conté crayon on paper
Philadelphia Museum of Art:
Louise and Walter Arensberg
Collection (50–134–183)

In her interpretation of the series, Rourke above all emphasizes formal considerations.[30] Similarly, other scholars have evaluated the early Bucks County barn drawings as evidence of the artist's fascination with synthetic cubism and collage in the late 1910s.[31] For example, *Bucks County Barn* (cat. 38) presents painted areas as if they were flat, pasted elements. Dense and opaque, the barn's colored planes resemble paper cutouts and raise formal issues that are also integral to the collage aesthetic.

The Bucks County barn series was in fact a milestone in Sheeler's lengthy project to absorb and adapt the principles of progressive European art. It followed a brief period of experimentation with virtually nonobjective compositions and then a return to minimally recognizable imagery. *Landscape, Abstraction* (cat. 4), for example, includes identifiable elements; yet in such works of 1915–16 the subject could be in Europe, America, almost anywhere where trees flourish and people erect buildings with gabled roofs. The depicted objects do not clearly manifest a national or local tradition.

Beginning with the barn series of 1917, Sheeler added specificity to his representations. Almost all the drawings subtly reveal the identity of the buildings as not only American but also as Pennsylvanian. For example, in *Barns* (cat. 35) the variegated strokes on the building's gable end evoke the fieldstone material characteristic of these regional barns. A cantilevered forebay appears prominently at the bottom right, a unique feature of these buildings, and the smaller outbuildings cluster around the larger structure in a way typical of Bucks County farmsteads.

The barns are still partially abstract, however. Most of the conté crayon drawings from 1917, such as *Barn* (cat. 32), float on the white paper with little indication of an environment. In the larger works of 1918, the artist similarly removes the barns from context; only one image, *Bucks County Barn* (cat. 39), extensively indicates sky and ground. All of the drawings lack human presence, even more acutely than in the corresponding photographs. No farm animals, tools, or crops appear. However, unlike the photographs, none of them conveys a sense of the buildings' obsolescence or decay.

The increased specificity of Sheeler's presentations therefore coexists with continued formal experimentation. For example, volume and three-dimensional space at first seem consistent in *Barns* (cat. 35), but on closer viewing, certain ambiguities emerge. In the main barn, Sheeler combines a fully frontal gable with side walls that recede in two opposite directions. The barn's eaves veer downward to the left and do not parallel those on the right. The building's shadow tilts inconsistently to the left, and the lack of a ridgepole on the roof defies the rules of realistic representation. The fence rail extending from the shed to the post falls short of its implied destination, and overall, the work displays a conscious disregard for polish and completeness. Areas are smudged, lines overextend their boundaries, false starts and subsequent erasures remain visible. The spatial inconsistencies and emphasis on drawing as a process rather than a finished product underscore Sheeler's evolving engagement with vanguard aesthetic issues in the barn series.

Barn Abstraction, 1917 (fig. 4; see cat. 36), best represents the experimentalism of the series. It shows the banked side of a Bucks County barn. The main building stands to the right, with an opaque void suggesting open doors at the center of the facade. Two perpendicular lines sketchily indicate the roof, but to the right, the structure disappears. A shadow falls under the eaves, one of the few conventions employed to indicate volume. Attenuated, overlapping, and interpenetrating forms to the left of the barn represent outbuildings. They adumbrate a low shed with

three asymmetrically placed windows, a long ell, and the roofs of two other buildings in the background. A mysterious dark rectangle and shaded triangle float inside the ell. Do they indicate that the ell is transparent, showing another building behind? Or does Sheeler's drawing present multiple structures occupying the same space simultaneously?

Flatness clearly predominates in this composition. Lines lie parallel or perpendicular to each other, denoting forms that are sketchy, incomplete, and seemingly provisional. The work is in fact the most abstract of the drawings, analogous to the contemporaneous photograph *Side of a White Barn* (cat. 27).

John Driscoll, a scholar of Sheeler's work, identifies this drawing as the "classic expression" of the Bucks County barn series:

Sheeler worked through a series of drawings … in 1917 and 1918, and arrived at the classic expression of it in Barn Abstraction.… *With a few simple lines, a massive "black hole," and some elementary shading he has given a bare bones analysis of what can clearly be seen as a "universal" barn form.*[32]

But *Barn Abstraction* did not culminate Sheeler's experimentation with the subject. The many barns that followed it (with the possible exception of *Barn Abstraction*, 1918 [fig. 5]) all move toward greater realism. Because of its extreme minimalism, authors like Driscoll have identified it as the

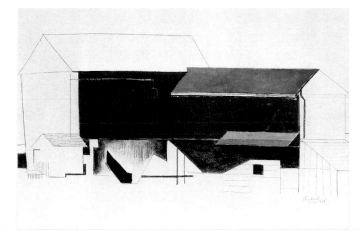

most significant of Sheeler's barns, but in fact, its relative lack of local specificity makes it the least characteristic of the series.

Barn Abstraction's starkly modernist composition also won the approval of Sheeler's patrons, such as Walter Arensberg and Constance Rourke. Despite the attention the work attracted, the artist nevertheless turned away from such pictorial experiments in his paintings and drawings and developed a more descriptive style. Various factors affected Sheeler's project during this period, and some of them discouraged working in nonrepresentational modes. During and immediately after World War I, native modernists were encouraged to emphasize the "Americanness" of their subjects and minimize their aesthetic dependency on Europe. Most likely, *Barn Abstraction* remained a singular work in Sheeler's series for this reason.

Like Robert Coady, Sheeler wanted to forge an alliance between modernist aesthetics and indigenous material previously unincorporated into the fine arts. By depicting a recognizable Bucks County farmhouse or barn, he simultaneously created an alternative to European-derived subjects and negated the dominant values of the artistic establishment in America. Indeed, Sheeler's depictions of Bucks County architecture highlight the nonacademic aspects of the structures—the rough handcrafted timbers, the irregular woodwork, the earthy material, the disregard for symmetry. These features contrast dramatically with the elite architecture of the Gilded Age and the early twentieth century—the grandiose mansions and public buildings based on Renaissance palaces and Roman temples. To Sheeler, rural Bucks County farm buildings must have seemed more authentically American than European-inspired Beaux-Arts architecture.[33]

Sheeler's appropriation of this material still followed the model of Europe, however. Modernists abroad did not depict Bucks County barns, of course, but they frequently looked to similar sources outside the high art tradition to inspire and reinforce their stylistic innovations. A diverse body of folk, popular, and non-Western artifacts—including Japanese, Peruvian, Polynesian, and African—served as "primitive" alternatives to bourgeois turn-of-the-century taste.[34] Modernist painters and sculptors viewed many dis-

parate traditions almost as one phenomenon. Their aesthetic qualities seemed to transcend historical circumstances and specific contexts. As Meyer Schapiro observes, "The art of the whole world was now available on a single unhistorical and universal plane as a panorama of the formalizing energies of man."[35]

Rourke recounts that Sheeler's awareness of European modernism fostered his appreciation of such "primitive" artifacts:

Medieval in their nearer origins, the tracings, scratchings, and cuttings, or the designs in slip of the [Pennsylvania German] ceramics, showed patterns that seemed akin to some of those he had been seeing in Paris. Matisse, going back to primary Asiatic sources, had restated designs not widely removed from those of this homely provincial art.[36]

This assessment of Pennsylvania German ceramics as equivalent to Matisse's Asiatic sources well illustrates Schapiro's observation about the ahistorical and universalizing tendencies in the modernist appropriation of noncanonical sources.

As in Europe, American modernists often used aesthetic material outside the fine art tradition to buttress their departures from academic norms. For example, when Marius de Zayas opened the Modern Gallery in New York in 1915, his press release declared: "To the products of modernity we shall add the work of such primitive races as the Mexican Indians and African Negroes because we wish to illustrate the relationship between these things and the art of today."[37] But in America, modernist appropriations often sought to assert a specific national lineage. Feeling their tenuous position in this country, the American vanguard not only needed to establish itself as modernist per se but was also compelled to construct a native heritage to validate its pictorial innovations.

Sheeler's series of Bucks County barns specifically addressed the artist's national and regional identity, unlike Picasso's collection of tribal sculpture or Matisse's admiration for Persian drawings. Furthermore, Sheeler turned to local resources for new ideas about how to represent his subjects. The American folk art tradition especially captured his imagination.

THE FOLK ART LINEAGE

Art historian Daniel Robbins describes how American folk art became a symbolic progenitor of modernism in this country:

The discovery of African and Oceanic art by Picasso and Matisse was followed a little later by the discovery of American folk painting and sculpture.... For a time these several modes of art (primitive, folk, modern) appeared to be related in a fundamental way....[38]

In this era, the category of American folk art encompassed almost any aesthetic object that seemed to correspond formally and symbolically to the kinds of "primitive" material prized by the European vanguard.[39] Yet many claimed it was uniquely American at the same time.[40] This contradiction did not lessen its importance to American modernists like Sheeler in search of a national heritage.

Bucks County provided abundant opportunities for Sheeler to study folk art. Henry Mercer owned a huge collection of Pennsylvania German stove plates, illuminated manuscripts, and ceramics. Folk paintings in oil interested Mercer less, but one local artist, Edward Hicks, captured his attention. Hicks—a Quaker preacher, sign painter, and artist of religious subjects—was, like Mercer, a native of Bucks County. Hicks gave several paintings to Mercer's great-grandfather Abraham Chapman, and Mercer eventually inherited these works. He became the first collector of Hicks's work and also encouraged scholarly study of the artist.[41]

The possibility exists that Mercer introduced Sheeler to Hicks's paintings. The kind of folk art that Hicks produced in fact displays stylistic features that interestingly relate to Sheeler's Bucks County barn series.[42] *The Cornell Farm*, 1848 (cat. 40), for example, adopts a nonacademic, bird's-eye view of the farmstead, with livestock in the foreground, sloping pastures, and distant fields. In the background to the left is the farmhouse and its dependencies; to the right stands a typical Pennsylvania barn. The buildings' most significant facades appear frontally. An academically trained artist would depict the adjacent facades as receding

Fig. 6

Living Room of New York Apartment of Walter and Louise Arensberg (Southeast Corner)
c. 1918
Gelatin silver print
Collection Whitney Museum of American Art
Gift of James Maroney and Suzanne Fredericks (80.30.1)

crops, animals, and buildings. Sheeler's drawings, in contrast, depict only an inanimate fragment of rural farm life. Human associations are veiled or absent. Despite the possible inspiration of folk painting, Sheeler's barn imagery remains essentially modernist in divorcing the subject from its original context.

Nevertheless, Sheeler clearly admired folk art. He owned several folk paintings and once photographed *Whittier's Home*, a work by an anonymous folk artist.[43] In addition, some of his still lifes display an awareness of typical folk motifs. Driscoll links Sheeler's early flower paintings, such as *Three White Tulips*, 1912 (cat. 42), to the ornamentation on an eighteenth-century Pennsylvania German dower chest once in the artist's own collection (cat. 43).[44] Such motifs also appear in many later paintings, notably *Red Tulips* of 1925 (cat. 44). At the time of Sheeler's memorial exhibition at the Downtown Gallery in 1966, which included both his own work and the folk art he collected, a *New York Times* critic noted a correlation.[45]

Many of Sheeler's colleagues during the 1910s and 1920s shared his interest in folk artifacts. Among the earliest students of American folk painting and sculpture were New York artists such as Hamilton Easter Field and Robert Laurent who summered in Ogunquit, Maine.[46] Sheeler undoubtedly knew of the Ogunquit artists' interest because in 1918, members of this group mounted a display of American folk art in New York, probably the first inspired by modernist values.[47] At the same time, Pennsylvania artists began to investigate the Bucks County folk tradition. An artist in New Hope persuaded the self-taught painter Joseph Pickett to submit a work to the Pennsylvania Academy annual exhibition in 1918.[48] Two decades later, artists and critics in West Chester, Pennsylvania, similarly encouraged the African-American folk painter Horace Pippin to gain official recognition.[49]

The Whitney Studio Club also vigorously promoted folk art as a complement to American modernism. Juliana Force, assistant to Gertrude Vanderbilt Whitney, became Sheeler's patron in 1923 when the artist and his wife, Katharine, moved into an apartment above the Club on 10 West Eighth Street.[50] Force was a native of Doylestown and had bought an eighteenth-century farmstead in neighboring

in space through the consistent alignment of orthogonals oriented toward a single vanishing point. But in Hicks's work, all facets of the buildings tend to lie flat on the picture plane. To a modernist like Sheeler, this method of representing architecture must have seemed not only refreshingly free of academic conventions but also instinctively (if ahistorically) cubist in the multiple viewpoints and spatial ambiguities.

The folk art method of pictorial construction might well have served to inspire or reinforce the spatial incongruities in Sheeler's series of drawings. In *Bucks County Barn* (cat. 38), for example, his presentation makes the monumental architecture almost toylike, similar to a child's building blocks stacked up at oblique angles. Here, too, as in *The Cornell Farm*, the buildings' facades seem to be flat and receding at the same time. In Sheeler's drawings of Bucks County barns, the purposely nonacademic style harmonizes with the subject's vernacular associations.

Profound differences exist between Sheeler's and Hicks's presentations of Bucks County architecture, however. They worked in completely different artistic contexts, and the meaning of their pictures diverges as well. Hicks portrays an idealized vision that includes human participants. As is evident in the pictures of farmers and their properties included in nineteenth-century Bucks County almanacs (cat. 41), the Cornell family appears as proud owners of their land,

Holicong in 1914.[51] Like Sheeler's other patrons the Arensbergs—who furnished their New York apartment with regional country furniture (fig. 6)—Force filled Barley Sheaf Farm with Americana, especially folk art and Shaker furniture—most of it purchased from original owners during forays into the countryside (cat. 45). The artists in Force's circle frequently visited her Bucks County retreat. Sheeler came often in the 1920s, and a legend arose that he once used the barn on her property as the subject of a painting.[52]

In 1924, the Club staged the most ambitious display of American folk art to that date.[53] New York painter Henry Schnakenberg selected and arranged the show, and many lenders to the exhibition were artists as well, including Robert Locher, Yasuo Kuniyoshi, Dorothy Varian, Alexander Brook, Katherine Schmidt, and Charles Demuth. Sheeler lent three works from his own collection, *The Temple of Egina* by H. M. Ware, a watercolor entitled *'Twas Ever Thus,* and *Portrait of a Woman*, which was illustrated in the catalogue. The exhibition included forty-five objects ranging from paintings on velvet to a cigar-store Indian.[54]

This display attracted the attention of many reviewers. Most enthused over the material, which seemed to them both intrinsically American and relevant to contemporary aesthetic values. One wrote, "The portrait of a woman loaned by Charles Sheeler with its simple directness and its absolute simplification might have been painted today."[55] Helen Appleton Read noted a formal relationship between the folk objects and the works produced by the artists who owned them:

[I]t occurred to some of our young artists that if the art fashion of the day must choose the primitive and naive, why shouldn't the American artist use his own primitives?… [It] is in a way a conscious imitation of the unconscious flowering of our ancestors' art spirit.

… A group of our younger painters believe that the Monroe Doctrine holds in art as well as in furniture and politics. They have poked about in antique shops, old saloons and chop houses and brought back quaint pictures and statues. They are now serving as decorations and inspirations in the studios of many of them. Why bother about French Gothic or

the frescos of Santa Croce when we have primitive material at hand that has the humor and tang of our native soil.…

Charles Sheeler, who is a collector of early American art and who in his own art reflects the simplicity and fineness of design inherent in it … loans two early American portraits. These are amazingly up to date and have the austerity and simplicity of a Derain or a Picasso.[56]

In this article, Read articulates a primary motive for the presentation of this material: to define an American "primitive" tradition equal to past art in Europe, which also exhibits the same aesthetic qualities as contemporary art abroad. And simultaneously (if incongruously), she asserts the uniquely indigenous character of this tradition.

The reviews of the Club exhibition establish that by 1924, American modernists had discovered in folk art an answer to Robert Coady's exhortations of 1917. American modernism claimed an independent identity through this construction of a native nonacademic lineage. But most commentators seemed unaware of a certain irony: European art remained their standard of comparison. Furthermore, one reviewer, Virgil Barker, soberly cautioned American artists against too great a reliance on folk art:

Our own day is in some respects, in its cosmopolitanism and its consequent lack of homogeneity, worse off than that earlier time; but the way of artistic salvation for us does not lie along that of antiquarianism. This needs to be affirmed just now because there is more than a hint of such a spirit among some of the younger painters of today. They have run away to the attic to play and are having a glorious masquerade.[57]

For this observer, American modernists were in danger of becoming overly dependent on their folk sources.

The basis of such criticism undoubtedly stemmed from a worry about violating an essential principle of modernist practice—the appearance of fundamental originality. Although modern art developed from a study of numerous traditions—academic, popular, and "primitive"—the most highly regarded modernists generally veiled their reliance on artistic precedents or radically transformed their models.

To be an "antiquarian" (an artist who mimics folk forms too closely) compromised one's status as a self-sufficient modernist.

American modernism's quest for a usable past therefore contained contradictory aspirations. On the one hand, Sheeler and his contemporaries wanted to create a context-specific, recognizably national tradition for their stylistic experiments, while on the other, they maintained that modernist identity was fundamentally ahistorical, transcultural, and free of stylistic debts. Rourke sums up this contradiction in reflecting on the artist's wide-ranging sources: "All these forms, from the Aztec to the Pennsylvanian had what may be called structural truth, and a singular unity.... What [Sheeler] gained from this ancient or primitive art was reinforcement for choices he had already made."[58] Avoiding charges of antiquarianism, Sheeler for the most part synthesized modernism and tradition so skillfully that the appearance of originality remained.

His haunting *Bucks County Barn* of 1923 (cat. 46) demonstrates how Sheeler both used and distanced himself from traditional models. This somber, almost elegiac work marked his return to Bucks County subjects after a lengthy hiatus following Schamberg's death in 1918.[59] It shows the banked side of a fieldstone barn with additions and outbuildings flanking its sides. The variegated stone walls, neat cedar shingled roofs, and gray sideboarding are delineated with thoroughgoing attention to detail, perhaps in homage to the earnest craftsmanship of folk art. But like the earlier drawings, the barn floats without an environmental context, and evidence of modernist formalism appears to the right of the barn door, where the complex polygonal shadow constitutes an independent abstract shape. However, unlike the earlier works, the forms here appear more resolutely volumetric, and the elegant silhouette is astonishingly precise. An aura of highly disciplined, almost classical authority pervades this drawing. Like *Staircase, Doylestown* (cat. 23), another major aesthetic achievement of the mid-1920s, this work seems more masterfully resolved than Sheeler's earlier treatments of the theme. The drawing impressively culminates the artist's early engagement with Bucks County barn imagery.

In this work, Sheeler achieved a delicate balance between aesthetic individuality and traditional associations. Produced contemporaneously with the Whitney folk art exhibition, the drawing displayed a synthesis of past and present that continued to please reviewers throughout the 1920s. In a review of the Whitney Studio Club annual member's exhibition in 1924, for example, Helen Appleton Read writes: "Charles Sheeler continues to give us in his clear, clean painting a combination of the naiveté of the American primitive and the sophistication of its modern version."[60] Another reviewer observed in 1926:

> There is subtle sensibility in his ability to sense the underlying beauty concealed in the humble object, the forbidding exterior. Abstract as this tendency seems to be, no contemporary artist has more sharply expressed the essential spirit of that type of scene and object we accept today as "early American." His earlier drawings of the barns of Bucks County, Pennsylvania, directed attention to a type of authentic American architecture that long had been neglected and which nevertheless concealed an indigenous beauty as authentic as a folksong. Sheeler's pictures of these buildings transposed the simple lines and beautifully proportioned masses of these barns into a realm of cool abstraction. No artist has done more for the neglected native scene, the very spirit of early America, than has Charles Sheeler.
>
> There seems to be an affinity between the mind of this artist and those builders and craftsmen of past centuries who created out of humble and neglected and spare materials a beauty at once expressive and enduring.[61]

"Affinity" is a key word in this passage.[62] Critics of the time posited an intangible but nevertheless identifiable relationship between Sheeler's work and the "spirit of early America." In both, they saw a preference for spare and coolly abstract forms. This relationship, because they judged it to be an almost mystical commonalty rather than mere imitation on Sheeler's part, earned the artist a leading position as interpreter of the "neglected native scene."

When Sheeler discussed American folk art in the 1930s, he played down the influence it had on his stylistic development:

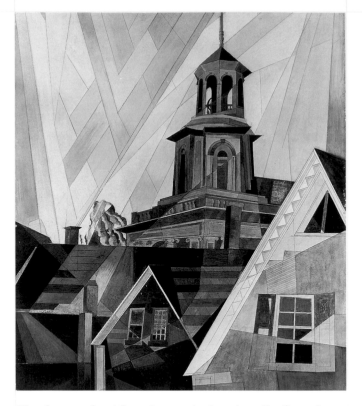

Fig. 7
Charles Demuth
After Sir Christopher Wren
1920
Tempera and pencil on
paperboard
The Metropolitan Museum
of Art, New York
The Dial Collection
(1994.433.156)
© 1997, Metropolitan Museum
of Art, New York

Simultaneously with my interest in American Crafts and Architecture has been an appreciation of our Folk Art. Not so much in the sense of being contributory to the direction of my work, but for the authentic record which it provides of the mentality and vision of the people at the time it was produced. Naiveté ... carries conviction and an accompanying interest, but may not be arbitrarily reverted to with the anticipation of a similarly resulting conviction. Aside from the innocence of vision there is frequently found a considerable sensitiveness and originality in the use of the medium employed. Characteristics common to the most satisfying expressions of any period are to be found in American Folk Art, simplicity of vision and directness of statement.[63]

Interestingly, Sheeler here comments on the value of this material for its ability to provide historical insight into "the mentality and vision of the people at the time it was produced." This contradicts Sheeler's usually stated disregard for "history or the record" in his art and his collecting activities. He further states that the folk tradition "may not be reverted to with the

anticipation of a similarly resulting conviction." By the 1930s, he felt the difficulty of replicating the authenticity of the nineteenth-century folk tradition. Characteristically, he both admired the material and kept it at arm's length.

Sheeler's statement indicates an evolving attitude toward the relationship of folk and modern art. In the late 1910s and early 1920s, a small vanguard of modern artists, critics, and gallery owners fostered appreciation of American folk art. But with the opening of the Metropolitan Museum's American Wing in 1924, a wider enthusiasm for early Americana resulted. Naturally, Sheeler's desire to protect himself from charges of antiquarianism increased as the 1920s progressed and the appreciation of folk art became a popular fad. Sheeler's stance in the 1930s was often adamant: "To revere the past for its antiquity rather than its intrinsic merit is as futile as to revere yesterday for no better reason than that it preceded today."[64]

As he became increasingly labeled a painter of the American scene, Sheeler necessarily reconceived his modernist identity. On the one hand, he felt fundamentally tied to a native tradition: "It seems to be a persistent necessity for me to feel a sense of derivation from the country in which I live and work."[65] But on the other hand, he was skeptical about defining the essential qualities of America's aesthetic traditions:

The question of an American tradition in painting could worry me quite a bit if I would let it. Obviously we are a composite of many influences, but the same thing is true to an extent even of French art. Consider our friend Picasso from across the Spanish border. We seem to derive from many sources. I suppose some variation from these sources makes something which is our own, but just how to define this.[66]

To his credit, Sheeler avoided simplistic concepts of national identity, realizing that in a profoundly hybrid country like America, visual language draws from extremely heterogeneous sources. This awareness also pervades the work of Sheeler's fellow Pennsylvanian, Charles Demuth. In Demuth's *After Sir Christopher Wren* (fig. 7)—a depiction of the eighteenth-century Trinity Lutheran Church in the

artist's native Lancaster—the title adds an unexpected dimension to what at first seems to be an exclusively American icon: the white steeple of a colonial church. By acknowledging the English derivation of a venerated local monument, Demuth, like Sheeler, qualifies the notion of a purely indigenous American tradition.

Although national identity was a pressing concern for modernists like Sheeler and Demuth in the 1910s and 1920s, their understanding of America as an amalgamation of various foreign traditions kept them from conceiving of their country in a zenophobic or rigidly exclusionary way.[67] In fact, Sheeler avoided defining "Americanness" at all. In an interview with Friedman in 1959, the artist stated that his painting was American because he used American subjects, and he would not go any further than that.[68]

Yet in his art, Sheeler repeatedly memorialized the places that gave him a sense of distinctive origins, most notably Bucks County. For him, as for his friend William Carlos Williams, regional specificity provided a workable alternative to an undefinable, general concept of "America."[69] The poet obviously spoke for himself when he wrote: "He wants to have the feet of his understanding on the ground, his ground, the ground, *the* only ground that he knows, that which *is* under his feet."[70] But Williams's assertion of native rootedness also applies to Sheeler's identification with specific locales. For Sheeler, however, this was better shown than said.

Over the years, Sheeler covered much ground in his survey of the nation. He added the Manhattan business district, Detroit factories, and Shaker villages to his repertoire of visually arresting American places. But he never forgot the lessons of the Pennsylvania countryside. He came back often to Bucks County (in his imagination if not in actuality) where he first discovered how to make modernist art from local tradition.

NOTES

1. Joseph W. Glass, *The Pennsylvania Culture Region: A View from the Barn* (Ann Arbor, Mich.: UMI Research Press, 1986), 9; Henry Glassie, review of Society of Architectural Historians session, "Vernacular Architecture," *Journal of the Society of Architectural Historians* 35 (December 1976): 294; Robert F. Ensminger, *The Pennsylvania Barn: Its Origin, Evolution, and Distribution in North America* (Baltimore: Johns Hopkins University Press, 1992): 8, 14–17, 109. Interestingly, Sheeler's series coincided with the first scholarly interest in the origins of these structures. See Marion Learned, "The German Barn in America," in *University of Pennsylvania Lectures Delivered by Members of the Faculty in the Free Public Lecture Course* (Philadelphia: University of Pennsylvania, 1915): 338–49.

2. For line drawings and photographs of typical Bucks County barns, see Glass, *Pennsylvania Culture Region*, and Ensminger, *The Pennsylvania Barn*.

3. The classic work on this topic is *The Invention of Tradition*, ed. Eric Hobsbawm and Terence Ranger (London: Cambridge University Press, 1983).

4. However, the negatives from which these photographs were printed are 1 x 5 inches. This indicates that Sheeler used a different camera for his barn subjects.

5. Millard, "Charles Sheeler," unpaged. Here the term "series" applies more loosely than with the Worthington house photographs. No evidence exists to suggest that Sheeler intended to market or exhibit the barns as a "set."

6. Stebbins and Keyes, *Charles Sheeler*, 11. I have never seen a barn photograph with a date inscribed on it.

7. Nomenclature is also a complicated aspect of Sheeler's barn images. Vintage prints of *Bucks County Barn (Vertical)* in the Whitney Museum of American Art and the Worcester Museum are inscribed in Sheeler's hand "Bucks County Barn"; the ones in the Lane Collection are inscribed "Pennsylvania Barn," except for cat. 26, which Sheeler originally titled *Buggy*. Stebbins and Keyes, *Charles Sheeler*, 12, n. 24. I have retained the traditional titles of the well-known barn images, such as *Side of a White Barn*. For the rest of the photographs, I have appended descriptive labels in parentheses for the sake of clarity in my discussion.

8. Troyen and Hirshler, *Charles Sheeler*, 8.

9. Henry McBride, "Charles Sheeler's Bucks County Barns," *Sun and New York Herald*, 22 February 1920, sec. 3, p. 7, reprinted in *The Flow of Art*, ed. Daniel Catton Rich (New York: Atheneum, 1975), 155–56.

10. Scratches in the upper portion of the frame exist in all the prints I have seen and therefore must be on the original negative.

11. Susan Fillin-Yeh speculates that this picture may have been taken in one of Mercer's storage barns. "Charles Sheeler and the Machine Age" (Ph.D. diss., City University of New York, 1981), 39. But the coats hanging from the racks suggest an environment of use rather than just storage.

12. Autobiographical notes, Sheeler Papers, AAA, Nsh 1, frame 92. Compare this passage to the more fluid version in Rourke, *Charles Sheeler*, 97–98.

13. Sheeler interview by Friedman, AAA, Tape 1, p. 14.

14. For the historical development of this idea, see Edward Robert de Zurko, *Origins of Functionalist Theory* (New York: Columbia University Press, 1957), and Larry L. Ligon, *The Concept of Function in Twentieth-Century Architectural Criticism* (Ann Arbor, Mich.: UMI Research Press, 1984).

15. Sheeler recollected that all the barns he depicted were within walking distance of the Worthington house. Sheeler interview by Friedman, AAA, Tape 2, p. 6. After extensive searching in Doylestown, I found no surviving barns that correspond to Sheeler's photographs, drawings, or paintings. Modern developments have apparently destroyed all the barns that attracted Sheeler's interest.

16. Marshall McLuhan, *Understanding Media* (New York: McGraw-Hill, 1964), vii–viii.

17. Herwin Schaefer, *Nineteenth-Century Modern: The Functional Tradition in Victorian Design* (New York: Praeger, 1970), 198.

18. Ensminger, *The Pennsylvania Barn*, 195–97.

19. Benjamin Latrobe executed one of the earliest pictorial representations of a Pennsylvania barn in 1801. Ensminger, *The Pennsylvania Barn*, xvii. But the subject is rare in nineteenth-century academic painting, although it appears in almanacs and folk art, as I discuss below.

20. One modernist predecessor was Paul Strand, who portrayed a Connecticut barn in *White Fence* (1916).

21. Reported in Rourke, *Charles Sheeler*, 68. Rourke does not identify the author of this comment.

22. Sheeler exhibited barn photographs at the Wanamaker Photography Exhibition in 1918, and at the De Zayas and Charles Daniel galleries in the early 1920s; *Side of a White Barn* and other barn images were reproduced in *Broom* 5 (October 1923) and appeared in a prestigious German architectural journal in the mid-1920s. Fiske Kimball to Charles Sheeler, 23 November 1927, Fiske Kimball Papers, Series 1 (General Correspondence), Philadelphia Museum of Art Archives.

23. From the time Sheeler first exhibited these drawings and paintings, he often gave identical titles to works dating from the same year. In addition, titles have changed over time, complicating the task of distinguishing between them. In this publication, I have retained the titles assigned by the owners of the works.

24. See *Broom* 5 (October 1923), facing p. 160. This lost work seems to be a large-scale tempera.

25. Private collection. See Santa Barbara Museum of Art, *A Selection of 19th and 20th Century American Drawings from the Collection of Hirschl & Adler Galleries* (Santa Barbara, 1981), no. 33, and Hirschl & Adler Galleries, Inc., *Realism and Abstraction: Counterpoints in American Drawing, 1900–1940* (New York, 1983), 68, no. 75.

26. Given to the artist Alexander Brook by Sheeler in the 1930s, now in the Columbus Museum of Art.

27. Private collection. The gouache and pastel work was published in *The Arts* 3 (May 1923): 338, but was subsequently scribbled over—apparently by the artist himself. It remained in the artist's collection until his death. See Sotheby, Parke, Bernet, Inc., *The Edith G. Halpert Collection of American Paintings* (New York, 1973), no. 102.

28. Coe Kerr Gallery, New York, as of 1984.

29. Rourke, *Charles Sheeler*, 66–67. Rourke gives the number of barn images as eight, but her reckoning must only include the larger works. See Lillian Dochterman, "The Stylistic Development of the Work of Charles Sheeler" (Ph.D. diss., State University of Iowa, 1963), 200, 208–12, 229, and 238.

30. Many of Sheeler's barn drawings were exhibited at the De Zayas Gallery, 16–28 February 1920. The catalogue indicates some very general and abstract titles, underscoring Sheeler's formalism of this period. But the majority of works had more specific names that identify the subjects as to their place of origin: "Bucks County Barn," "Bucks County Barn with Silo," "Upright Bucks County Barn Contrast," and "Downright Bucks County Barn." Handwritten transcription of De Zayas Gallery catalogue, 1920, courtesy Carol Troyen. Only the lithograph (cat. 36) and the two works once owned by the Arensbergs, *Barn Abstraction*, 1917, and *Barn Abstraction*, 1918, retain the early formalist titles.

31. See Lillian Dochterman, *The Quest of Charles Sheeler* (Iowa City, Iowa: State University of Iowa, 1963), 11–14, and John Driscoll, *Charles Sheeler 1883–1965, Classic Themes: Paintings, Drawings and Photographs* (New York: Terry Dintenfass Gallery, 1980), 11–15.

32. Driscoll, *Charles Sheeler*, 15.

33. Actually, these Bucks County structures were not purely indigenous in their origins. As noted earlier, they came quite directly from Europe. Nor were they as humble and unpretentious when originally built as they must have appeared to Sheeler in the early twentieth century. Pennsylvania barns, for instance, were considered quite elegant in the early nineteenth century and some even had blinds on the windows. Beatrice B. Garvan, *The Pennsylvania German Collection* (Philadelphia: Philadelphia Museum of Art, 1982), 4.

34. According to William Rubin, Western observers applied the term "primitive" to an amazingly diverse variety of traditions in the late nineteenth century, including much courtly and sophisticated art. The common denominator was that their styles all contrasted sharply with the late phases of Western realism then dominating the art establishment, but deemed inauthentic by the vanguard. After 1906–07, the term "primitive" became increasingly identified with tribal art. William Rubin, "Modernist Primitivism: An Introduction," in *Primitivism in 20th Century Art: Affinity of the Tribal and the Modern*, ed. William Rubin (New York: Museum of Modern Art, 1984), 2–3, 7.

35. Meyer Schapiro, "Nature of Abstract Art," in *Modern Art: 19th and 20th Centuries* (New York: George Braziller, 1978), 186.

36. Rourke, *Charles Sheeler*, 31.

37. Undated file, Marius de Zayas Papers, Rare Book and Manuscript Library, Columbia University Libraries, New York. Sheeler, like de Zayas, Picasso, and Braque, was also drawn to African tribal art. His series of photographs of masks has already been discussed. But his attraction to the material culture of America was more profound and long-lived, undoubtedly for the reasons discussed here.

38. Daniel Robbins, "Folk Sculpture without Folk," in *Folk Sculpture U.S.A.*, ed. Herbert W. Hemphill, Jr. (New York: Brooklyn Museum, 1976), 12.

39. Today, scholars often find the term "folk art" to be meaningless in the American context. See Kenneth Ames, "The Paradox of Folk Art," in *Beyond Necessity: Art in the Folk Tradition* (Winterthur, Dela.: Winterthur Museum, 1977), 13. Having found no adequate substitute, I use the term here in the sense that it was understood in the early twentieth century.

40. David Park Curry describes how, since the 1970s, folklorists have challenged the modernists' invention of folk progenitors. Those trained in material culture study tend to look at folk artifacts not as precursors of modernism but as documents of individual makers: "Objects once automatically admired for their impersonal, abstract qualities are now seen as palimpsests that might lead us straight to the artists who made them." "Rose-Colored Glasses: Looking for 'Good Design' in

American Folk Art," in *An American Sampler: Folk Art from the Shelburne Museum* (Washington, D.C.: National Gallery of Art, 1987), 26.

41. Eleanore Price Mather and Dorothy Canning Miller, *Edward Hicks: His Peaceable Kingdom and Other Paintings* (Newark, Del.: University of Delaware Press, 1983), 60, 156–57, 178; and Henry D. Paxson, Jr., "Edward Hicks and His Paintings," *Bucks County Historical Society Papers* 6 (1930): 1–5.

42. Alan Trachtenberg first suggested this possibility to me.

43. Reproduced in Troyen and Hirshler, *Charles Sheeler*, 13.

44. John Driscoll, "Charles Sheeler's Early Work: Five Rediscovered Paintings," *The Art Bulletin* 62 (March 1980): 130. Also, the Barber Collection of Pennsylvania German ceramics went on view at the Pennsylvania Museum during the first year that the artist studied at the School of Industrial Art, the museum's teaching institution.

45. Hilton Kramer, exhibition review, *New York Times*, 7 May 1966, p. 27, in Downtown Gallery Papers, AAA, Roll 1843, frame 44.

46. For a detailed account, see Beatrix T. Rumford, "Uncommon Art of the Common People: A Review of Trends in the Collecting and Exhibiting of American Folk Art," in *Perspectives on American Folk Art*, ed. Ian M. G. Quimby and Scott Swank (New York: W.W. Norton, 1980), 13–53. This history was first assembled in Wanda Corn's M.A. thesis, "Return of the Native: The Development of Interest in American Primitive Painting" (New York University, 1965). My thanks to her for allowing me to read this unpublished paper.

47. This exhibition was staged by the Penguin Club, New York, which was in existence from 1916 to about 1919. Its moving spirit was Walt Kuhn, and its members also included John Quinn, Wood Gaylor, Jules Pascin, Louis Bouché, Albert Gleizes, Elie Nadelman, Abraham Walkowitz, Max Weber, and William Zorach. Yasuo Kuniyoshi[?], unsigned typescript, Kuniyoshi Papers, AAA, Roll N670, frame 20,

48. The painting, probably *Manchester Valley*, was rejected but received three votes from Robert Henri, William Lathrop, and Robert Spencer. Holger Cahill, *American Folk Art: The Art of the Common Man in America, 1750–1900* (New York: Museum of Modern Art, 1932), 33. In subsequent years, Pickett was often cast in the role of the American equivalent of Henri Rousseau. See Holger Cahill, *American Primitives: An Exhibit of the Paintings of Nineteenth-Century Folk Artists* (Newark, N.J.: Newark Museum, 1930), 64.

49. Judith E. Stein, "An American Original," in *I Tell My Heart: The Art of Horace Pippin* (Philadelphia: Pennsylvania Academy of the Fine Arts, 1993), 5 ff.

50. Avis Berman, *Rebels on Eighth Street: Juliana Force and the Whitney Museum of American Art* (New York: Atheneum, 1990), 198–201; Troyen and Hirshler, *Charles Sheeler*, 14. Beginning in 1927, Sheeler rented a house in South Salem, New York, apparently with the help of Peggy Bacon and Alexander Brook, two artists closely associated with the Club. The cottage was on the property of Bacon's mother, a well-to-do collector of Americana. Alexander Brook to Mrs. C. R. Bacon, undated, Peggy Bacon Papers, AAA, Roll 895, frame 309. Sheeler gave Brook at least two drawings of Bucks County subjects, one in the Pisano/Baker Collection and the other at the Columbus Museum of Art.

51. Although Force reestablished a home in the region at the same time as Sheeler set up residence there, no evidence exists of their acquaintance until about 1920, when they probably met in New York. But as with Sheeler's first encounter with Mercer, when the two did meet, they most likely shared an immediate rapport because of their common love of Bucks County traditions. See Berman, *Rebels on Eighth Street*, 106–07, 145–48.

52. This story, according to Lloyd Goodrich, originated with Force herself. But I have failed to find a convincing correspondence between any of Sheeler's Bucks County barns and the buildings at Barley Sheaf Farm. Information contained in the above two paragraphs was generously provided to me by Carl Rieser, Force's nephew; Avis Berman; and Don Mills, subsequent owner of the Barley Sheaf Farm, in interviews I conducted in March and April 1984. See also Berman, *Rebels on Eighth Street*, 198–99.

53. See Virgil Barker, "Notes on Exhibitions," *The Arts* 5 (March 1924): 161–65.

54. Whitney Studio Club, *Early American Art* (New York, 1924), unpaged. Sheeler also took the photographs of the works of art reproduced in the catalogue, including the previously mentioned *Whittier's Home*.

55. Margaret Breuning, "Early American Art Makes an Interesting Exhibition," *Evening Post*, 16 February 1924, in H. E. Schnakenberg Papers, AAA, Roll 851, frame 928.

56. Helen Appleton Read, "Introducing the Cigar Store Indian into Art," *Brooklyn Daily Eagle*, 17 February 1924, in ibid., frame 926.

57. Barker, "Notes on Exhibitions," 161.

58. Rourke, *Charles Sheeler*, 87–88.

59. See Troyen and Hirshler, *Charles Sheeler*, 98. Other Bucks County subjects followed; they are landscapes showing groups of buildings from a distance. These include *Bucks County Barns*, 1924 (Munson-Williams-Proctor Institute), and two works in the Philadelphia Museum of Art, *Pennsylvania Landscape*, 1925, and *Landscape*, 1925.

60. Helen Appleton Read, "Annual Exhibition of Whitney Studio Club," *Brooklyn Daily Eagle*, 11 May 1924, sec. b, p. 2, in archival file, "Whitney Studio Club and American Art, 1900–1932," Library, Whitney Museum of American Art, New York.

61. Robert Allerton Parker, "The Classical Vision of Charles Sheeler," *International Studio* 84 (May 1926): 71.

62. An interesting parallel exists in the use of this term during the 1920s with a concept vital to "Primitivism in 20th Century Art: Affinity of the Tribal and the Modern" at the Museum of Modern Art in 1984. The organizers of that exhibition also took pains to distinguish modernist innovators from mere "imitators" of tribal art.

63. Autobiographical notes, Sheeler Papers, AAA, Nsh 1, frames 122–23. Compare Rourke, *Charles Sheeler*, 183–84.

64. Autobiographical notes, Sheeler Papers, AAA, Roll 1811, frame 873.

65. Quoted in Rourke, *Charles Sheeler*, 130.

66. Ibid., 182.

67. Compare Baigell, "American Art and National Identity," 48 ff.

68. Sheeler interview by Friedman, AAA, Tape 1, p. 24.

69. Stewart, "Charles Sheeler, William Carlos Williams, and Precisionism," 103–06.

70. William Carlos Williams, *In the American Grain* (New York: New Directions Books, 1956; first published 1925), 213.

25

Bucks County Barn (Vertical)
c. 1916–17
Gelatin silver print
10 x 8 in.
The Lane Collection
Courtesy of the Museum of
Fine Arts, Boston

Sheeler's early prints of Bucks County barns resemble the Doylestown house photographs in their warm tonalities. In the 1930s and 1940s, Sheeler reprinted several images of *Bucks County Barn (Vertical)* and *Side of a White Barn* (cat. 27) from original negatives, as he had done with some photographs of the house. In these later prints, the silvery hues are cooler and crisper, and the forms look sharper and more hard-edged. Only by examining the early prints do we grasp the artist's original conception of the subject.

As Millard points out, Sheeler experimented with subtle variations in cropping his photographs by printing the image first and then varying the size of the mounts.[1] Examining various versions of *Bucks County Barn (Vertical)* reveals how the artist meticulously reevaluated the subject with each new printing, making slight adjustments in the framing to create slightly different aesthetic effects.

[1] Millard, "Charles Sheeler," unpaged, n. 78.

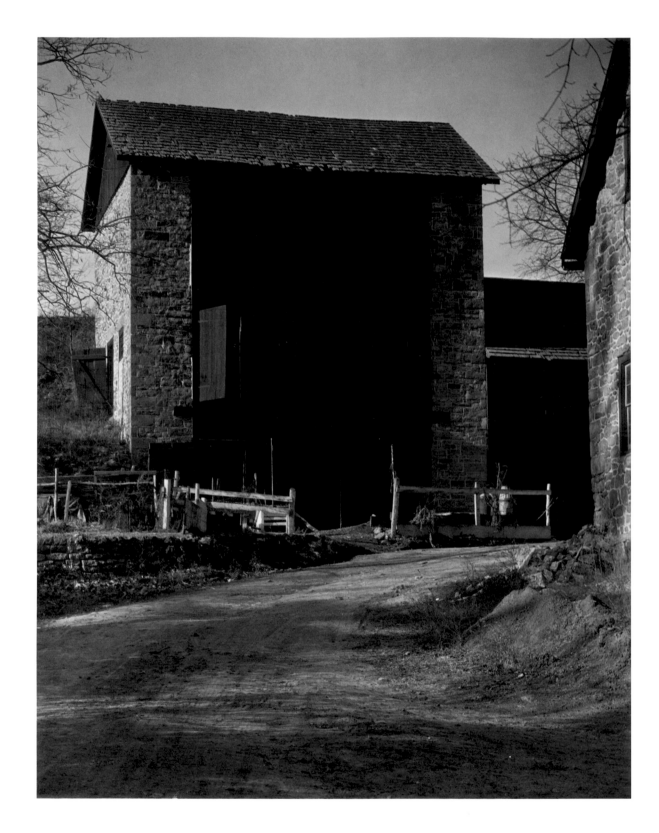

26

Buggy (Interior, Bucks County Barn)
c. 1916–17
Gelatin silver print
7 ⅜ x 9 ½ in.
The Lane Collection
Courtesy of the Museum of
Fine Arts, Boston

A comparison of this image with
*Untitled, Hay Wagon, Lake
George*, 1923 (fig. 13), by Alfred
Stieglitz demonstrates the grow-
ing interest among modernists
in the subject of rural architec-
ture and artifacts. In many ways,
Lake George inspired the older
photographer as Bucks County
had captivated Sheeler.[1] But
their works also reveal impor-
tant differences in the two asso-
ciates' sensibilities. In Stieglitz's
photograph, the overflowing hay
in the wagon and mow suggests
abundance and active use; it also
presents the architecture as
open and integrated with nature
because the rear door leads to
a light-filled space with sky and
trees. Conversely, Sheeler's work
indicates closure and suspended
activity. The backlighting created
by a photographer's lamp asserts
that art, not nature, is the point
of departure in this image.

[1] See John Szarkowski, *Alfred Stieglitz at
Lake George* (New York: Museum of
Modern Art, 1995), and Rosenblum,
"Paul Strand," 206–07.

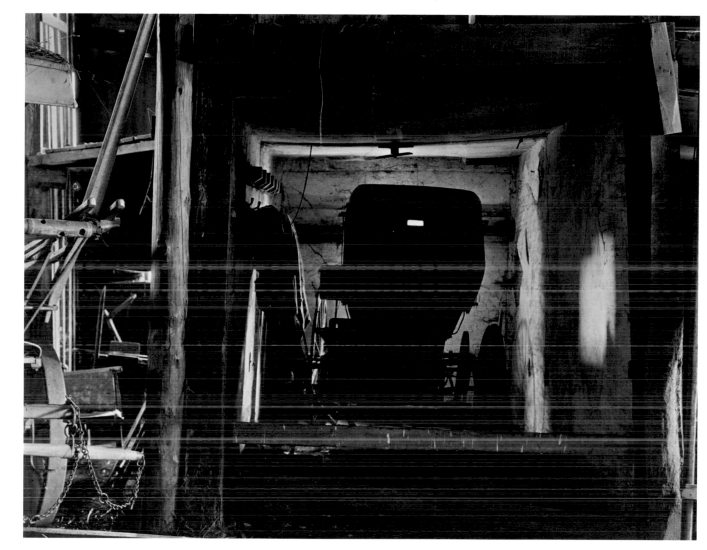

27

Side of a White Barn
c. 1916–17
Gelatin silver print
7 5/16 x 9 5/16 in.
The Lane Collection
Courtesy of the Museum of Fine Arts, Boston

Creative individuals like Sheeler engaged in an open-ended investigation of what defined modernist photography during the 1910s. But by the 1920s, a more fixed definition had emerged, with progressive critics like Henry McBride validating Sheeler's most rigorous formal experiments, such as *Side of a White Barn*. He wrote in 1923 that it "seems to me one of the most noteworthy productions in the history of photography. [Sheeler] has been enamored of barns for years ... and succeeds because of a passionate insistence on composition."[1] Sheeler no doubt reacted positively to such assessments that valued, above all, "passionate" formalism and chose the more modernist images for public display while keeping others in the series private.

In variant printings of this image, Sheeler left visible more of the shingles on the roof and the chicken to the left. He entered this photograph in the 1918 Wanamaker competition, and it won fourth prize.[2]

[1] Henry McBride, "Salons of America Now Include Art Specimens of Entire World," *New York Herald*, 27 May 1923, sec. 7, p. 7.

[2] Stebbins and Keyes, *Charles Sheeler*, 11.

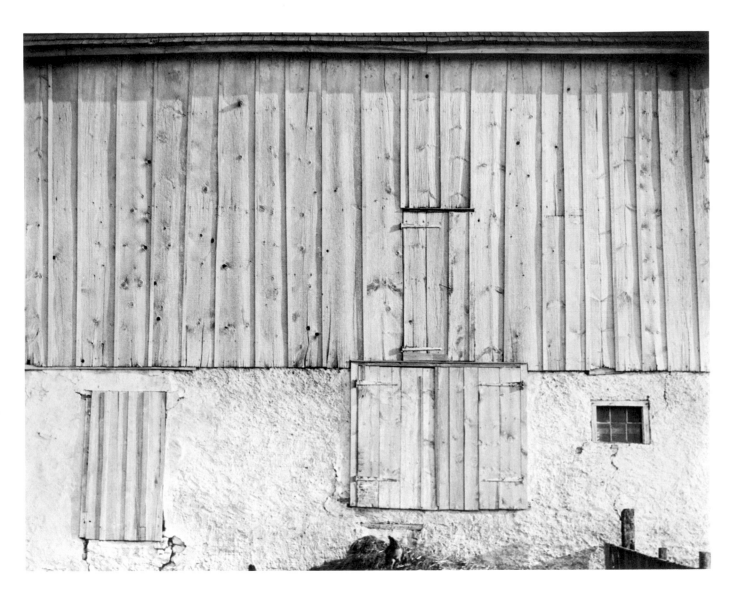

28

*Bucks County Barn
(with Chickens)*
 c. 1916–17
Gelatin silver print
8 x 10 $^{15}/_{16}$ in.
The Lane Collection
Courtesy of the Museum of
Fine Arts, Boston

Like *Bucks County Barn
(Vertical)*, *Side of a White Barn*,
and *Buggy*, this image survives
in multiple versions. But unlike
the more well-known examples
from the series, only a few prints
of *Bucks County Barn (with
Chickens)* exist, one signed in an
old exhibition mount.[1] This evi-
dence suggests that Sheeler mar-
keted or exhibited the image to a
limited extent in his early career,
but most likely infrequently.

Sheeler carefully distin-
guished between what he called
his "pictorial photographs" and
his regularly commissioned
work of documenting art for
collectors. He wrote to the
collector John Quinn in 1920,
explaining that the former were
"allied to my paintings and
drawings in their intention (and
the small number that I select
to show)." In that year, he priced
his "pictorials" at twenty-five
dollars, whereas he charged
seven dollars for a commissioned
photograph.[2]

[1] Information courtesy of Howard Read,
Robert Miller Gallery, New York. See also
Christie's East, *19th and 20th Century Pho-
tographs* (New York, 16 May 1980), and
Lita Solis-Cohen, "Old Photographs
Pack 'Em in at Three Auctions, with
Unclear Results," *Philadelphia Inquirer*,
22 June 1980, sec. k, p. 13.

[2] Charles Sheeler to John Quinn, 13
February and 14 September 1920, John
Quinn Papers, Rare Books and Manu-
scripts Division, New York Public
Library.

29

Bucks County Barn (with Wall)
c. 1916–17
Gelatin silver print
7 ¼ x 8 ⅜ in.
The Lane Collection
Courtesy of the Museum of
Fine Arts, Boston

This photograph, along with
Bucks County Barn (with Tree)
and *Bucks County Barn (with
Gable)*, were not found mounted
in Sheeler's estate. Therefore,
the artist may not have exhibited
any of them during his lifetime.
Nevertheless, this image served
as an important model for work
in other media (see cat. 39).

30

Bucks County Barn (with Tree)
c. 1916–17
Gelatin silver print
7 ⁷⁄₁₆ x 9 ⁵⁄₈ in.
The Lane Collection
Courtesy of the Museum of
Fine Arts, Boston

Bucks County Barn (with Tree) is the most humble and derelict of Sheeler's barns; this view of the banked side of the building gives no indication of the monumental space contained within. The various rough textures on the barn and fences may have attracted the artist's attention. He explored such features at closer range in *Side of a White Barn* (cat. 27).

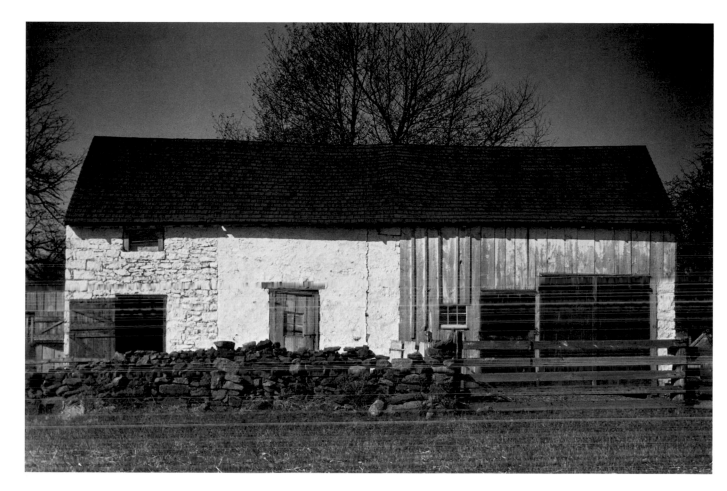

31

Bucks County Barn (with Gable)
c. 1916–17
Gelatin silver print
7 x 9 in.
The Lane Collection
Courtesy of the Museum of Fine
Arts, Boston

A classic Pennsylvania barn with
a sloping, asymmetrical profile
stands behind the foreground
ell and pent roof shed extending
perpendicularly from the main
structure. Complex geometric
relationships and contrasting
textures characterize this amal-
gamation of wooden and stone
fences, outbuildings, and central
barn. The view emphasizes the
marvelous intricacy of the inter-
penetrating shapes while reveal-
ing little about how these forms
actually function.

32

Barn
1917
Conté crayon on paper
4 ½ x 6 in.
Private Collection, New York

Sheeler's earliest barn drawings are surprisingly diminutive, given his subjects' massive proportions. Nevertheless, these tiny works well convey the interesting geometries and textures characteristic of Bucks County barns.

This work and cat. 33 are views of the same building but from two different angles. Possibly Sheeler drew these images on the site, but most likely he used *Bucks County Barn (with Gable)* (cat. 31) and another lost photograph as models for these drawings. Sheeler's attitude toward his photographic sources for the Bucks County barn drawings is difficult to ascertain. He occasionally destroyed photographs after completing works based on them,[1] but not consistently.

[1] Stebbins and Keyes, *Charles Sheeler*, 9, n. 10.

33

Barn
1917
Conté crayon on paper
4 ½ x 6 in.
The Museum of Modern Art, New York
Anonymous gift (212.40)
© 1997, The Museum of Modern Art, New York

Comparing this work with *Barn* (cat. 32) reveals that Sheeler viewed the building as a vehicle to experiment with formal elements, especially relative flatness and volume. At first glance, the MoMA version seems more abstract, yet surprisingly, it clearly indicates the barn's Pennsylvanian origins to the left of the ell in the cantilevered forebay and the dark stalls below it.

This drawing, once owned by Arthur B. Davies (organizer of the Armory Show), was subsequently purchased by Abby Aldrich Rockefeller, one of Sheeler's (and MoMA's) most important patrons. Alfred H. Barr, MoMA's first director, recognized that both patron and artist were united in their shared enthusiasm for American folk art and other vernacular traditions.[1]

[1] Alfred H. Barr to Mrs. John D. Rockefeller, 26 February 1947. *Barn*, 212.40, Object File, Museum of Modern Art, New York.

34

Barns (Fence in Foreground)
1917
Conté crayon on paper
5 ½ x 9 in.
The Albright-Knox Art
Gallery, Buffalo
Gift of A. Conger Goodyear
(54:1:22)

Since this work has no known photographic analogue, we might assume that the artist quickly rendered it in a small sketchbook at the site. But the careful creation of spatial ambiguities and the deliberate application of crayon strokes belie the idea of a spontaneous sketch executed *en plein air*. Still roving the Bucks County countryside for inspiring views, Sheeler by this date had completely abandoned Chase's impressionistic methods.

This work, done early in 1917, appeared in the Society of Independent Artists exhibition in April of that year. Purchased by John Quinn, an adventurous Irish-American collector who also owned Matisse's *Blue Nude* and Brancusi's *Mademoiselle Pogany*, the drawing later appealed to A. Conger Goodyear. He bought the work in 1926 from the Quinn estate, and ultimately gave it to the Albright-Knox Art Gallery.[1]

[1] See Quinn Collection, *John Quinn 1870–1925: Collection of Paintings, Watercolors, Drawings & Sculpture* (Huntington, N.Y.: Pidgeon Hill Press, 1926), 180.

35

Barns
1917
Conté crayon on paper
6 x 9 in.
The Albright-Knox Art
Gallery, Buffalo
Gift of A. Conger Goodyear to
the Room of Contemporary Art
(RCA 40:3j)

Another work once owned by
Quinn and given to the Albright-
Knox by Goodyear, this drawing
depicts the same building seen
in cat. 38.

36

Barn Abstraction
1918
Lithograph
19 ¾ x 25 ½ in.
The Lane Collection
Courtesy of the Museum of
Fine Arts, Boston

Shortly after Sheeler completed
the 1917 drawing *Barn
Abstraction* (fig. 4), Walter and
Louise Arensberg purchased it,
displaying it prominently among
their African art, American
country furniture, and works
by prominent European mod-
ernists. A photograph taken by
Sheeler of the Arensbergs' New
York apartment shows *Barn
Abstraction* hanging near works
by Picasso and Duchamp's
Nude Descending a Staircase.[1]

 In the following year, Sheeler
produced this lithograph based
on the earlier drawing. Constance
Rourke may have owned a print;
she singled out *Barn Abstraction*
as Sheeler's most outstanding
treatment of the subject.[2]

[1] See illustration in Patterson Sims, *Charles
Sheeler* (New York: Whitney Museum of
American Art, 1980), 13.

[2] Rourke to Sheeler, 21 January 193[8],
Sheeler Papers, AAA, Roll 1811, frame 167.

37

Bucks County Barn
1918
Gouache and conté crayon
on paper
15 x 21 ¼ in.
Collection of Mr. and Mrs.
Bernard Schwartz, New York

Similar in composition to *Barn
Abstraction* of 1917 (fig. 4), this
arresting drawing elaborates on
the earlier conception with the
addition of subtly colored scum-
bled paint. The artist openly
reveals the progressive evolution
of the work, leaving clear evi-
dence of omissions, erasures,
and modified boundaries. The
work belonged for many years
to Sheeler's onetime friend and
associate, Paul Strand.

38

Bucks County Barn
1918
Gouache and conté crayon on
paper
16 ⅛ x 22 ⅛ in.
Columbus Museum of Art
Gift of Ferdinand Howald, 1931
(31.101)

This handsome drawing relates
to a smaller conté crayon work
(cat. 35) produced in the previous
year. Both depict the same barn
complex, and in each, Sheeler
creates tensions between two-
and three-dimensional space
while exploring different formal
means for representing contrast-
ing textures. Yet the earlier work
is more naturalistic, with receding
orthogonals in the foreground
and greater volume in the struc-
tures. In the later drawing, the
foreground disappears and the
attenuated buildings are stretched
out and flattened as if pinned to
the right and left margins. Bright
color patches lend density to
the representation, but the barn
becomes extremely insubstantial
as it transforms into mere skeletal
rectangles to the right. Interest-
ingly, the artist's signature
appears at bottom right where
the subject is only barely
sketched in. This signals the
drawing's evolution from a
stark, abstract grid to a more
mimetic representation.

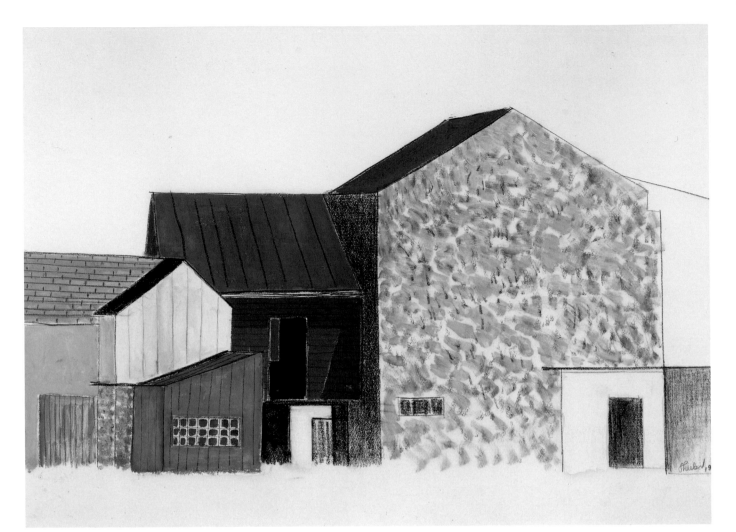

39

Bucks County Barn
1918
Opaque watercolor and
black chalk on paper
10 ¼ x 13 ¾ in.
Philadelphia Museum of Art
A. E. Gallatin Collection
(52-61-119)

This drawing displays Sheeler's
frequently overlooked talent as a
colorist. The intensely blue sky
makes an effective backdrop to
the varied pinks, buffs, and reds
on the building. Compared to
the analogous photograph (cat.
29), this work brings the viewer
closer to the structures. Here
Sheeler selectively eliminates
details, flattens the forms, solidi-
fies the shadows, and almost
whimsically alters the geometric
regularity of the sideboarding on
the barn's facade. Notice how it
bends improbably to the left.

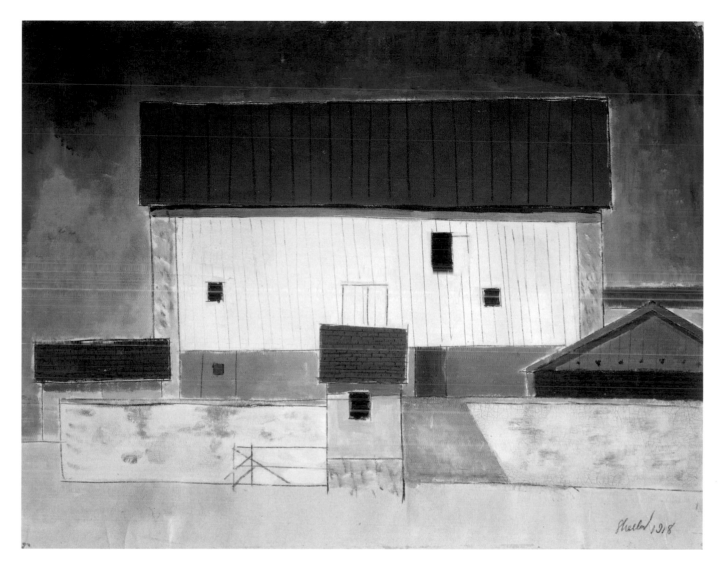

40

Edward Hicks
(American, 1780–1849)
The Cornell Farm
1848
Oil on canvas
36 ¾ x 49 in.
National Gallery of Art,
Washington, D.C.
Gift of Edgar William and
Bernice Chrysler Garbisch
(1964.23.4)
© 1997, Board of Trustees,
National Gallery of Art,
Washington, D.C.

Depictions of Bucks County farm buildings served a similar role for Hicks and Sheeler: they kept the past alive. Hicks began painting this kind of subject in the last four years of his life. *The Residence of David Twining*, 1845–46 (Abby Aldrich Rockefeller Folk Art Center), re-created a childhood memory of the farm belonging to Hicks's adopted parents. The owner of a neighboring estate commissioned *The Cornell Farm*, which not only depicts the house, barn, and outbuildings but also the prize-winning livestock of James C. Cornell. The landscape evokes an almost dreamlike harmony between nature and humankind and memorializes the world Hicks knew as a child. In fact, the painting is virtually the sole remaining evidence of Cornell's agricultural showplace; only the springhouse of the original farm remains today.[1]

[1] Eleanore Price Mather, *A Peaceable Season by Edward Hicks* (Princeton, N.J: Pyne Press, 1973), unpaged; Northampton Township Historical Study Commission, *Winds of Change: A Pictorial History of Northampton Township* (Northampton, Pa., 1985), unpaged.

41

"Sylvan Retreat, Farm & Res.
of S.T. Broadhurst"
James D. Scott
Almanach
(Doylestown, Pa., 1876)
Spruance Library
Bucks County Historical Society,
Doylestown, Pennsylvania

Almanacs such as this one attest
to Bucks County's status in
the mid-nineteenth century as
a prosperous agricultural region.
Profusely illustrated with expan-
sive bird's-eye views of impres-
sive farms, the James D. Scott
almanac shows neatly tended
lands, carefully fenced bound-
aries, healthy abundant herds,
and characteristic vernacular
architecture. Interestingly, nine-
teenth century almanac illustra-
tions resemble Hicks's vision of
the Cornell farm in both format
and the sense of idealized order
and harmony in settings. By
the time Sheeler moved there
in 1910, modernization was
rapidly eroding Bucks County's
agricultural identity.

42

Three White Tulips
1912
Oil on panel
13 ¾ x 10 ½ in.
Gift of the William H. Lane
Foundation
Courtesy of the Museum of Fine
Arts, Boston (1990.442)

Sheeler's reputation rests on
his depictions of architecture
and artifacts; therefore his
engaging flower studies have
not attracted sufficient attention.
Such subjects appeared repeat-
edly throughout his career. Dat-
ing from Sheeler's earliest years
in Doylestown, this painting
belongs to a series of works
depicting tulips. In them, he
intensively investigated varia-
tions in modernist form and
color. Yet Sheeler's long-stand-
ing interest in Pennsylvania
German traditions, well pre-
served in Bucks County, may
have determined his choice of
motif. Sheeler also explored
rural Lancaster County during
these years, where he would
have found abundant examples
of Pennsylvania German arti-
facts displaying stylized tulips.[1]

[1] Troyen and Hirshler, *Charles Sheeler*,
56, 152.

43

Christian Seltzer
(American, 1749–1831)
Dower Chest
1781
Painted poplar
22 ⁷⁄₁₆ x 51 ¾ in.
Palmer Museum of Art
The Pennsylvania State Univer-
sity, University Park (76.22)

This Pennsylvania German chest
was once owned by the artist.
Stylized, brightly colored tulips
typically appear on furniture of
this type, as well as on the Penn-
sylvania German slip-decorated
ceramics that Sheeler studied in
the Barber Collection at the
Pennsylvania Museum. The
artist also purchased such pot-
tery for his own extensive collec-
tion of American decorative arts.

By the 1930s, Sheeler had
become well known as a discrimi-
nating connoisseur of Shaker arti-
facts, and from the time of
Rourke's biography, scholars
have assumed that only spare,
unornamented vernacular
objects—objects that seemed to
anticipate the modernist precepts
"form follows function" and
"truth to materials"—appealed to
the artist's sensibilities.[1] But this
Pennsylvania German chest
demonstrates that Sheeler's tastes
were much more heterogeneous.
The chest is not simple and
spare, but elaborately ornament-
ed. Its painted surfaces do not
reflect the function of the piece;
instead, they mimic more expen-
sive and elaborately crafted cabi-
nets and architectural embellish-
ments. And the imitation graining
does not truthfully reveal the
object's materials; instead, it gives
the illusion of more expensive
wood than was actually used.

[1] Rourke, *Charles Sheeler*, 69–70.

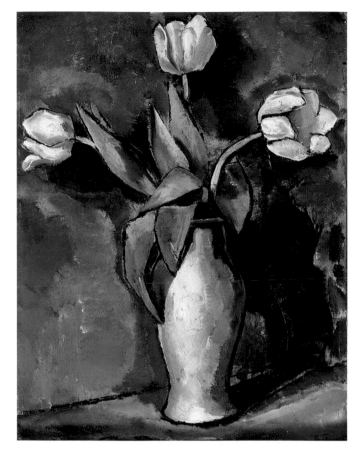

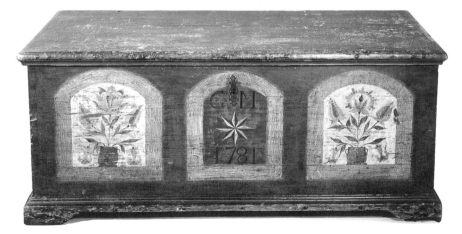

44

Red Tulips
1925
Oil on canvas
30 x 20 in.
Collection of Alexandra R.
Marshall

This elegant work shows Sheeler's stylistic development from the earlier painting *Three White Tulips* (cat. 42) toward greater clarity of form, disciplined brushwork, and concern for precise description. Yet the splayed tulips reveal the artist's continuing interest in a characteristic Pennsylvania German motif.

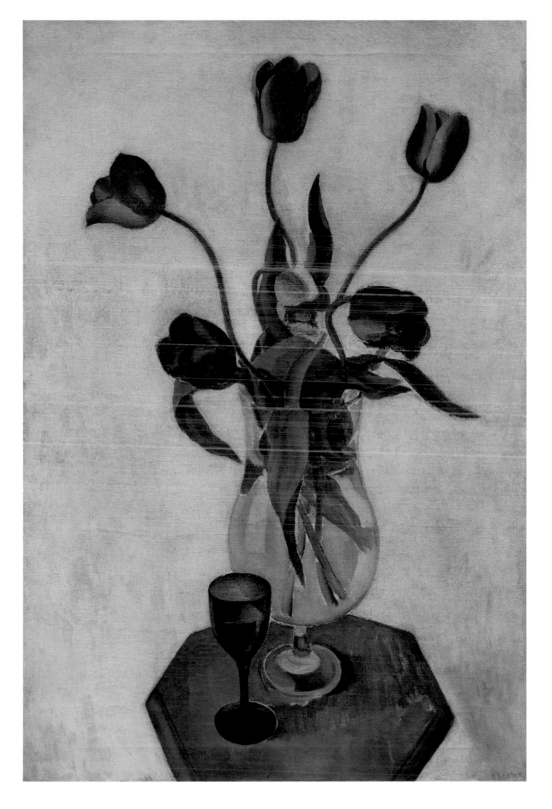

45
Unknown Photographer
Interior, Barley Sheaf Farm
c. 1920s
Gelatin silver print
7 ½ x 9 ½ in.
Collection of Carl Rieser

In this view of the entrance hall at Barley Sheaf Farm, we glimpse a portion of Juliana Force's eclectic collection of modernist art, ladder-back chairs, folk portraits, highly patterned weavings, and a painted dower chest. Unlike Sheeler's earlier patrons, the Arensbergs, Force included ornate Victoriana in her collection of American decorative arts. Notice the sentimental genre figures sculpted by John Rogers and the lavish still life painted by the German-born artist Severin Roesen, who worked in Pennsylvania during the mid-nineteenth century. Sheeler also owned some exuberantly decorated Victorian objects, in particular, pressed glass and elaborate floral-patterned quilts. These objects can be seen in photographs he took of his South Salem house during the late 1920s (now preserved in the Lane Collection).[1]

[1] See Troyen and Hirshler, *Charles Sheeler*, 23–24, figs. 19 and 20.

46

Bucks County Barn
1923
Tempera and crayon on paper
19 ½ x 25 ½ in.
Whitney Museum of
American Art, New York
Gift of Gertrude Vanderbilt
Whitney (31.468)

Juliana Force bought this large
tempera and crayon drawing
from Sheeler's one-person exhi-
bition sponsored by the Whit-
ney Studio Club in 1924. It was
acquired by the Whitney Muse-
um of American Art in 1933 and
remains one of the highlights of
its collection.[1]

[1] Berman, *Rebels on Eighth Street*, 200–01.

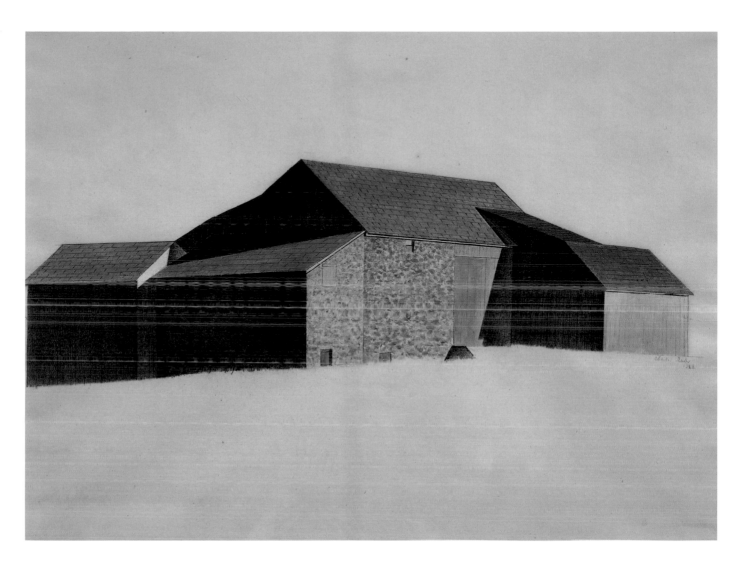

Doylestown Revisited

Throughout the 1920s, Sheeler periodically showed his work in New York, primarily at the De Zayas Gallery, the Whitney Studio Club, and the Charles Daniel Gallery. Simultaneously, he continued to support himself through commercial photography, working for *The Arts*, *Vogue*, and *Vanity Fair,* and also for advertising agencies, such as N. W. Ayer & Son in Philadelphia. But in 1931, his career decisively shifted when Sheeler began his exclusive affiliation with Edith Halpert's Downtown Gallery. The dealer so successfully promoted his work—despite the Depression's unfavorable economic conditions—that the artist could limit his commercial photography and devote more time to painting.[1] This era marked a high point in Sheeler's career. In impressive images such as *Upper Deck,* 1929 (Harvard University Art Museums), and *American Landscape,* 1930 (fig. 1), he helped define the country's Machine Age in visual terms.[2] With Halpert's help, he sold works to America's wealthiest and most powerful patrons, including Edsel Ford and Abby Aldrich Rockefeller.

At the same time, Sheeler's art remained grounded in the rural vernacular, and in his private life, he increasingly distanced himself from the urban milieu. In 1932, he and his wife moved from South Salem, New York, to Ridgefield, Connecticut, and there the artist began a fresh survey of the

Fig. 8
Interior with Stove
1932
Conté crayon on paper
Collection of Joanna T.
Steichen

region's architectural traditions. Along with new sources of inspiration from the New England countryside, Sheeler returned to his earlier Bucks County pictures for creative ideas. Sadly, the era of his greatest public triumph was also a time of intense personal loss, and the Doylestown imagery came back to him during experiences of shattering grief.

RETURN TO THE DOYLESTOWN HOUSE

Sheeler had abandoned his tenancy of the Worthington house in 1926, but he repeatedly revisited it in his art. He frequently reassessed his original series of photographs to inspire works in other media. Through this process, Sheeler internalized the subject and continually made it relevant to his artistic concerns.

In the post-Doylestown period, images of the house first recurred powerfully when Sheeler faced another imminent loss that no doubt recalled Schamberg's death. Katharine was diagnosed as having stomach cancer in the early 1930s and succumbed to the disease in June 1933.[3] This death was not a sudden one, as Schamberg's had been, but involved many months of increasingly incapacitating illness.

During the time of Katharine's protracted infirmity, Sheeler began to use the medium of conté crayon in a new and demanding way. Instead of his earlier improvisational approach to drawing, Sheeler now used a finely sharpened crayon to create an incredibly controlled and meticulously stippled surface. From 1931 to 1935, he executed at least fourteen images in this medium and represented the Worthington house in four of them, taking the Doylestown photographs as a point of departure. Far more than did his oil painting *Staircase, Doylestown* (cat. 23) of 1925, these later drawings uncannily evoke the photographs. The modestly scaled drawing *The Stove* (cat. 47), came first in 1931. In composition and size (6 ¾ x 9 ¾ inches), the work almost exactly duplicates the photograph *Stove* (cat. 16), but changes in medium and technique produce a profoundly different viewing experience. Although the black-and-white hues suggest photography as a source of inspiration, the exquisite velvety surface reveals intensive hand labor—signs of a unique, irreproducible object. In the next year, Sheeler executed two larger conté crayon works depicting the

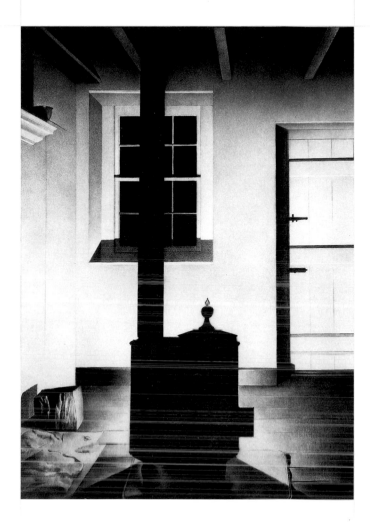

Doylestown house, *The Open Door* (cat. 49) and *Interior with Stove* (fig. 8), as well as the related image *Interior, Bucks County Barn* (cat. 48). At 28 x 21 inches, *Interior with Stove* represents a truly monumental effort, given the demands of Sheeler's technique. In 1933, the year of Katharine's death, Sheeler finished only one work, *Of Domestic Utility* (fig. 9), that portrays the left side of the hearth in the Worthington house. This area corresponds to the view seen in *Door with Scythe* (cat. 14) but is more tightly focused and shows a different array of objects.[4] Its impressive size also gives abundant evidence of painstaking artistic labor.

In composition, all the Doylestown house drawings closely resemble the earlier photographs. But in important details, the later series is vastly different. Sheeler clarified and

Fig. 9
Of Domestic Utility
1933
Conté crayon on paper
The Museum of Modern Art,
New York
Gift of Abby Aldrich
Rockefeller (147.35)
© 1997, The Museum of
Modern Art, New York

illuminated places that were dark and obscure in the corresponding photographs. The house's interior appears more pristine in the drawings than in the photographs. Rendered in conté crayon, it seems impervious to the disintegrating effects of time. In *Interior with Stove,* Sheeler smoothed over the cracked plaster, made the soiled walls pure white, and removed the faded pattern on the pan beneath the stove. In *The Open Door,* the artist excised the messy patch on the door; the woodwork looks perfectly intact—as if it had been made the day before.

In these works, Sheeler's subtle transformations of the original photographs bring time to a halt. The images float suspended in memory and imagination.[5] Another small conté crayon work, *Portrait (Katharine)* (fig. 10), reveals the motivation for the artist's desire to arrest time. Sheeler rarely included the human figure in his work; therefore this portrait

is a poignant anomaly. The drawing shows Katharine with a pained expression seated in an armchair. Executed in 1932, it relates intimately to the Doylestown house drawings. Katharine had shared the Worthington house with the artist, and during his wife's illness and death, its image apparently accompanied thoughts about her imminent absence. As her form emerges from a countless array of dots, we feel the artist attempting to stabilize and preserve the melancholy face that looks back at him.[6] The task of minute, repetitive applications of crayon may have distracted or consoled Sheeler, keeping at bay the anxiety of impending loss.

In whatever medium he employed, Sheeler was an extremely slow but diligent worker. Typically, he spent seven to eight hours a day at his easel and could take as long as nine months to complete a moderate-sized work.[7] In the portrait of Katharine, as in the Doylestown drawings, the demanding technique suggests a compensatory strategy. Assertions of permanence and stasis in the images symbolically effaced the change and decay that Sheeler's subjects inalterably suffered in life.

Sheeler deeply mourned the loss of his wife and could not work for several months immediately following her death. But although he returned to painting and drawing steadily, almost compulsively, after 1933, he produced no more images of the Worthington house for several years. This hiatus recalls the absence of Bucks County subjects from 1919 to 1923 following Schamberg's death. But in 1937 and 1938, Sheeler experienced new crises. His much-loved father died, the artist himself was hospitalized for surgery, and he began to question the essential foundations of his art. He judged his painting arid and overly intellectual, complaining to Constance Rourke that he had "been working from the head rather than the heart."[8]

During this confused and troubled time, the image of the house returned yet again. Sheeler produced another powerful oil painting, *The Upstairs* (cat. 50), in 1938, based on the photograph *Stairway with Chair* (cat. 13). In the same year, he executed a smaller version in tempera that entered Rourke's collection.[9] At the time, Rourke and the artist were working together on Sheeler's biography, and he may have given her the small version of *The Upstairs* when the book

Fig. 10
Portrait (Katharine)
1932
Conté crayon on paper
Collection of Constance B. and
Carroll L. Cartwright

was completed in 1938.[10] Letters between the two suggest that they shared more than professional concerns. According to Rourke's biographer Joan Shelley Rubin, Sheeler even proposed marriage to Rourke during this period—a proposal that she turned down.[11] This must have increased the artist's unhappiness, given his already dejected mood at the time. Their correspondence does not tell us what *The Upstairs* might have meant to Rourke and Sheeler. But once again, the Worthington house's image touched one of Sheeler's intimate and troubled relationships—this time, albeit, through the exchange of art and recollections rather than by sharing time together in the actual building.

The now unlocated tempera no doubt resembled the larger oil *The Upstairs*, which in turn closely recalls the original photograph, especially in the way a compelling shaft of light beckons the viewer into unknown regions. But again, like *Staircase, Doylestown*, *The Upstairs* also departs significantly from the photograph that inspired it. Changes in size and medium, as well as the addition of color, create a very

different mood; the alternation of strong primaries—red, yellow, and blue—enlivens the arrangement of flattened, interlocking planes. Similar to the conté crayon drawings, the painting is more timeless, without soiled walls or cracked plaster. This nocturnal, empty interior seems uncannily attractive and unsettling at the same time.

Sheeler at last found a willing bride and married Musya Metas Sokolova, a Russian-born dancer, in 1939.[12] But despite his renewed marital status, World War II was another anxious period for the artist,[13] and the house reappeared in his art in 1943. *The Artist Looks at Nature* (cat. 51) is perhaps the most thematically complex of all of Sheeler's Bucks County images. The artist sits at his easel, and with characteristic self-effacement, turns his back to the viewer. The pose derives from a photograph Sheeler took in his New York studio about 1932 (cat. 52), aided by his assistant, Maurice Brattner; an alternate version depicts Sheeler with legs uncrossed and a cigarette in his left hand (cat. 53). The painting adopts this core image but departs from the photographic self-portrait by situating the artist in a fanciful context. Sitting outdoors, Sheeler faces a landscape of walled-in lawns with an inexplicably perilous drop to the left. The painting shows Sheeler at work (as does the photograph) on the 1932 conté crayon drawing *Interior with Stove* (fig. 8), which is in turn based on the c. 1917 photograph (cat. 15). *The Artist Looks at Nature* presents us with a sense of infinite regress.

Contrary to its title, the artist is not looking at nature but at art—specifically, a fragment of his past preserved through a drawing based on an earlier photograph. Sheeler explained in late career, "I can't go out and find something to paint. Something keeps recurring in memory with an insistence increasingly vivid…. Gradually a mental image is built up which takes on a personal identity. The picture attains a mental existence that is complete…."[14] This painting visually exemplifies Sheeler's stated method. His art grows from persistent memories and previous compositions, rather than from an unmediated response to nature. And paradoxically, "Nature" in this painting is in fact quite *denatured*: carefully trimmed, bounded, and textureless. Wight wrote of this work: "The artist is close to reality, but what reality? To nature, but whose nature?"[15] The walled-in, subdivided

property surrounding the artist, painted in strident acid green, suggests a sterile suburban housing development—the kind of development in fact that "killed" the value of the Doylestown house for Sheeler. Is he therefore symbolically re-creating the circumstances that caused him to separate from a place of great attachment? By resurrecting the drawing within the hated suburban milieu, did Sheeler give himself another chance to master the situation, to use his art to mitigate change in life? If so, the easel dangerously veers toward the precipice on the left. At any moment, it could slip over the edge, and then the inhospitable environment would completely negate Sheeler's act of compensation.

The Artist Looks at Nature portrays Sheeler in a self-enclosed world, tending a garden of recurring images from the past. The work presents a lonely position from which to make art, but it also suggests that such matters are not open to individual choice. Self-referral is the only viable option because unmediated interaction with the world represents a highly unattractive—even dangerous—course of action. The artist remains earnestly, even—in an understated way—heroically, attached to the imagery on which he has come to depend. The Doylestown house remains a center of safety, countering threats of physical and psychological annihilation.

In 1946, Sheeler produced his last depiction of the Worthington house. *The Yellow Wall* (cat. 56) recalls the austere, minimal photograph *Downstairs Window* (cat. 17). But the attractive color transports this work into a different aesthetic realm, and its mood also differs fundamentally from the troubling painting of three years earlier. The composition reflects the more abstract idiom Sheeler adopted during the late 1940s. The brushwork's rough, improvised quality signals a renewed interest in process and formal experimentation. The exploratory energy of Sheeler's earliest Bucks County drawings reappears in this work, marking yet another synthesis of modernism and tradition.

The image of the Doylestown house, pristine and transported from its original context, served an important psychological and artistic purpose in Sheeler's later career. Like an irresistible fantasy, it represented a permanent haven invulnerable to death and change. In it, inanimate objects substituted for human associations. "He feels normally that

people are less permanent than their things," observes Wight. "One begins to see *things* in Sheeler as stand-ins for something more living."[16] This metamorphosis allowed Sheeler to turn misfortune into creative advantage, despite the potentially crippling losses he endured. But sometimes his compensatory efforts produced haunted, lonely images, such as *The Artist Looks at Nature*, which evokes a painful but profoundly human sense of isolation.

As a stand-in for human attachments, the Doylestown house resonated with memories of the ones Sheeler loved and no longer possessed. But his images of the house constitute a self-portrait as well. As Sheeler once commented, "Art is self-inventory, that's all there is to it."[17] But what kind of self does Sheeler's work portray? We can only partially reconstruct the Worthington house as self-representation, given our distance from Sheeler's world. Nevertheless, we can recognize that the imagery presents us with complex metaphors for selfhood that reveal fragmentation and a longing for wholeness at the same time.

REIMAGINING BUCKS COUNTY BARNS

In 1932, Sheeler rekindled his interest in the theme of Pennsylvania barns. The conté crayon drawing *Interior, Bucks County Barn* (cat. 48) dates from that year, and the earlier photograph *Buggy* (cat. 26) provided impetus for the work. Another photograph, *Bucks County Barn (with Chickens)* (cat. 28), inspired the oil painting *Bucks County Barn*—sometimes known as *White Barn*—(cat. 54), also executed in 1932. In addition, Sheeler produced a small watercolor depiction of the image,[18] and another version in the same medium, *Study after Bucks County Barn*. This work illustrates the dust jacket of Rourke's *Charles Sheeler: Artist in the American Tradition* and may have been executed especially for that purpose.[19]

In 1940, the artist fundamentally reconceived the subject that inspired *Barn Abstraction* of 1918 (fig. 5). The oil painting *Bucks County Barn* (fig. 11) continues the meticulous realism of *Bucks County Barn*, 1932, and includes previously omitted anecdotal details such as precisely rendered Holstein cows and a loaded hay wagon. Despite its apparent dependence on visual appearances, however, the picture

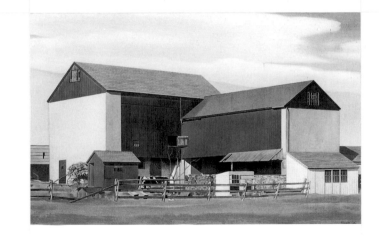

Fig. 11
Bucks County Barn
1940
Oil on canvas
The Daniel J. Terra Collection
(24.1985)

actually slyly departs from mere description. Shingles adorn the left roof but not the right. The hay wagon's sepia hue suggests artifice within the overall naturalistic color scheme. And the cows disconcertingly lack heads.

By the late the 1930s, some critics dismissed Sheeler's paintings as hyperrealistic and overly dependent on photographic sources, ignoring subtle spatial paradoxes in the margins of his compositions or in easily overlooked details.[20] There Sheeler revealed a rigorously formulated, imaginatively conceived composition beneath the surface realism. Nevertheless, such harsh criticism may have contributed to his reconsideration of abstraction as the 1940s progressed. In *Barn Abstraction* of 1946 (cat. 55), for example, Sheeler minimized recognizable details and again concentrated on formalist concerns. And in 1948, the artist painted a similarly abstract work, *Thundershower* (fig. 12), which recalls not only the photograph *Bucks County Barn (with Gable)* (cat. 31), but also the 1917 drawing *Barn* (cat. 32).

Significantly, the barns reappeared concurrently with images of the Worthington house. At times of personal crisis and aesthetic reevaluation for Sheeler, photographs of both the barns and the house stimulated renewed efforts to reengage his Bucks County experiences. He used both subjects, as in the 1910s, not only for personal reasons but also to establish new directions for his art.

As with the house imagery, Sheeler spruced up his barns considerably in later incarnations. *Bucks County Barn*, 1940, for example, has smooth, unblemished walls, perfectly regular wooden siding, and a soft, green field in the foreground. The photograph of the same building from a different angle, *Bucks County Barn (with Gable)* (cat. 31), shows cracked plaster, decrepit woodwork, and stubby, unattractive grass. When Sheeler returned to Bucks County imagery—either house or barn—he reworked the earlier photographs into more idealized presentations.

What kind of thoughts inspired this transformation of aging, disintegrating structures into pristine timeless icons? Edith Halpert once said of *Interior, Bucks County Barn*: "It really is a portrait of Ethan Frome, according to the artist's confession."[21] Associating Sheeler's work with Edith Wharton's downtrodden New England farmer at first seems inexplicable. But the artist—bereft of his best friend in youth and soon to lose his first wife in middle age—may have identified with Frome's singularly unlucky life. The drawing may have functioned as yet another surrogate self-portrait. Furthermore, the themes of denied access and abandonment link the drawing to Frome's doomed attempt to obtain love. Tragically, his effort resulted in becoming even further entrapped in a stultifying existence.

In Wharton's novel, Starkville—the setting of Frome's story—represents not merely an isolated village in the Berkshires but also a traditional agricultural way of life in decline. Despite her portrayal of Starkville's outmoded ways and ramshackle buildings, the author exhibits an understated attachment to this world. In her introduction, Wharton states that she wants to endow her creation with "that imponderable something more which causes life to circulate in it, and preserves it for a little from decay."[22] Like Sheeler, Wharton conceived of her art as achieving, if only temporarily, symbolic permanence for the people and things she loved.

For Sheeler, photography provided the iconography of memorialization. *Bucks County Barn (with Chickens)* (cat. 28) must have especially stimulated memories of time spent in Doylestown because he based several later works on it, such as *Bucks County Barn,* 1932 (cat. 54). He once remarked on this painting:

In the "White Barn" there is something to which I gave some thought when I painted it, building up a sense of permanence

Fig. 12
Thundershower
1948
Tempera on board
The Carnegie Museum of Art
Bequest of Mr. and Mrs. James
H. Beal (93.189.49)

by using contrast between elements which were mobile and static. The chickens might change their places, the barn wouldn't—that was the idea. Well these things might fool us. The barn might change and the chickens wouldn't. One might do something with ideas like that in painting.[23]

Sheeler's whimsically stated wish to substitute stasis for mobility, permanence for change, resonates with the themes of other Doylestown images. Particularly illuminating is the chickens' central role in establishing permanence. As they moved from a photographic to a painted image, these birds (like their counterparts in *Side of a White Barn*) may have suggested—in their mobility and mortality—human associations. Conceived in this way, they add a new dimension to Wight's previously quoted statement, "[Sheeler] feels normally that people are less permanent than their things."[24] To depict chickens with the idea that they will never change could—by extension—grant an ideal permanence to all living beings, including humans.

Along with the private meanings invested in these pictures, their public significance expanded as Sheeler's career progressed. When he returned to Bucks County barn imagery in the early 1930s, he no longer encountered unfavorable comments from critics about his "uninteresting" models. Since his first experiments with the subject, barns had become fully integrated into the modernist repertoire, not only for photographers, but for painters as well. Charles

Demuth drew barns during his trip to Bermuda in 1917.[25] Arthur Dove executed several charcoal drawings of barn interiors from 1917 to 1920.[26] Alfred Stieglitz photographed the barns on his property at Lake George in the early 1920s (fig. 13). Georgia O'Keeffe painted these same buildings and depicted similar barns in Canada.[27] Explicitly following Sheeler's model, Ralston Crawford regularly portrayed barns in the Chadds Ford and Exton sections of Pennsylvania during the 1930s.[28] In fact, by 1938 the subject had become so prevalent that one commentator exclaimed, "How these modernists are obsessed by barns!"[29] Another wrote in 1939, "It is no mere coincidence that so many painters have turned to the countryside, no mere sentimentality. The cubes and cones and cylinders are there, out-of-doors in the open, in a far more inspiring environment than the tedious studio arrangements which were portrayed with intellectual determination not very long ago."[30] Thoroughly aestheticized and stripped of nineteenth-century associations, the subject seemed inherently modernist to contemporary viewers. A barn, in essence, became a Cézannesque collection of cubes, cones, and cylinders. Seemingly devoid of extrapictorial meanings, it now served as the perfect model for formalist experimentation.

In 1932, Ernest Brace noted Sheeler's central role in the aesthetic reevaluation of this subject:

Any of the New England farmers whose barns have been the subject of countless canvases would certainly be ... dumbfounded to find pictures of their property hanging in art museums.... To the farmer, his barn connoted mortgages, manure piles and drudgery.... Perhaps Sheeler's training as a photographer, his gazing at objects upside down through a piece of ground glass, has purified his sense of form and design, has rid it of prejudices. At all events, he has achieved in his too infrequent canvases an individual loveliness that is now being distinguished, as are all significant achievements, by frequent imitation.[31]

According to Brace, Sheeler's way of seeing the world, which discovers "individual loveliness" in unlikely objects such as barns, derives from his photographic work, from "gazing at

objects upside down through a piece of ground glass." This technologically mediated perception results in an abstract approach to form and design, free of "prejudices." Brace realized that Sheeler's "purified" vision so removes the barns from their original context that those most concerned with the realities of rural existence cannot recognize their own lives in it—"their mortgages, manure piles and drudgery."

Of course, few farmers had the time, interest, or opportunity to see Sheeler's images of barns in the art galleries and museums that showed his work. His barns were incomprehensible to the buildings' actual users yet increasingly important to urban sophisticates who knew little of farm life. A 1949 issue of *Harper's Bazaar* provides a telling example of this transformation. In a two-page spread, backdrops inspired by Sheeler's paintings of Bucks County barns appear in Louise Dahl-Wolfe's fashion photographs (fig. 14).[32] The magazine's readers may have found haute couture in the context of rural Bucks County humorously incongruous. Or these same readers may have turned the page with complete nonchalance, given how aestheticized the subject had become by this time.

Whatever the viewers' responses may have been, these fashion illustrations demonstrate how Sheeler dramatically affected the social significance of Bucks County barns. He helped make the subject visible by depicting it as modernist art. Simultaneously, other artists employed similar motifs, and commercial imagemakers soon sensed the barns' potential glamour, using them to promote fashionable commodities. In this way, the significance of these nonelite structures gradually drifted from context to context, making unlikely juxtapositions—such as an expensively dressed model in a farmyard—seem natural.

By the 1930s, American commentators regularly linked barns with a modernist pictorial aesthetic; they also claimed—equally ahistorically—that the makers of Bucks County barns anticipated functionalist principles in contemporary architecture and design.[33] As previously noted, Sheeler himself appreciated the barns in these terms during the 1930s, asserting that "the functional intention was very beautifully realized" in their structure. Rourke, too, in her biography of Sheeler, identified the American vernacular design tradition with contemporary functionalism.[34] She asserted the essential equivalence of all his subjects, both machine-made and handcrafted, urban and rural.[35] Like folk art, vernacular architecture and design became the American counterpart of the so-called primitive sources that had inspired avant-garde painting and sculpture abroad. The historic material suddenly seemed to prefigure modern trends that had actually evolved from very different sources and contexts.

Rourke posited Sheeler's work as an important link between preindustrial craft traditions and modern design, and her linkage points to yet another "invented" heritage of the era. Wight senses the imaginative dimension of this construct: "*Bucks County Barn* [cat. 46], with its perfect balance between stone and wood ... had summoned up modern architecture through [Sheeler's] ability to see down into the evolution of form. This is an art of seeing what is there—but is it there until it was seen this way?"[36]

From our vantage point, distanced from the enthusiasms of the 1920s and 1930s, we recognize such invented lineages relatively easily. A more complex task involves discovering why such notions appealed to Sheeler and his contemporaries. As with folk art, American preindustrial architecture and crafts became precursors to contemporary functionalism because this conflation enhanced the position of the vanguard in this country.

Fig. 14
Louise Dahl-Wolfe
*Fashion Photograph with
Background Inspired by
Charles Sheeler*
1949
Harper's Bazaar,
February 1949, p. 121

American modernists needed an identifiably national heritage because the general public still disregarded them. Even as late as 1931, McBride claimed that Sheeler's works hid their abstract structure under a veneer of realism in order to "get away with cubism in a country that says that cubism is against the law."[37] Furthermore, the few who did appreciate modernism generally assumed the European avant-garde's superiority. And European modernists themselves, while idolizing American industry, dismissed the nation's artists and architects. Marcel Duchamp declared in 1917, "The only works of art America has given are her plumbing and her bridges."[38] Le Corbusier stated, "Let us listen to the counsels of the American engineers. But let us beware of the American architects."[39] Even taste-making institutions, such as the Museum of Modern Art, displayed condescending attitudes toward native modernists.[40] These influential voices assumed that the most sophisticated art and design originated abroad. No wonder American modernists of the 1920s and 1930s looked for ways to bolster their status. Producing a venerable and constitutive heritage that related both to national identity and to international design innovations furthered this end.

Sheeler's exhibitions, and the critical response to his work during the 1920s, chart the evolution of this invented lineage. A 1920 exhibition at the De Zayas Gallery displayed thirty-nine works by Sheeler. The subjects—Bucks County barns, interiors, still lifes, and landscapes—included no urban or industrial scenes.[41] By 1922, Sheeler's exhibitions mixed rural vernacular subjects with Machine Age iconography, and reviewers thereafter described all of his work as having the cold beauty of industrial objects, "the severe impersonality of a mechanical drawing."[42] In 1923, Forbes Watson placed Sheeler's art within a uniquely American tradition of good design:

Good taste is [the American artist's] native inheritance. Witness, for example, American architecture, so choice in its early stages, and in its latest developments so superior to any other contemporary architecture, and witness also American furniture, American glass,… and finally, Charles Sheeler.… In the clean-cut fineness, the cool austerity, the complete distrust of

superfluities which we find in some pieces of early American furniture, I seem to see the American root of Sheeler's art.[43]

In 1926, another reviewer linked all of his subjects—again, both handmade and industrially produced—to functionalist precepts, claiming, like Watson, that these principles essentially belonged to America:

It is easy to understand why certain European connoisseurs find in Sheeler's pictures the most complete expression of current tendencies of the American spirit. His choice of material is invariably American, either of the past or present. Yet even more characteristic of our country and of our period is the artist's disdain of non-essentials, his disregard of merely superimposed decoration. Expressed in this widely diversified effort we find always the directness, the incision, the insistence upon a coordination of factors and functions which is equally evident in the work of our engineers and scientists.[44]

Sheeler and his sympathetic critics established the notion of the nation's preindustrial design tradition and homegrown modernism as equivalents both to American industry and an international engineering aesthetic. To them, Bucks County barns unquestionably prefigured modern functionalism, and Sheeler's work served as a connecting link in this indigenous line of descent.

American modernists attempted to structure a viable national identity by appropriating artifacts—such as Bucks County barns—that originated in a radically different historical and aesthetic context from their own. This necessarily gave rise to tenuous and expedient justifications. Yet this strategy nevertheless successfully generated art, like Sheeler's, that conveyed a strong sense of Americanness. Although the artist avoided articulating fixed notions of the "American" tradition in art, Williams recognized his contribution to defining its character: "And what has he had to give? Bucks County Barns? How shall we … organize our history other than as Shaker furniture is organized? It is a part, totally uninfluenced by anything but the necessity, the total worth of the thing itself, the relationship of parts to the whole."[45]

To Sheeler's admiring contemporaries, his skillful

synthesis of past and present uncovered an essential connection that was already there. Viewed from our perspective, the artist's later Bucks County barns reveal how ingenuously Sheeler invented new linkages, as well strategies for reconciling the conflicting aspects of his cultural and aesthetic context. The images vacillate between cosmopolitan formalism and a sense of local rootedness, between modernism and tradition. In *Bucks County Barn*, 1932, and *Bucks County Barn*, 1940, he reconstituted a tangible picture of farm life, albeit without human actors, but populated instead with fat chickens, placid cows, and hay-filled wagons. He reconstructed a habitable world of Bucks County plenitude while emphasizing the barns' visual features that appeal to a modernist aesthetic: bold colors, appealing textures, and varied materials, as well as unornamented, blocky, "functional" forms.

Later, in *Barn Abstraction*, 1946, and *Thundershower*, 1948, Sheeler presented the subject in a way that obscures the buildings' regional roots. The barns float without foundation; reduced to simple, geometric shapes, their links to tradition become attenuated, and formal considerations eclipse associational ones. These more "modernist" paintings fragment and isolate, undercutting a sense of continuity with the past and with local identity. But characteristically, even these late, highly abstract barns contain signs of their traditional Pennsylvania origins. Some indications remain of their cantilevered forebays, extending ells, pent roofs, and contrasting materials.

These fascinating vacillations give visual expression to the complex task of national self-definition for artists like Sheeler, and to how that task changed over the decades. This quest involved a seemingly irreconcilable paradox: to create an art that was international and universally valid while at the same time exhibiting a rootedness in local tradition. For Sheeler and his contemporaries, this involved a modernist approach to the past that focused on the reevaluation of objects divorced from ancestors or famous historical events. The project involved aestheticizing formerly "unartistic" material, and in the process, asserting the value of American objects as abstract forms rather than as sentimental symbols. Sheeler therefore depersonalized the past in his art, even though in his private life it remained an extremely intimate concern.

Both the Bucks County barn images and the Doylestown house series suggest that Sheeler found his own experiences of personal loss mirrored in a rapidly modernizing society that was losing its rural traditions. To preserve antiquated subjects on the verge of eclipse kept absence at bay. At the same time, such artistic acts created a new context for the rural architecture of Bucks County. The subject entered a novel aesthetic realm that made a place for artifacts from the past while stripping them of the values they had traditionally represented. Sheeler's Doylestown photographs, paintings, and drawings resulted from such multivalent and sometimes conflicting motivations and contexts. They represent a complexly crafted alternative to the pervasive amnesia of modernity—new and old simultaneously, close to the heart but forever just out of reach.

NOTES

1. Troyen and Hirshler, *Charles Sheeler*, 140.

2. See Lucic, *Charles Sheeler and the Cult of the Machine*, and "Charles Sheeler and Henry Ford: A Craft Heritage for the Machine Age," *Bulletin of the Detroit Institute of Arts* 65 (1989): 37–47.

3. Troyen and Hirshler, *Charles Sheeler*, 223.

4. Ibid., 148. No photograph survives that exactly corresponds to *Of Domestic Utility*, but since Sheeler had long since moved from the Worthington house, he no doubt relied on one for the composition of the drawing. Because he sometimes destroyed photographic sources, we will probably never know the full story of Sheeler's artistic engagement with the Doylestown house.

5. Fillin-Yeh, *Charles Sheeler*, 15, notes Sheeler's tendency to create images frozen in time. See also Troyen and Hirshler, *Charles Sheeler*, 39.

6. Given Sheeler's compositional procedures at the time, the artist undoubtedly used a photograph of Katharine to work from. This in no way diminishes the poignancy of his time-consuming task.

7. Ann Whelan, "Barn is a Thing of Beauty to Charles Sheeler, Artist," *Bridgeport Post*, 21 August 1939, in Sheeler Papers, AAA, Roll ND/40, frame 502.

8. For letters articulating these difficulties, see Constance Rourke to Charles Sheeler, 4 August 1937, 17 August [1937], and 12 September [1937], Sheeler Papers, AAA, Roll 1811, frames 129, 131, and 136; Louise Arensberg to Sheeler, 14 January 1938, Sheeler Papers, AAA, Roll 1811, frames 70–72; and Sheeler to William Carlos Williams, 8 December 1938, Sheeler Papers, AAA, Roll 1812, frame 738.

9. Dochterman, "The Stylistic Development of the Work of Charles Sheeler," 370.

10. In 1937, Rourke obtained another work by Sheeler, probably the lithograph *Barn Abstraction* of 1918. Rourke to Sheeler, 27 September 1937, Sheeler Papers, AAA, Roll 1811, frame 138. One of the Doylestown drawings, *Interior with Stove*, also went to a close friend of Sheeler's, Edward Steichen.

11. Rubin, "A Convergence of Vision," 205. A few years earlier, Sheeler apparently proposed marriage to Halpert as well and suffered an identical rejection. Sheeler to Halpert, 22 January 1935, "Artists' Files," Downtown Gallery Papers, AAA, Box 132.

12. Troyen and Hirshler, *Charles Sheeler*, 223.

13. Beaumont Newhall to Sheeler, 24 December 1957, Sheeler Papers, AAA, Roll 1811, frame 108.

14. Quoted in Wight, "Charles Sheeler," 40.

15. Ibid., 42.

16. Wight, "Charles Sheeler," 21.

17. Quoted in Rourke, *Charles Sheeler*, 187–88. Wight applies this quote specifically to *The Artist Looks at Nature*. "Charles Sheeler," 40.

18. The unsigned, undated work is now in the San Diego Museum of Art. It was exhibited in Sheeler's 1939 retrospective at the Museum of Modern Art; the date assigned in the catalogue was 1926. But given the lack of evidence to explain the six-year gap between the watercolor and the oil, a later date is more likely. Troyen and Hirshler, *Charles Sheeler*, 140.

19. *Study after Bucks County Barn*, now in the Delaware Art Museum, is signed and dated 1938, the same year Sheeler's biography was published. Ibid.; see also John Driscoll, *Charles Sheeler: The Works on Paper* (University Park, Pa.: Pennsylvania State University, 1974), 79.

20. See Emily Genauer, "Charles Sheeler in One Man Show," *New York World Telegram*, 7 October 1939, p. 34.

21. Edith Gregor Halpert, "NBC Television (Time Capsule)," typescript, 6 October 1939, Downtown Gallery Papers, AAA, Roll 1883, frame 433.

22. Edith Wharton, *Ethan Frome* (New York: Charles Scribner's Sons, 1911), x.

23. Quoted in Rourke, *Charles Sheeler*, 198.

24. Wight, "Charles Sheeler," 21.

25. For example, *Abstract Trees and Barns, Bermuda*, 1917, Baltimore Museum of Art, and *Trees and Barns, Bermuda*, 1917, Williams College Museum of Art.

26. Several of these are in the Museum of Modern Art, New York.

27. For example, *My Shanty—Lake George*, 1922, the Phillips Collection, and *White Canadian Barn No. 2*, 1932, the Metropolitan Museum of Art.

28. Such as *White Barn*, 1936, Albright-Knox Art Gallery. Stewart, "Charles Sheeler, William Carlos Williams, and Precisionism," 113.

29. Whelan, "Barn is a Thing of Beauty," AAA, Roll ND/40, frame 502.

30. Dorothy Adlow, unidentified clipping, 20 October 1939, Downtown Gallery Papers, AAA, Roll ND/40, frame 458.

31. Ernest Brace, "Charles Sheeler," *Creative Art* 2 (October 1932): 104.

32. *Harper's Bazaar* (February 1949): 120–21. Downtown Gallery Papers, AAA, Roll ND/41, frame 86.

33. For example, Eleanor Raymond describes Pennsylvania vernacular architecture: "Observation of the modern movement, both abroad and at home, and a close study of these old Pennsylvania buildings will clearly show that the motives and ideals of both are the same…. An unstudied directness in fitting form to function, which seems to have been guided by an instinctive appreciation of proportion, and by skill in the use of materials have then resulted in the excellent design shown in these buildings." Foreword to *Early Domestic Architecture of Pennsylvania* (New York: William Helburn, 1931), unpaged.

34. Rourke, *Charles Sheeler*, 69.

35. Virtually all of the subsequent scholarship on Sheeler adopts this view. Most recently, see Fillin-Yeh, *Charles Sheeler*, 9. "At Doylestown, he found ready-made Cubist forms in the American countryside, forms that Constance Rourke called Sheeler's 'Urformen [basic forms]'." But an eighteenth-century spiral staircase is only a ready-made cubistic form to those familiar with avant-garde aesthetics. There is nothing inherently modernist about it. For a review of Fillin-Yeh's catalogue, see Karen Lucic, "Charles Sheeler: American Interiors," *Arts Magazine* 61 (May 1987): 44–47.

36. Wight, "Charles Sheeler," 27.

37. Henry McBride, *New York Sun*, 21 November 1931, quoted in Troyen and Hirshler, *Charles Sheeler*, 25.

38. Marcel Duchamp, "The Richard Mutt Case," *The Blind Man* 2 (May 1917): 5.

39. Le Corbusier, *Vers une Architecture* (Paris: G. Cres and Cie, 1924). Published in English as *Towards a New Architecture*, translated by Frederick Etchells (London: Architectural Press, 1927; reprint, New York: Praeger Publishers, 1960), 42.

40. In 1931, when the Museum of Modern Art organized the exhibition "The International Style: Architecture since 1922," only a few American architects were included. Henry-Russell Hitchcock and Philip Johnson's references to modern American architecture in the accompanying publication were highly critical. For example: "The ornament of the half-moderns has failed to stand the test of time even as well as that of the more cultured revivalists. The continuance of this superficially novel decoration which the half-moderns originated most effectually distinguishes the mass of American modern architecture from that of Europe." Hitchcock and Johnson, *The International Style* (New York: Museum of Modern Art, 1932; reprint, New York: W.W. Norton, 1966), 68.

41. Catalogue, De Zayas Gallery.

42. Dudley Poore, "Current Exhibitions," *The Arts* 7 (February 1925): 115.

43. Forbes Watson, "Charles Sheeler," *The Arts* 3 (May 1923): 336, 338.

44. Parker, "The Classical Vision of Charles Sheeler," 72. Since the nineteenth century, commentators had equated the American spirit with its feats of engineering and industrial production. In the 1920s, this equation was reconceived in terms of the arts.

45. William Carlos Williams, *The Autobiography of William Carlos Williams* (London: MacGibbon and Kee, 1968), 333–34. Cited in Stewart, "Charles Sheeler, William Carlos Williams, and Precisionism," 109, n. 72.

47

The Stove
1931
Conté crayon on paper
6 ¾ x 9 ¾ in.
The Wadsworth Atheneum,
Hartford
The Collection of Philip L.
Goodwin through James L.
Goodwin and Henry Sage
Goodwin (1958.232)

This exquisite drawing relates
to the photograph *Stove* (cat. 16)
taken about 1917. During the
1920s, Sheeler increasingly used
photographs, rather than pre-
liminary drawings, as aids for
producing works in a variety of
media. He explained that they
brought back "a reduced image
of my subject matter, more infor-
mative than any drawing."[1] His
use of photographs for creative
inspiration continued for the
rest of his career.

　　Sheeler once described the
drawing technique he used for
works such as *The Stove:*

*Coinciding with the new direc-
tion in my painting, beginning
with* Upper Deck, *there was a
similar change in regard to my
drawing.… I [now] … desire to
make my drawings as completely
realized as paintings in account-
ing for form, color and design
[and] … as much time is
required for the completion of a
drawing as of a painting.*[2]

Despite the artist's stated desire
for completion and high finish,
notice how in this work the pre-
cisely controlled, stippled effect
loosens slightly to the left of the
stove. The technique especially
animates the stone hearth, which
resembles viscose lava.

[1] Autobiographical notes, Sheeler Papers,
AAA, Roll Nsh 1, frame 113.

[2] Ibid., frame 111.

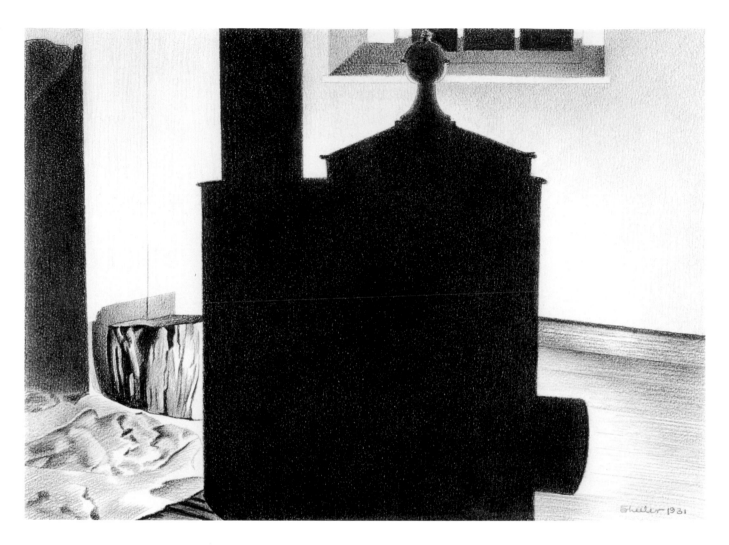

48

Interior, Bucks County Barn
1932
Conté crayon on paper
15 x 18 ¾ in.
Whitney Museum of American
Art, New York
Purchase (33.78)

As in *The Stove* (cat. 47) and
The Open Door (cat. 49), several
abstract passages contrast with
the overall meticulous finish of
this work. More thickly applied
to the left, the crayon is less
dense and its texture more
apparent to the right, especially
evident on the spokes of the
buggy's wheel. Like the earlier
photograph (cat. 26), chains and
planks keep the viewer at bay,
preventing entrance into this
very alluring, tactile, and com-
plex interior.

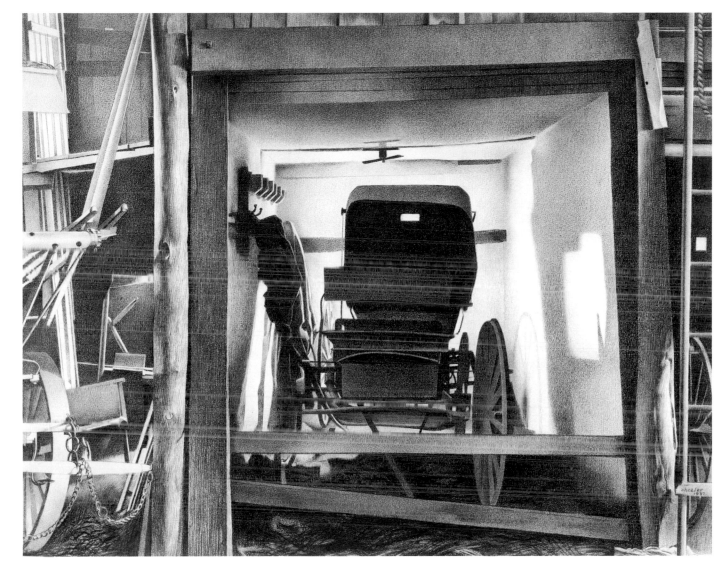

49

The Open Door
1932
Conté crayon on paper,
mounted on cardboard
18 ⅞ x 14 ¼ in.
The Metropolitan Museum
 of Art, New York
Edith and Milton
Lowenthal Collection
Bequest of Edith Abrahamson
Lowenthal, 1991, (1992.24.7)
© 1992, by the Metropolitan
Museum of Art, New York

In 1945, Sheeler articulated his
distinctive approach to the
medium of conté crayon: "The
pencil was kept to needle sharp-
ness and the drawing [was]
produced … without rubbing.
Since the crayon is only deposit-
ed on the highest points of the
grain of the paper it leaves the
valleys in between white, which
gives brilliance to the blacks."[1]
Although Sheeler also depicted
industrial, urban, and still life
subjects in conté crayon, his
elaborate method seems
especially appropriate to the
Doylestown themes. In an article
entitled "The Unveiling of a
Self-Portrait," J. Frank Dobie
reproduces *The Open Door* with
a caption reading, "A vanished
life that is part of me."[2]

[1] *Art News* (October 1945) in Sheeler
Papers, AAA, ND/41, frame 146.

[2] *New York Times*, book review section, 1
September 1957, p. 1.

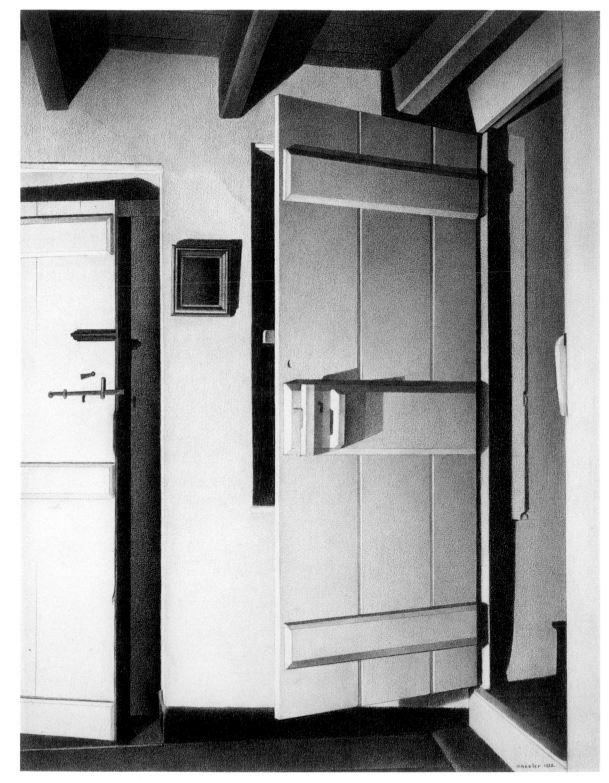

50

The Upstairs
1938
Oil on canvas
19 ½ x 12 ¾ in.
The Cincinnati Art Museum
Fanny Bryce Lehmer
Endowment (1938.10557)

After the Cincinnati Museum
purchased this work, the institu-
tion's bulletin stated: "Viewed
superficially the painting will
make the spectator think first
of a photograph, but Sheeler is
an artist first of all, and only
incidentally are his architectural
forms 'natural.' His work is
essentially the art of selection
and simplification carried to a
degree just short of cubism."[1]

In the 1930s, the relation
of Sheeler's photography to his
painting practice began to inter-
est critics of his art. Some wor-
ried that reliance on mechanically
reproduced images might com-
promise modernist originality.
But sympathetic commentators,
like this one, perceived sophisti-
cated invention in his photo-
inspired compositions.

[1] *Bulletin of the Cincinnati Art Museum* 10
(January 1939): 21.

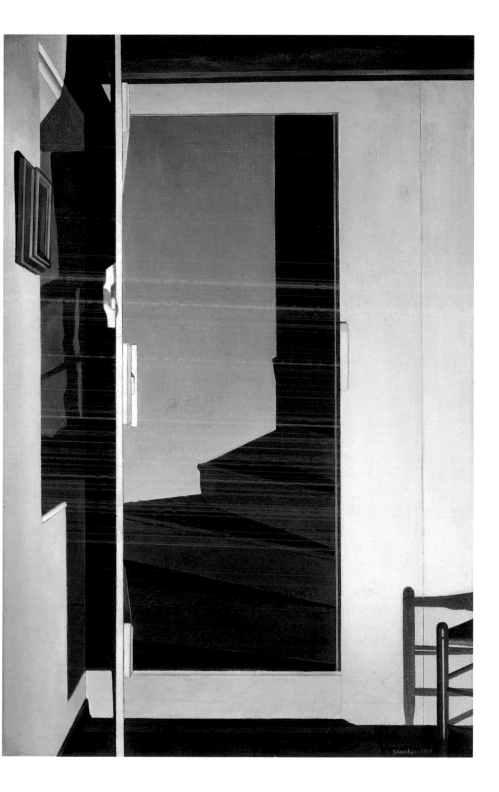

51

The Artist Looks at Nature
1943
Oil on canvas
21 x 18 in.
The Art Institute of Chicago
Gift of the Society for
Contemporary Art (1944.32)

The Artist Looks at Nature is a
rare example of self-portraiture
in the artist's work. A contempo-
rary source reports that the
painting includes scenes from
his former home in Ridgefield,
Connecticut (Sheeler had
moved to Irvington-on-Hudson,
New York, in 1942), and views
of Boulder Dam, where Sheeler
had recently taken some
photographs.[1]

 The Art Institute of Chicago
acquired this work shortly after
it was completed. Its bulletin
recounts: "Sheeler, in writing
about the picture, said it 'was
not painted at a specific spot but
is rather an assembly of ele-
ments.... I was interested in the
association of irrelevancies."[2]
Indeed, the artist brings togeth-
er seemingly unrelated elements
in one composition with an
uncharacteristic lack of integra-
tion. The past and present, the
industrial and the handmade,
the specific and the general all
improbably coexist in this het-
erogeneous amalgamation. Yet
at the same time, they all reflect
aspects of Sheeler's life and
artistic interests. In a moment of
self-examination, he used his art
to illustrate his recognition that
"the world is in one's back yard,
with the eyes to see it."[3]

[1] *Art News* 43 (15-31 October 1944): 10, in
Downtown Gallery Papers, AAA, Roll
ND/41, frame 152.

[2] *Bulletin of the Art Institute of Chicago* 39
(1945): 6.

[3] Autobiographical notes, Sheeler Papers,
AAA, Roll 1811, frame 826.

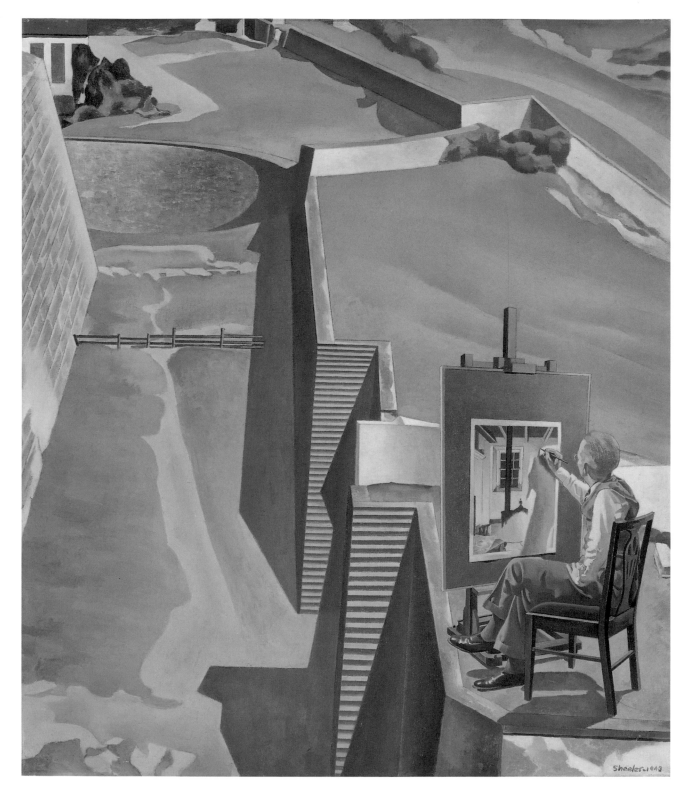

52

Self-Portrait at Easel
c. 1932
Gelatin silver print
9 ⅝ x 7⅜ in.
The Art Institute of Chicago
Ada Turnbull Hertle
Endowment (1988.431)

This photographic self-portrait
played an essential role in the
conception of *The Artist Looks
at Nature* (cat. 51). The camera's
low angle distorts the drawing
on the easel, making it wider at
the top than the bottom. The
painting replicates this feature,
along with the artist's pose, cos-
tume, and chair. But the later
work leaves out many elements
in the photograph, such as the
two photographer's lamps that
appear to Sheeler's left and
right. Neither is illuminated, but
an unseen source casts a halo of
light on the lamp's shiny surface
to the upper right. In it, we see
another image of the artist,
reflected from a different angle.
The double signs of artistic
presence in the photograph not
only recall Dutch and Flemish
precedents, but also illustrate
Sheeler's tendency to compli-
cate and objectify his expres-
sions of artistic identity.

53

Self-Portrait at Easel
c. 1932
Gelatin silver print
10 x 8 in.
The Lane Collection
Courtesy of the Museum of Fine
Arts, Boston

Undoubtedly taken at the same
session that produced cat. 52,
this image is remarkably similar
except for the differing pose and
the absence of the photograph-
er's lamp at right. At first we
might assume that Sheeler sim-
ply removed the lamp from the
corner, but on close inspection,
a portion of its foot remains near
the baseboard. This ghostly
detail indicates that Sheeler
"burned out" the lamp during
the printing process, a curious
intervention for a proponent
of "straight" photography.

54

Bucks County Barn
1932
Oil on gesso on composition
board
23 ⅞ x 29 ⅞ in.
The Museum of Modern
Art, New York
Gift of Abby Aldrich
Rockefeller, 1935 (145.35)
© 1997, The Museum of
Modern Art, New York

Sheeler defined "realism" during the 1930s as "a consideration of forms having a recognizable reference to the forms in nature."[1] But he mediated his realist style and use of photographic sources such as *Bucks County Barn (with Chickens)* (cat. 28) with a modernist aim to reveal what he considered a universal geometric structure underneath surface detail.[2] He denied wanting to "transcribe" photographs into paintings and used them instead as informational resources:

Not to produce a replica of nature but to attain an intensified presentation of its essentials through greater compactness of its formal design by precision of vision and hand.... Color in the picture seldom has a literal reference to that of nature, being subject to modification or frequently of arbitrary selection with a view of enhancing the design.[3]

[1] Autobiographical notes, Sheeler Papers, AAA, Roll 1811, frame 789.

[2] Stewart, "Charles Sheeler, William Carlos Williams, and Precisionism," 104–06.

[3] Autobiographical notes, Sheeler Papers, AAA, Nsh 1, frame 113.

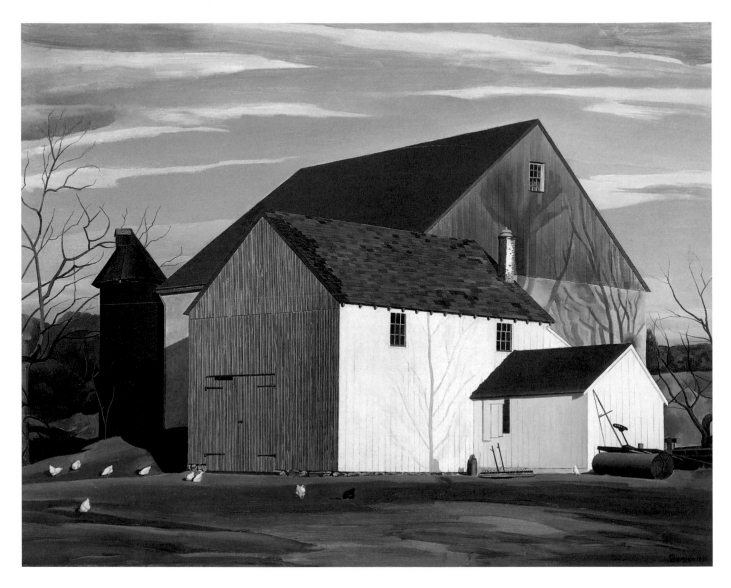

55

Barn Abstraction
1946
Tempera on board
22 x 29 ¼ in.
Collection of Mr. Arthur E.
Imperatore

This stately work presents the main outlines of the same building that inspired the 1918 *Barn Abstraction* (fig. 5) and the 1940 *Bucks County Barn* (fig. 11). Like the initial drawing, the composition of the 1946 painting simplifies and geometricizes the forms, leaving out the cows, wagons, and environmental details that the artist included in the canvas done six years earlier. It also purposely entertains ambiguities of two- and three-dimensional space, especially in the torqued gables of the main barn and the perpendicular ell, both seen from improbable frontal perspectives. The later work displays a rich palette of blues, pinks, tans, lavenders, and grays. Sheeler also exhibits a renewed interest in transparency and overlapping forms; for example, the shed to the left reveals the white plastered wall behind it and the windows located within the overhanging forebay. At the same time, the firmer contours and precisely bounded composition give more solidity to the work than its 1918 counterpart.

Despite the fact that Sheeler became best known for his industrial subjects, he produced at least eighty images of barns from 1917 to 1959, when his career ended because of a debilitating stroke. To a reporter who once asked him why he painted so many barns, Sheeler replied simply: "I think they are beautiful."[1]

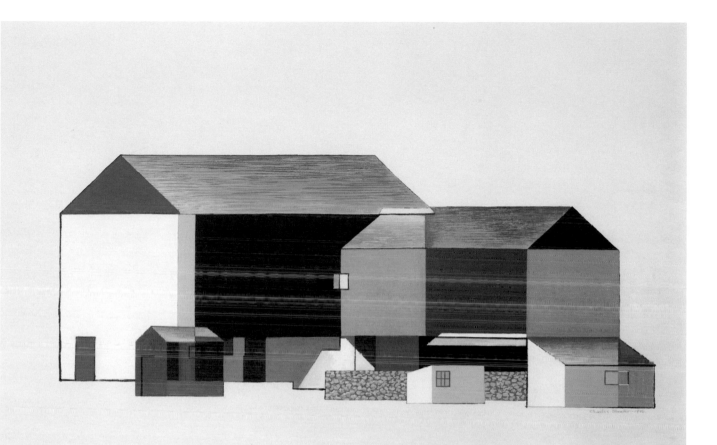

[1] Whelan, "Barn is a Thing of Beauty," frame 502.

56

The Yellow Wall
1946
Tempera on board
14 x 11 in.
Collection of Mr. and Mrs.
Vanderbes, New York

In the post-World War II era, a new American vanguard assertively rejected realism as a viable stylistic option and favored extremely gestural, expressionist approaches to painting. These stylistic tendencies were basically incompatible with Sheeler's temperament and aesthetic priorities. However, his awareness of his younger contemporaries' innovations may have affected this work. The deliberate lack of finish in *The Yellow Wall* indicates a renewed focus on the painting process and the medium's materiality. At the same time, the geometricized composition revives aesthetic concerns that the artist first explored in photographs such as *Downstairs Window* (cat. 17). As such, *The Yellow Wall* fittingly culminates Sheeler's long-lived artistic engagement with the Doylestown house.

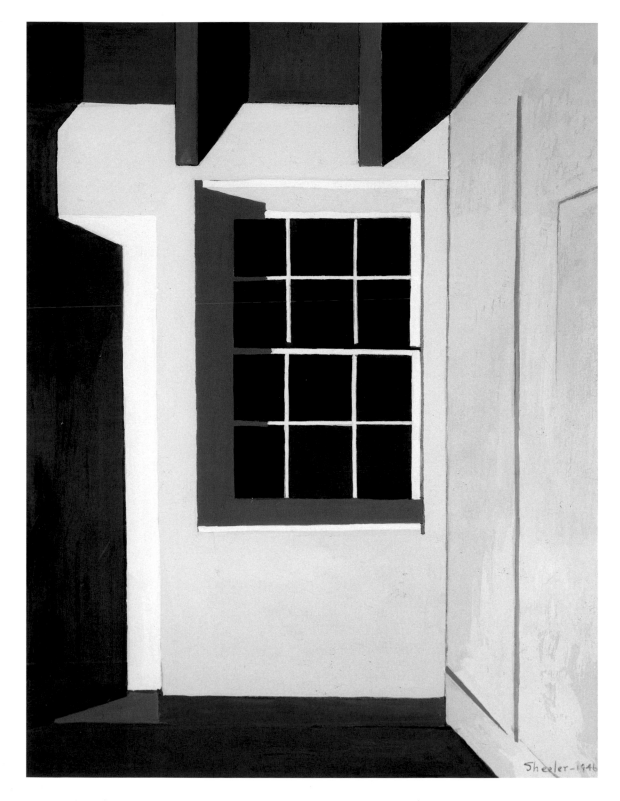

Sources Consulted

Ames, Kenneth. Introduction to *The Colonial Revival in America*, ed. Alan Axelrod. New York: W.W. Norton, 1985.

———. "The Paradox of Folk Art." In *Beyond Necessity: Art in the Folk Tradition*. Winterthur, Dela.: Winterthur Museum, 1977.

Amsler, Cory M. "Henry Mercer and the Dating of Old Houses." *Mercer Mosaic* 6 (Winter 1989): 18–28.

Anderson Galleries. *Forum Exhibition of Modern American Painters*. New York, 1916.

Andrews, Faith and Edward D. "Sheeler and the Shakers." *Art in America* 1 (1965): 590–95.

Art News 43 (15–31 October 1945): 10.

Baigell, Matthew. "American Art and National Identity: The 1920s." *Arts Magazine* 61 (February 1987):48–55.

Barendsen, Joyce P. "Wallace Nutting, an American Tastemaker: The Pictures and Beyond." *Winterthur Portfolio* 18 (Summer/Autumn 1983): 187–212.

Barker, Virgil. "Notes on Exhibitions." *The Arts* 5 (March 1924): 160–65.

Barr, Alfred. Correspondence with Mrs. John D. Rockefeller. Archives of the Museum of Modern Art, New York.

Berman, Avis. *Rebels on Eighth Street: Juliana Force and the Whitney Museum of American Art*. New York: Atheneum, 1990.

Brace, Ernest. "Charles Sheeler." *Creative Art* 2 (October 1932): 97–105.

Breuning, Margaret. "Early American Art Makes an Interesting Exhibition." *Evening Post*, 16 February 1924. In H. E. Schnakenberg Papers, Archives of American Art, Smithsonian Institution, Washington, D.C.

Brook, Alexander. Correspondence with Mrs. C. R. Bacon. Peggy Bacon Papers, Archives of American Art, Smithsonian Institution, Washington, D.C.

Brooks, Van Wyck. "On Creating a Usable Past." *The Dial* 64 (11 April 1918): 337–41.

Broom 5 (October 1923): 160.

Brown, Milton, and others. *American Art: Painting, Sculpture, Architecture, Decorative Arts, Photography*. New York: Harry N. Abrams, 1979.

Bry, Doris. *Alfred Stieglitz: Photographer*. Boston: Museum of Fine Arts, 1965.

Bucks County Deed Books. Nos. 382, 408, 441 and 534. Bucks County Courthouse, Doylestown, Pa.

Bucks County Historical Society. *The Mercer Mile*. Doylestown, Pa., 1972.

Bulletin of the Art Institute of Chicago 39 (1945): 6.

Bulletin of the Cincinnati Art Museum 10 (January 1939): 20–22.

Cahill, Holger. *American Folk Art: The Art of the Common Man in America, 1750–1900*. New York: Museum of Modern Art, 1932.

———. *American Primitives: An Exhibit of the Paintings of Nineteenth-Century Folk Artists*. Newark, N.J.: Newark Museum, 1930.

Christie's East. *19th and 20th Century Photographs*. New York, 16 May 1980.

Coady, Robert J. "American Art." *The Soil* 1 (1917): 3–4, 54–56.

Conn, Steven. "Henry Chapman Mercer and the Search for American History." *The Pennsylvania Magazine of History and Biography* 116 (July 1992): 323–55.

Corn, Wanda. *In the American Grain: The Billboard Poetics of Charles Demuth*. Poughkeepsie, N.Y.: Vassar College, 1991.

———. "Return of the Native: The Development of Interest in American Primitive Painting." M.A. thesis, New York University, 1965.

Craven, George M. "Charles Sheeler, A Self-Inventory in the Machine Age." Term paper, Ohio State University, 1957. Charles Sheeler Papers, Archives of American Art, Smithsonian Institution, Washington, D.C.

Craven, Thomas. "Charles Sheeler." *Shadowland* 8 (March 1923): 11, 71.

Curry, David Park. "Rose-Colored Glasses: Looking for 'Good Design' in American Folk Art." In *An American Sampler: Folk Art from the Shelburne Museum*. Washington, D.C.: National Gallery of Art, 1987.

Davies, Karen [Lucic]. "Charles Sheeler in Doylestown and the Image of Rural Architecture." *Arts Magazine* 59 (March 1985): 135–39.

de Zayas, Marius. Papers. Rare Book and Manuscript Library, Columbia University Libraries, New York.

de Zurko, Edward Robert. *Origins of Functionalist Theory*. New York: Columbia University Press, 1957.

Dobie, J. Frank. "The Unveiling of a Self-Portrait." *New York Times*, book review section, 1 September 1957, p. 1.

Dochterman, Lillian. *The Quest of Charles Sheeler*. Iowa City, Iowa: State University of Iowa, 1963.

———. "The Stylistic Development of the Work of Charles Sheeler." Ph.D. diss., State University of Iowa, 1963. Reproduced Ann Arbor, Mich.: University Microfilms International, 1984.

Driscoll, John. "Charles Sheeler's Early Work: Five Rediscovered Paintings." *The Art Bulletin* 62 (March 1980): 124–33.

———. *Charles Sheeler, 1883–1965, Classic Themes: Paintings, Drawings and Photographs*. New York: Terry Dintenfass Gallery, 1980.

———. *Charles Sheeler: The Works on Paper*. University Park, Pa.: Pennsylvania State University, 1974.

Duchamp, Marcel. "The Richard Mutt Case." *The Blind Man* 2 (May 1917): 5.

Ely, Warren S. "The Old Worthington House." N.p., c. 1908. In "Miscellaneous Papers Relating to Bucks County." Spruance Library, Bucks County Historical Society, Doylestown, Pa.

Ensminger, Robert F. *The Pennsylvania Barn: Its Origin, Evolution, and Distribution in North America*. Baltimore: Johns Hopkins University Press, 1992.

Fillin-Yeh, Susan. *Charles Sheeler: American Interiors*. New Haven: Yale University Art Gallery, 1987.

———. "Charles Sheeler and the Machine Age." Ph.D. diss., City University of New York, 1981.

Fitz, W. G. "A Few Thoughts on the Wanamaker Exhibition." *The Camera* 22 (April 1918): 204.

Folk, Thomas. *The Pennsylvania School of Landscape Painting: An Original American Impressionism*. Allentown, Pa.: Allentown Art Museum, 1984.

Friedman, Martin. "The Art of Charles Sheeler: Americana in a Vacuum." In *Charles Sheeler*, by National Collection of Fine Arts. Washington, D.C.: Smithsonian Institution Press, 1968.

Garvan, Beatrice B. *The Pennsylvania German Collection*. Philadelphia: Philadelphia Museum of Art, 1982.

Genauer, Emily. "Charles Sheeler in One Man Show." *New York World Telegram*, 7 October 1939, p. 34.

Glass, Joseph W. *The Pennsylvania Culture Region: A View from the Barn*. Ann Arbor, Mich.: UMI Research Press, 1986.

Glassie, Henry. "Vernacular Architecture." *Journal of the Society of Architectural Historians* 35 (December 1976): 293–95.

Halpert, Edith Gregor. "NBC Television (Time Capsule)." Typescript. 6 October 1939. Downtown Gallery Papers, Archives of American Art, Smithsonian Institution, Washington, D.C.

Harper's Bazaar (February 1949): 120–21.

Hirschl & Adler Galleries, Inc. *Realism and Abstraction: Counterpoints in American Drawing: 1900–1940*. New York, 1983.

Hitchcock, Henry-Russell, and Philip Johnson, *The International Style*. New York: Museum of Modern Art, 1932. Reprint, New York: W. W. Norton, 1966.

Hobsbawm, Eric, and Terence Ranger, eds. *The Invention of Tradition*. London: Cambridge University Press, 1983.

Homer, William Innes. *Alfred Stieglitz and the American Avant-Garde*. Boston: New York Graphic Society, 1977.

Hosmer, Charles B., Jr. *The Presence of the Past: A History of the Preservation Movement in the United States Before Williamsburg*. New York: G.P. Putnam's Sons, 1965.

Josephson, Matthew. Correspondence with Abram Lerner. Provenance file, "Staircase, Doylestown." Archives, Hirshhorn Museum and Sculpture Garden, Washington, D.C.

Kimball, Fiske. Correspondence with Charles Sheeler. Fiske Kimball Papers, Series I (General Correspondence), Philadelphia Museum of Art Archives.

Kimmelman, Michael. "An Iconographer for the Religion of Technology." *New York Times*, 24 January 1988, sec. H, pp. 29–30.

Kirby, C. Valentine. *A Little Journey to the Home of Edward W. Redfield*. This is Bucks County Series. Doylestown, Pa.: Public Schools of Bucks County, n.d.

Kramer, Hilton. Exhibition review. *New York Times*, 7 May 1966, p. 27.

Kuniyoshi, Yasuo [?]. Unsigned typescript. Yasuo Kuniyoshi Papers, Archives of American Art, Smithsonian Institution, Washington, D.C.

Kyle, Richard. Interview by author, 9 October 1984, Old Saybrook, Conn.

Laurent, Robert. Autobiographical notes. Robert Laurent Papers, Archives of American Art, Smithsonian Institution, Washington, D.C.

Learned, Marion. "The German Barn in America." In *University of Pennsylvania Lectures Delivered by Members of the Faculty in the Free Public Lecture Course*. Philadelphia: University of Pennsylvania, 1915.

Le Corbusier. *Vers une Architecture*. Paris: G. Cres et Cie, 1924. Published in English as *Towards a New Architecture*, translated by Frederick Etchells. London: Architectural Press, 1927. Reprint, New York: Praeger Publishers, 1960.

Ligon, Larry L. *The Concept of Function in Twentieth-Century Architectural Criticism*. Ann Arbor, Mich.: UMI Research Press, 1984.

Lucic, Karen. "Charles Sheeler: American Interiors." *Arts Magazine* 61 (May 1987): 44–47.

———. "Charles Sheeler and Henry Ford: A Craft Heritage for the Machine Age." *Bulletin of the Detroit Institute of Arts* 65 (1989): 37–47.

———. *Charles Sheeler and the Cult of the Machine*. Cambridge: Harvard University Press, 1991.

———. "On the Threshold: Charles Sheeler's Early Photographs." *Prospects* 20 (1995): 227–55.

———. "The Present and the Past in the Works of Charles Sheeler." Ph.D. diss., Yale University, 1989.

———. "Charles Sheeler's Bucks County Barns." *Sun and New York Herald*, 22 February 1920, sec. 3, p. 7. Reprinted in *The Flow of Art*, ed. Daniel Catton Rich. New York: Atheneum, 1975, 155–56.

———. "Salons of America Now Include Art Specimens of Entire World." *New York Herald*, 27 May 1923, sec. 7, p. 7.

McBride, Henry. "Art News and Reviews." *New York Herald*, 17 February 1924, sec. 7, p. 13.

McCoy, Garnett. "Charles Sheeler: Some Early Documents and a Reminiscence." *Journal of the Archives of American Art* 2 (April 1965): 1–4.

McLuhan, Marshall. *Understanding Media*. New York: McGraw Hill, 1964.

Mather, Eleanore Price, and Dorothy Canning Miller. *Edward Hicks: His Peaceable Kingdom and Other Paintings*. Newark, Del.: University of Delaware Press, 1983.

Mather, Eleanore Price. *A Peaceable Season by Edward Hicks*. Princeton, N.J.: Pyne Press, 1973.

Mercer, Henry Chapman. Correspondence with Charles Sheeler. Spruance Library, Bucks County Historical Society, Doylestown, Pa.

———. "The Dating of Old Houses." *Bucks County Historical Society Papers* 5 (1924). Reprint, Doylestown, Pa.: Bucks County Historical Society, 1976.

Millard, Charles. "Charles Sheeler: American Photographer." *Contemporary Photographer* 6 (1967): unpaged.

"Modernist Photographs." *American Art News* 16 (15 December 1917): 3.

Naef, Weston J. *The Collection of Alfred Stieglitz: Fifty Pioneers of Modern Photography*. New York: Metropolitan Museum of Art, 1978.

Newhall, Beaumont. Correspondence with Charles Sheeler. Charles Sheeler Papers, Archives of American Art, Smithsonian Institution, Washington, D.C.

Northampton Township Historical Study Commission. *Winds of Change: A Pictorial History of Northampton Township*. Northampton, Pa., 1985.

"Old Stone House, Relic of Colonial Days, Near Cross Keys Is To Be Restored Soon." *Bucks County Intelligencer*, 15 April 1926, p. 8.

Parker, Robert Allerton. "The Classical Vision of Charles Sheeler." *International Studio* 84 (May 1926): 68–72.

Paxson, Henry D., Jr. "Edward Hicks and His Paintings." *Bucks County Historical Society Papers* 6 (1930): 1–5.

"Photography—New Acquisitions." *The Bulletin of the Museum of Modern Art* 9 (February 1942): 12.

Poore, Dudley. "Current Exhibitions." *The Arts* 7 (February 1925): 115.

Prince, Hugh. "Revival, Restoration, Preservation: Changing Views about Antique Landscape Features." In *Our Past Before Us: Why Do We Save It?*, ed. David Lowenthal and Marcus Binney. London: Temple Smith, 1981.

Quinn Collection. *John Quinn 1870–1925: Collection of Paintings, Water Colors, Drawings & Sculpture*. Huntington, N.Y.: Pidgeon Hill Press, 1926.

Raymond, Eleanor. *Early Domestic Architecture of Pennsylvania*. New York: William Helburn, 1931.

Read, Helen Appleton. "Annual Exhibition of Whitney Studio Club." *Brooklyn Daily Eagle*, 11 May 1924, sec. b, p. 2. Archival file, "Whitney Studio Club and American Art, 1900–1932." Library, Whitney Museum of American Art, New York.

———. "Introducing the Cigar Store Indian into Art." *Brooklyn Daily Eagle*, 17 February 1924. H. E. Schnakenberg Papers, Archives of American Art, Smithsonian Institution, Washington, D.C.

Reed, Cleota. *Henry Chapman Mercer and the Moravian Pottery and Tile Works*. Philadelphia: University of Pennsylvania Press, 1987.

Rezer, Wilma. "The Old Worthington House," unpublished manuscript.

Robbins, Daniel. "Folk Sculpture Without Folk." In *Folk Sculpture U.S.A.*, ed. Herbert W. Hemphill, Jr. New York: Brooklyn Museum, 1976.

Rosenblum, Naomi. "Paul Strand: The Early Years, 1910–32." Ph.D. diss., City University of New York, 1978.

Rourke, Constance. *Charles Sheeler: Artist in the American Tradition*. New York: Harcourt, Brace and Co., 1938.

———. Correspondence with Charles Sheeler. Charles Sheeler Papers, Archives of American Art, Smithsonian Institution, Washington, D.C.

Rubin, Joan Shelley. "A Convergence of Vision: Constance Rourke, Charles Sheeler and American Art." *American Quarterly* 42 (June 1990): 191–222.

———. *Constance Rourke and American Culture.* Chapel Hill, N.C.: University of North Carolina Press, 1980.

Rubin, William, ed. *Primitivism in 20th Century Art: Affinity of the Tribal and the Modern.* New York: Museum of Modern Art, 1984.

Rumford, Beatrix T. "Uncommon Art of the Common People: A Review of Trends in the Collecting and Exhibiting of American Folk Art." In *Perspectives on American Folk Art,* ed. Ian M. G. Quimby and Scott Swank. New York: W.W. Norton, 1980.

Santa Barbara Museum of Art. *A Selection of 19th and 20th Century American Drawings from the Collection of Hirschl & Adler Galleries.* Santa Barbara, 1981.

Schaefer, Herwin. *Nineteenth-Century Modern: The Functional Tradition in Victorian Design.* New York: Praeger, 1970.

Schapiro, Meyer. *Modern Art: 19th and 20th Centuries.* New York: George Braziller, 1978.

Schwarz, Arturo. *The Complete Works of Marcel Duchamp.* New York: Harry N. Abrams, 1969.

Sheeler, Charles. Autobiographical notes. Charles Sheeler Papers, Archives of American Art, Smithsonian Institution, Washington, D.C.

———. Correspondence with Walter Arensberg. Charles Sheeler Papers, Arensberg Archives, Philadelphia Museum of Art.

———. Correspondence with Edith Gregor Halpert. "Artists' Files," Box 132. Downtown Gallery Papers, Archives of American Art, Smithsonian Institution, Washington, D.C.

———. Correspondence with Henry Chapman Mercer. Spruance Library, Bucks County Historical Society, Doylestown, Pa.

———. Correspondence with John Quinn. John Quinn Papers, Rare Books and Manuscripts Division, New York Public Library.

———. Correspondence with Constance Rourke. Charles Sheeler Papers, Archives of American Art, Smithsonian Institution, Washington, D.C.

———. Correspondence with Alfred Stieglitz. Alfred Stieglitz Archive, Collection of American Literature, Beinecke Rare Book and Manuscript Library, Yale University.

———. Correspondence with William Carlos Williams. Charles Sheeler Papers, Archives of American Art, Smithsonian Institution, Washington, D.C.

———. Interview by Martin Friedman, 18 June 1959. Charles Sheeler Papers, Archives of American Art, Smithsonian Institution, Washington, D.C.

Sims, Patterson. *Charles Sheeler.* New York: Whitney Museum of American Art, 1980.

Siskind, Aaron, and William Morgan. *Bucks County: Photographs of Early Architecture.* Doylestown, Pa.: Horizon Press and Bucks County Historical Society, 1974.

Solis-Cohen, Lita. "Old Photographs Pack 'Em in at Three Auctions, with Unclear Results." *Philadelphia Inquirer,* 22 June 1980, sec. k, p. 13.

Sotheby, Parke, Bernet, Inc. *The Edith G. Halpert Collection of American Paintings.* New York, 14–15 March 1973.

Stebbins, Theodore E., Jr., and Norman Keyes, Jr. *Charles Sheeler: The Photographs.* Boston: Museum of Fine Arts, 1987.

Stein, Judith E. "An American Original." In *I Tell My Heart: The Art of Horace Pippin.* Philadelphia: Pennsylvania Academy of the Fine Arts, 1993.

Stewart, Rick. "Charles Sheeler, William Carlos Williams, and Precisionism: A Redefinition." *Arts Magazine* 58 (November 1983): 100–14.

Stieglitz, Alfred. Correspondence with Charles Sheeler. Alfred Stieglitz Archive, Collection of American Literature, Beinecke Rare Book and Manuscript Library, Yale University.

Strand, Paul. Correspondence with Alfred Stieglitz. Alfred Stieglitz Archive, Collection of American Literature, Beinecke Rare Book and Manuscript Library, Yale University.

Stryker, Charlotte. "The Colonial Architecture of Bucks County, Pennsylvania." Unpublished manuscript. Spruance Library, Bucks County Historical Society, Doylestown, Pa.

Szarkowski, John. *Alfred Stieglitz at Lake George.* New York: Museum of Modern Art, 1995.

Troyen, Carol, and Erica E. Hirshler. *Charles Sheeler: Paintings and Drawings.* Boston: Museum of Fine Arts, 1987.

University of New Hampshire. *The Robert Laurent Memorial Exhibition.* Robert Laurent Papers, Archives of American Art, Smithsonian Institution, Washington, D.C.

Watson, Forbes. "Charles Sheeler." *The Arts* 3 (May 1923): 334–44.

Watson, Steven. *Strange Bedfellows: The First American Avant-garde.* New York: Abbeville, 1991.

Wharton, Edith. *Ethan Frome.* New York: Charles Scribner's Sons, 1911.

Whelan, Ann. "Barn is a Thing of Beauty to Charles Sheeler, Artist." *Bridgeport Post,* 21 August 1939. Charles Sheeler Papers, Archives of American Art, Smithsonian Institution, Washington, D.C.

"The White Door: A Study by Charles Sheeler." *Vanity Fair* 20 (April 1923): 47.

Whitney Studio Club. *Early American Art.* New York, 1924.

Wight, Frederick S. "Charles Sheeler." In *Charles Sheeler: A Retrospective Exhibition.* Los Angeles: Art Galleries, University of California, 1954.

Williams, William Carlos. Correspondence with Charles Sheeler. Charles Sheeler Papers. Archives of American Art, Smithsonian Institution, Washington, D.C.

———. *The Autobiography of William Carlos Williams.* London: MacGibbon and Kee, 1968.

———. *In the American Grain.* New York: New Directions Books, 1925.

———. Introduction to *Charles Sheeler: Paintings, Drawings, Photographs.* New York: Museum of Modern Art, 1939.

Wolf, Ben. *Morton Livingston Schamberg.* Philadelphia: University of Pennsylvania Press, 1963.

Woods, Marianne Berger. "Viewing Colonial America Through the Lens of Wallace Nutting." *American Art* 8 (Spring 1994): 67–86.

Yount, Sylvia. "Rocking the Cradle of Liberty: Philadelphia's Adventures in Modernism." In *To Be Modern: American Encounters with Cézanne and Company.* Philadelphia: Museum of American Art of the Pennsylvania Academy of the Fine Arts, 1996.

Zilczer, Judith K. "Robert J. Coady: Forgotten Spokesman for Avant-Garde Culture in America." *American Art Review* 2 (November/December 1975): 77–89.

Addendum

The following objects are on view at the venues listed:

Cat. 38: Cincinnati and Fort Worth
Cats. 39, 46, 48: Allentown
Cat. 47: Allentown and Fort Worth
Cat. 49: Cincinnati

The following objects are also included in the exhibition "Charles Sheeler in Doylestown: American Modernism and the Pennsylvania Tradition":

PHOTOGRAPHS

Charles Sheeler
Bucks County Barn (Vertical)
c. 1916–17
Gelatin silver print
10 x 8 in.
The Lane Collection
Courtesy of the Museum of Fine Arts, Boston

Charles Sheeler
Bucks County Barn (Vertical)
c. 1916–17
Gelatin silver print
9 ⅛ x 7 ¼ in.
The Lane Collection
Courtesy of the Museum of Fine Arts, Boston

Unknown Photographer
Interior, Barley Sheaf Farm, c. 1920s
Gelatin silver print
7 1/2 x 9 1/2 in.
Collection of Carl Rieser

Unknown Photographer
Interior, Barley Sheaf Farm, c. 1920s
Gelatin silver print
7 1/2 x 9 1/2 in.
Collection of Carl Rieser

BOOKS AND RELATED MATERIALS

Henry C. Mercer, *The Dating of Old Houses* (Doylestown, Pa., c. 1923)
Spruance Library, Bucks County Historical Society, Doylestown, Pennsylvania

Wallace Nutting, *Pennsylvania Beautiful* (Framingham, Mass.: Old America Co., 1924)
Private Collection

Constance Rourke, *Charles Sheeler* (New York: Harcourt, Brace and Co., 1938)
Courtesy of Dr. Carol Troyen, Boston

Vanity Fair 20 (April 1923)
Collection of the Vassar College Libraries, Poughkeepsie, New York

LETTERS

**Charles Sheeler to Alfred Stieglitz,*
13 June 1917
Yale Collection of American Literature, Beinecke Rare Book and Manuscript Library, Yale University

**Charles Sheeler to Alfred Stieglitz,*
22 November 1917
Yale Collection of American Literature, Beinecke Rare Book and Manuscript Library, Yale University

***Charles Sheeler to Walter Arensberg,*
c. 1918 (undated)
Arensberg Archives, Philadelphia Museum of Art

**Charles Sheeler to Alfred Stieglitz,*
15 October 1918
Yale Collection of American Literature, Beinecke Rare Book and Manuscript Library, Yale University

Henry Mercer to Charles Sheeler,
18 March 1924
Spruance Library, Bucks County Historical Society, Doylestown, Pennsylvania

Charles Sheeler to Henry Mercer,
26 March 1924
Spruance Library, Bucks County Historical Society, Doylestown, Pennsylvania

Charles Sheeler to Henry Mercer,
4 March 1926
Spruance Library, Bucks County Historical Society, Doylestown, Pennsylvania

*Facsimiles in Cincinnati and Fort Worth

**Facsimile at all locations

Photo Credits

Geoffrey Clements: cats. 46, 48; fig. 6, 10

Ron Forth: cat. 44

David Haas: cat. 6

Helga Photo Studio: cats. 4, 20, 32

Robert Hennessey: cats. 1–2, 8–18, 22, 25–31, 36, 52–53

Biff Henrich: cat. 35

Lee Stalsworth: cat. 23

Laura Voight: cat. 22; fig. 5

Robert Walsh: cats. 3, 7, 24, 45; fig. 14

Graydon Wood: fig. 3